MODERN
SCULPTURE
THE NEW OLD MASTERS

OTHER BOOKS BY HERBERT CHRISTIAN MERILLAT

Sculpture West and East: Two Traditiions
The Island: First Marine Division on Guadalcanal
Legal Advisers and Foreign Affairs
Legal Advisers and International Organizations
Land and the Constitution in India

MODERN SCULPTURE

THE NEW OLD MASTERS

HERBERT CHRISTIAN MERILLAT
Illustrated with photographs

DODD, MEAD & COMPANY · NEW YORK

ISBN: 0-396-06987-8
Library of Congress Catalog Card Number: 74-6801
Printed in the United States of America

To Margaret
and the memory of Dick

Preface

THE TWENTIETH has been one of the important centuries for sculpture in the West, like the fifth century B.C. in Greece and the sixteenth in Italy. We may wonder what Phidias or Michelangelo would make of the new three-dimensional objects that are the distinctive creation of our times. Indeed, many of us wonder what to make of them ourselves. The *bourgeois*, however, was *épaté* to a pulp long ago, and a widening circle, including staid business establishments, seems to welcome ever more novel experiments—without always, we may suspect, being truly initiated into the mysteries.

What is there in the new sculpture for you and me—for those of us, that is, who consider art to be a significant part of experience, but for whom it is not a livelihood, a way of life, or The Way? We are, let us modestly say, intelligent, literate, sensitive to nuances of perception and feeling and meaning, and fairly well in pace with the rapid changes of our times. Yet many of us, confronted with modernist sculpture, are bored, baffled, annoyed, wary. Ah, say the true believers, that is because you are prisoners of the past, and you have not yet developed the special

sensibilities needed to appreciate the new sculpture. We must, in part, agree. Those who tend to resist change of any kind are most likely to dismiss modernist sculpture without a second look. And many of us have not seriously tried to understand the forces that have led modernist sculptors, who are creatures of their times as well as creators of its visible symbols, to take leave of old traditions and try to establish new ones.

Several things new, or newly vivid, in this century have influenced its sculpture: awareness of unconscious forces at work in our psyches; dissatisfaction with a cultural chauvinism that disdains anything outside the familiar traditions; dissolution of old certitudes, and invention of new working hypotheses, about the nature of man and the universe; discovery, by artists, of the industrial age; interest in new materials of which ancient carvers in marble and casters in bronze knew nothing; a frequent turning toward form as the distinctive ingredient of aesthetic experience; and a deepening suspicion that man has been given the wit to ask ultimate questions but not the wit to find the answers, and had best learn to live with, and enjoy, paradox and ambiguity.

I have traced some of these influences through the work of the main innovators, who have in turn influenced later generations of sculptors. I have limited the number to about twenty, with only occasional references to the works of others. The restriction is not entirely arbitrary: these are the old masters of the new sculpture. A dozen of them would appear on anyone's list; opinions may differ on the rest.

The selection is also a matter of discipline: it would be unnecessarily cluttering to attempt a survey of all modernist sculpture in a book intended as an introduction to the main new trends in form, theme, and technique—although the major innovators in the first few decades of this century were a small group, most of whom knew each other and were aware of each other's experiments. I have tried to focus on their contributions rather than on the men and women themselves, and have not

attempted a full survey of the work of any. I have kept to a
minimum the description of the myriad "isms," although the
tracing of their history can be fascinating. All in our group were
somehow affected by the influences distinctive of this century.
Accordingly, assignment of a sculptor to this or that chapter is
bound to be somewhat arbitrary. Most of those referred to in
these pages came to maturity in the first half of the century.
Degas and Rodin are the earliest born, David Smith the latest. I
have seldom referred to the explosion of contemporary sculp-
ture that began after the Second World War with younger men
and women whose antecedents can often be found in the old
masters.

With few exceptions our group is made up of men and
women who deliberately and drastically broke with the tradition
that prevailed in the West through the nineteenth century. I do
not mean to disparage the work of many talented sculptors who
have continued to work within that tradition. But the distinctive
flavor of this century comes from those who broke with the past.
They are, moreover, the ones who most need "explaining" to
intelligent laymen interested in modern sculpture. "Modernist"
has been used to distinguish our innovative group.

Most of the artists have been reticent about explaining their
own works, except in terms of general purposes. Their inter-
preters have been under no such constraint. Some of the sculp-
tors and their interpreters alike have been voluble in elaborating
the aims of a particular trend or movement. There has been an
outpouring of manifestoes, personal memoirs, recollections by
friends and disciples, and interviews with critics, art historians,
and journalists. I have used the artists' own words liberally, while
realizing that selection results in some distortion. And lest we
regard the mass of written material as having scriptural author-
ity, let us keep in mind that memories fade, opinions change,
and recollections communicated to others are rarely to the dis-
credit of the speaker. The legendmakers have been busy, in this
as in other fields. Moreover, as creative artists would be the

first to say, attempted verbal communication is inadequate to reveal the qualities, or conceal the deficiencies, in the visible creation.

Much of the writing by artists and critics is on an almost mystical plane. Debates about the nature of sculpture, about "form" as against "content," about abstraction as against representation, often attain a theological intensity. There is a shabbier side to modernist art (well documented elsewhere, and not explored here), involving opportunistic converts and money-changers in the temple. And there is a lighter side, a frequent mixture of playfulness with seriousness. Modernist sculpture can be fun.

I have started from the assumption that an art for our century is not beyond the capacity of intelligent people to comprehend and appreciate. If we cannot reach the tenth and topmost stage of enlightenment, where, in certain Buddhist sects, the Absolute will be revealed, we will at least find it rewarding to circumambulate the shrine in its lower courses.

For whatever they may be worth to others, in an exploration that must be personal, I offer a few suggestions to those who visit modernist collections.

1. Do not compare Michelangelo and Henry Moore. Although their similarities are greater than might appear at first glance, each is saying something different and in his own way. You can enjoy both without worrying about being inconsistent. Modern sculpture is best approached as a wholly new art form.

2. As a corollary, remember that a modernist sculptor rarely tries to copy nature as we see it. It is not (in all cases, at least) from lack of skill that the modernist does not carve for you a pleasing and convincing nymph or Greek god. Usually (if he uses natural figures at all) he is trying, in Picasso's phrase, not to imitate, but to intimate. Suggestiveness, indirect allusiveness, unexpected conjunctions, metamorphoses, wit, irony, and ambiguity are characteristic of much modernist art, rather than

clarity in representing a well-defined subject, comfortably un-
derstandable as heroic or saintly or titillating.

3. As a further corollary, remember that the modernist is,
like all of us, something of a depth psychologist, distrustful of
surface appearances, curious about the workings of unconscious
and irrational forces beneath the bland face of order and reason.
A desired and desirable "Aphrodite of Cnidos" by Praxiteles
may turn into a *Woman with Her Throat Cut* by Giacometti. A
gracefully posed and draped Greek goddess, reclining in a ped-
iment of the Parthenon, may become a woman-mountain, sym-
bol of the eternal feminine, an archetypal earth-mother by
Henry Moore, also reclining, but now nourishing a fetus, nurs-
ing an infant, nestling a lover's head—we cannot be sure which it
is, or whether it is all, or none, of these. (*See* illustration 40.)

4. Expand your vision of the world through history beyond
that segment comprising Greece, Rome, and Christendom
(however centrally important these remain to those of us who
are their heirs). People began carving three-dimensional figures
in the Old Stone Age, more than thirty thousand years ago,
remarkably (in some instances) like sculpture of recent times, in
theme and form—and also, it should be added, sometimes re-
markably like our traditional sculpture. Of all the civilizations
that have grown and faded since then, ours is but one. Cultural
chauvinism is out of date.

5. In the debate between devotees of pure form (angular or
ovoid figures, for example) and those who insist on links with the
observed world, be neutral. The creations of both can be en-
joyed, on their own terms. An exception must be made, of
course, for those who find in either the expression of ultimate
truths.

6. Do not feel obliged to "like" what you see. But before
forming a judgment (let alone expressing it to anyone else), you
are obliged to look long and attentively, and look again. Julio
Gonzalez, the first of the welders, said it was incumbent on all

viewers, each "according to his capabilities, [to] try to elevate himself to the work of art. If they don't succeed at the first try, let them persist, even several times." Persist, by all means—until you decide it is not worth your time to keep on looking. Each of us, in the last analysis, knows from his own experience what he enjoys. Greater appreciation of the new sculpture is likely to come with better understanding of the ideas that have gone into its development. A few selected titles that may sharpen a viewer's sensibility are suggested in the section on Further Reading. In my personal exploration I have found much of the literature helpful, some of it obscure and annoying. Fortunately, you need take no one else's views—certainly not mine—as the single and ultimate guide.

I want to thank the library staffs at the National Gallery and National Collection of Fine Arts, both in Washington, D.C., where I did much of my reading for this book, and the many members of museum staffs who have helped me to gather the illustrations. I am also grateful to friends and to experts in the world of art who have kindly assisted me through guidance to source materials, answers to inquiries, provision of photographs, comments on parts of the manuscript in draft, or general encouragement: Caroline Backlund, Adelyn Breeskin, Albert Elsen, Sidney Geist, Lincoln Kirstein, Allen Klots, Henry Moore, and Barbara Zabel. My thanks, I must add, do not imply responsibility on their part for my personal statements of fact or opinion. I am especially grateful to Edward Weismiller for his review of the manuscript.

H. C. L. MERILLAT

Washington, D.C.

Contents

MODERN SCULPTURE

THE NEW OLD MASTERS

The titles of works of art that are illustrated in the book appear in italics in the text. The identifying numbers of illustrations referred to in the text appear in brackets.

The titles of works of art not illustrated appear in roman with quotation marks.

1

Bridges to a New Century

REACTING TO RODIN

Toward the end of his long life Auguste Rodin (1840–1917) saw himself as the link between the old tradition in sculpture, based on Greek naturalism, and the new forms of three-dimensional art that were beginning to burgeon around him. "I am a bridge," he said, "joining the two banks, the past and the present."

Many on the nearer bank have disagreed. The avant garde of the early twentieth century, those who had broken with the past, saw in Rodin a late revival of the tradition. But he was the giant of his times, the one who had restored vitality to sculpture and won an audience. Without Rodin, the radical innovators might not have been drawn to three-dimensional art. He was the one to react to, and react they did, as we shall see.

Rodin once told how he happened to make one of his most famous statues. An Italian peasant, hearing that the sculptor sometimes hired models, came to his door unannounced. Rodin was seized, he later said, with admiration for "that rough, hairy

man, expressing in his bearing and physical strength all the violence, but also all the mystical character of his race." The peasant took off his clothes, mounted the model's stand, and struck a natural untutored pose, with his feet planted wide apart, one before the other, his body straight, his head high. "The movement was so right," said Rodin, "so determined, and so true that I cried: 'But it's a walking man.' I immediately resolved to make what I had seen."

The outcome was *St. John the Baptist Preaching* [5], one of Rodin's first major works in bronze. In creating his earlier "Age of Bronze" Rodin had been unjustly accused of taking a cast from a living model, so faithful to life it seemed. Perhaps that is one reason Rodin made his *St. John* somewhat larger than life. It is an early example of the sculptor's interest in trying to depict motion. Traditionally, the movement of walking has been suggested in sculpture by the obvious device of placing a human figure's weight on the forward foot with the heel of the other foot lifted, as if the weight were coming off it. Here both feet are firmly planted, to suggest two sequential movements in the act of walking.

Years later the same basic posture appeared in a strong male figure, headless and armless, known as *Walking Man* [4]. (This was an enlargement, somewhat altered, of a study he had made in 1877–78, less than a yard high, for *St. John.*) The photograph was taken on the grounds of the Hirshhorn estate in Greenwich, Connecticut (before the sculpture was moved in 1974 to the Hirshhorn Sculpture Garden in Washington). At first glance we might wish that the bronze figure stood out more distinctly from its background. But, by a happy chance, the broken light and shadow in the leaves behind offer a striking metaphor for the surface effects that were among Rodin's distinctive contributions to the art of sculpture. *Walking Man* is bigger than *St. John*, and more roughly finished. Modernist sculptors and critics tend to admire him more than the more highly finished Baptist,

complete with arms and hands—one raised in a gesture of preaching—and an expressive head. In the reasons for that preference we will find some of the characteristic attitudes toward sculpture that set off the new so sharply from the old.

Rodin rejected, in much of his work, the prettiness into which the academic tradition had lapsed, demonstrated that the true was not necessarily also beautiful, and restored vitality to a form of art grown sickly. The uneven surfaces of his bronzes, like those of a pond agitated by crosswinds, had far more life and liveliness than the smooth polished marbles and bronzes of most contemporaries. He distorted boldly, to convey burden, tension, anxiety, or despair.

The avant garde among sculptors, however—those who had deliberately and radically broken with the past—saw in Rodin a representative of the tradition. He was a major artist, certainly, but in their eyes one still addicted to Greece and the Renaissance in his preoccupation with the nude human body, his concern with "content"—telling a story or honoring a hero—and his effort to reproduce surface appearances. To them *Walking Man* was more admirable than *St. John* because it was untainted by literary allusions. It is not the Forerunner preaching to his fellows, or anyone else in particular, but a generalized powerful male figure. Modernists tend to frown on telling stories, and to value essences.

Throughout history sculpture had served causes. It celebrated kings and heroes, revered the gods, honored the saints. It was the literature of the illiterate, reciting in stone or wood or metal the legends that bound a people together and the scriptures of their religions. Churches may use pictures, Pope Gregory wrote in the seventh century, so that "those who are ignorant of letters may by merely looking at the walls read there what they are unable to read in books." Philosophy for the learned, images for the ignorant: it was a precept followed by Buddhist abbots and Brahmin priests as well as their counterparts in the Chris-

tian West. Dynasties must be glorified and immortalized, patriotism instilled, martial leaders thanked and held up as examples, civic and personal virtue inculcated.

The nineteenth-century romantics had to some extent departed from these solemn purposes, with their emphasis on individual creativity, search for emotional impact, and insistence on the aesthetic validity of the commonplace and ugly. Rodin was the towering sculptor of that movement. For the avant garde at the turn of the century, however, the old causes and faiths seemed faint and wan. Why go on repeating representations of people and allegories that no longer rang true? And why not leave storytelling to novelists, and preaching to clerics, and official propaganda to the leaflet-writers? Moreover—and this was an even more important consideration—sculpture had its own unique characteristics that set it off from other forms of art and communication: mass, three-dimensional form, surface texture, lights and shadows, unique structural strengths and weaknesses, contours. These formal qualities should be the true sculptor's concern. Leave it to photographers to record how people look.

Rodin, with his meticulous observation of, and recordings from, living models, could not be warmly welcomed by those who tended to this way of thinking. Thus *Walking Man* was more admirable than *St. John*, all the more so because its expressiveness was condensed in a torso and did not rely on gesturing arms and an individual face. Henry Moore, for example, has pointed out that Michelangelo relied on the body more than the face to express what he wanted: "The face shows superficial expressions. Much deeper indications of a person's feelings will be found in action, all the movements of the body, how they hold themselves. By their movement you recognize who they are." For him, the lack of arms and a head did not deprive *Walking Man* of its humanity. And Moore himself, as will be apparent, rarely treated a human head in any detail.

In part the early rejection of Rodin by modernists (his work,

especially the bronzes, has more recently come back into favor) resulted from the success he had enjoyed in the world of wealth and fashion—his triumphant visits to London, his busts of the rich and powerful and famous, his liaisons with high-placed ladies, and the affluence and acclaim he enjoyed. One so embraced by the establishment could only be suspect among those who insisted mankind must be transformed, the old and corrupt and decadent rooted out.

A more worthy objection had to do with the rather casual way in which he signed marbles carved by others from his plaster originals, authorized reproduction of his works in various sizes (with enlargements and reductions made by others using copying machines), and turned out an unknown number of castings. It is simply not known today how many castings there are of most of his works. In such casualness Rodin was a man of his times. In the nineteenth century (and long before) it was the practice of sculptors—who presumably deserve the designation "artists"— to make plaster models, which were turned over to assistants or professional stone-carvers (a more lowly order of "artisans"), who did most of the chipping and shaping, with the "masters" adding, perhaps, a few final touches. One of Rodin's first jobs was to make statuettes for Carrier-Belleuse, a fashionable artist of his day, on which his employer's name would be signed.

How many castings of sculptures in bronze or other metal can be made before the molds begin to deteriorate, resulting in a marked loss of quality in the finished object? There is no definite code of professional conduct or law to determine how many castings made from the sculptor's original molds should be regarded as "originals" by him. Under United States tariff laws only the original plaster model and the first ten castings are admitted duty-free as "originals." Quite apart from the number of castings, can a particular version be called an authentic work if the sculptor did not himself chase and polish the metal when it came in unfinished form from the foundry, add the final details, and give it the patina he wanted—or at least closely supervise

these important finishing touches if they were performed by others?*

Early in this century modernist sculptors rebelled against the practice of turning over plaster models to others for carving into stone or marble. Rodin, as the most eminent modeler of the time, was the natural target of their criticism. Sculpture had become "very sick with Rodin," Amedeo Modigliani said to Jacques Lipchitz. "There was too much modeling in clay, too much 'mud.' " The only way to save sculpture, he believed, was to begin carving again, directly in stone. Constantin Brancusi was another of the early believers in direct carving. Briefly working as Rodin's assistant, he soon turned away. "Nothing can grow in the shadow of great trees," he later said. "Direct carving, that is the true road to sculpture, but also the roughest for those who don't know how to walk" was one of his pronouncements.

Jean Arp, Jacob Epstein, and Henry Moore were among those who thought the true sculptor was not one who shaped a figure in "mud," or turned over a plaster model to someone else to be copied in stone, but he who himself cut into marble or stone or wood. Sculptural integrity demanded what came to be called "truth to the materials"—an early tenet among many modernists. The artist must be guided by the nature of the material he is working with. He must draw out (as it was sometimes said Michelangelo did) the figure lurking within the block of marble or log of wood. Each raw material has characteristics that must be respected: the blockiness of stone, the glow of marble, the grain and fibrous strength of wood. As a corollary, an object made in one material should not be copied in another. What was appropriately created with the soft glow of marble or the rough texture of most stone should not be reproduced with the shiny surfaces of polished bronze. In his early years (as we shall later see) Moore was dedicated to "truth to the material," working almost entirely in stone and wood. Eventually he came to think

*Comments on "originals" appear in the *Note on Sculpture in the Customs Shed* (see pp. 125–142).

BRIDGES TO A NEW CENTURY 7

that the significant thing was the form, which might be in any material, and he often modeled figures to be cast in metal. Brancusi often made the same object in marble and in bronze. Indeed, when he became fascinated with problems of precarious balance, he sometimes so ignored the properties and limitations of marble that his sculptures broke apart.

Although he thought of himself as a bridge between the old and the new, there are few grounds for thinking that Rodin concerned himself with questions that preoccupied the modernists—such matters as truth to materials or supremacy of form over content. One of his last creations, and the most controversial of all, was perhaps closest to the modernist spirit. This was his *Monument to Balzac* [1], modeled between 1891 and 1898. The Société des Gens de Lettres had commissioned him to make a monument to the novelist. The sculptor thoroughly studied Balzac's writings, drawings and other portraits of him, his clothes—and made more than forty studies in plaster before settling upon the final design. The author of the *Comédie Humaine* had stood five feet three inches high, had a big head and a fat body, and swaggered with self-confidence and high spirits. The "truest" of the various studies Rodin made was a powerful pot-bellied figure, striding like *St. John,* with arms folded across his chest. This "Nude Balzac" grew into a towering figure clothed in the loose-fitted robe of a Dominican that Balzac often wore when working. Rodin, who prided himself on the care with which he observed his models and reproduced their "contours" from every angle, presumably scaled his monument to the novelist's reputation rather than to his physical being.

When Rodin first showed a plaster cast of his *Balzac* to a startled Parisian public, the world of art and fashion divided sharply over its merits. The society that had commissioned the memorial turned it down after a heated argument. Rodin, hurt by the affront, refused to sell it to other bidders and set it up in his own garden in suburban Meudon. Twenty-two years after Rodin's death the plaster figure was finally cast in bronze. One

casting stands at the intersection of the Boulevards Raspail and Montparnasse, visible from the famous brasseries, the Dôme and Coupole.

"Bear in a bag," "snowman," hostile critics had called *Balzac* when it was first shown. The lack of ordinary dress was a novel departure from the statues of eminent men that dotted Paris and other cities. Rodin had chosen the "bag" partly because it would not tie the object of his tribute to any particular period. Does it strike you that beneath the rumpled robe there is a nude body? Henry Moore thought it should, adding that "what makes Rodin the great sculptor that he is, is his complete understanding of the body's internal structure, his ability to feel inside into the sculpture."

By enveloping the body and stretching a short, fat figure into an altogether grander one, Rodin had made one gesture toward the modern movement. *Balzac* is like a geologic event, standing like a high tor, a volcanic extrusion, over that intersection in Paris (and also on the grounds of the Musée Rodin, in the Hirshhorn Sculpture Garden, and in the Sculpture Garden of New York's Museum of Modern Art). It is a highly monumental monument. Whatever his ups and downs in the favor of modernist critics, Rodin was one of the towering figures of sculpture.

WOMEN UNADORNED

There was another bridge, or at least an arch reaching toward the opposite bank, among Rodin's contemporaries. Edgar Degas was born in 1834, six years before Rodin, and died in the same year, 1917. During his lifetime he was known almost entirely as a painter, but by 1880 he was spending almost as much time on modeling as on painting or drawing. As he grew old and his eyesight failed, he turned almost entirely to modeling, always of fairly small statuettes. When he died, Paris was under bombardment from long-range German guns. Under the supervision of his friend Bartholomé, a sculptor, the little

figures in wax or plaster and most of them in fragments, were moved to the cellar of the brass founder A.-A. Hébrard for safekeeping. The Paris dealer who took inventory of thése works reported that about a hundred and fifty pieces were scattered about Degas's studio and apartment. Of these, he said, about thirty were in good condition, thirty others badly broken, and the rest "almost valueless." But two years later, on the instructions of Degas's widow, Hébrard cast seventy-three works, in editions of twenty-two or twenty-three copies each.

Degas was a self-taught sculptor, and his ignorance of the tricks of the trade caused him problems. In particular, he usually improvised the armatures on which the clay or plasticene or wax (which he came increasingly to prefer) was to be built up. The armatures were often not strong enough for the weight of the material he attached to them, or for the wrenching he gave them in trying to twist a figure into the desired posture. These "accidents" would infuriate him, according to John Rewald, the art historian and critic who has written the definitive book on Degas sculptures.

Degas's favorite theme, in sculpture as in paintings, drawings, and pastels, was women and girls, especially ballet dancers, caught in a variety of informal attitudes. Some of his variations on this theme were so natural, so free from the flattery to the female form that was characteristic of nineteenth-century academic sculpture, that Degas was thought by some to be a woman-hater. And, it seems, his sexual interests were indeed something of a mystery, unlike those of most major artists, known through well-publicized affairs and attachments.

Picasso slyly gave his own opinion through a series of etchings made from monotypes that Degas had drawn as scenes in a bordello. In some of the etchings Picasso planted a figure of a fully clothed man—clearly Degas—watching the naked girls. When showing the etchings to one friend, Picasso poked him in the ribs, and asked: "Hey, what do you think he was doing in those places?" The friend took it as an implication that Degas

liked to watch. The artist himself once spoke to the Irish novelist George Moore of his studies of nudes who are bathing, washing, toweling themselves, combing their hair: "these women of mine are honest, simple folk, unconcerned by any other interests than those involved in their physical condition. Here is another; she is washing her feet. It is as if you looked through a keyhole."

Degas was known as a demanding master while making his statuettes, requiring models to hold difficult poses—perhaps balanced on one foot, leaning forward, with arms outstretched, in an arabesque position—for long periods of time. One complaining model held the uncomfortable pose of the *Dancer Holding Her Right Foot* [8] during a morning session. At the end he kept the weary girl on the stand while he measured her with a compass, inflicting some scratches on her naked body.

The largest and most famous of his sculptures is the *Little Fourteen-Year-Old Dancer* [7], the only one exhibited in his lifetime, in 1881. She was, for her time, daringly realistic, made the more so by a tutu of real muslin, a linen bodice, satin slippers, and a satin hair ribbon. The slippers and bodice, later coated with wax, appear in bronze in the cast versions. The *Little Dancer* is a familiar figure in the museums of Europe and America. At least eight bronze casts, bearing serial marks from the founder, are known to exist, as are another ten that do not bear serial marks. One example fetched a bid of $380,000 in an auction at Sotheby Parke-Bernet Galleries in New York in 1971. The castings were among those made after Degas's death from a wax model now in the collection of Mr. and Mrs. Paul Mellon.

Realism in the *Little Dancer* went beyond the real bits of cloth that she would wear in the *corps de ballet* at the Opéra to a pert and attentive face and wrinkles in her stockings. "M. Degas dreamed an ideal of ugliness," wrote the critic for *Le Temps*. "The happy man! He has achieved it." J. K. Huysmans—symbolist, diabolist, and certainly himself a bridge to modernism in the literary world—took a more sympathetic and prophetic view: "The frightful realism of this statuette evidently makes people un-

comfortable; all [their] ideas on sculpture, on those cold, inanimate white objects, on those memorable imitations copied over and over for centuries, are upset. The fact is that, at one blow, M. Degas has overthrown the traditions of sculpture as he long ago weakened the conventions of painting."

The later statuettes are smaller and usually more roughly modeled, especially as the aging artist's eyes failed. With them the main modernist characteristic is simplicity—reduction of the figure to essentials, with little attention to surface detail. Both Degas and Rodin were fascinated by the human figure and strove to depict movement. "Vitality" has come, with them, to replace classic beauty (all too often, in the nineteenth century, merely prettiness) as a major value in sculpture.

WITH THE PALM OF THE HAND

Among those in the generation after Degas and Rodin who helped to build a new modernist tradition in sculpture was Aristide Maillol (1861–1944). He came from a Mediterranean fishing village, Banyuls, near the Spanish border, and there he saw the solid well-rounded girls and women who incarnated his ideal of feminine beauty. "Where I live," he once told a friend, "there are three hundred Venus de Milos. The Kores [young women, carved in marble during the archaic period in Greece] are alive; they are the young girls whom the Greeks saw in the street."

Of all the sculptors noted in these pages, Maillol was the closest to the classic tradition, in his love of the human form and his concern to depict it naturalistically. But with differences. He simplified. Where others were preoccupied with accuracy of detail and resemblances to living flesh, Maillol kept his surfaces smooth. Separate volumes (torso, thighs, legs, arms, and head) flow into each other in a way reminiscent of the sculpture of India, which he much admired. At first impression there may seem to be little to set Maillol off from the academic sculptors of

his own and earlier days. Those puzzled and annoyed by modernist art can feel at home with him. His Mediterranean women are palpably women; there seem to be no mysteries to decipher. Yet they could not be mistaken for the classic statues of Greece or the Renaissance or later academic tradition.

Rodin admired Maillol's work, and pronounced his little "Leda" of 1902 a masterpiece: "I do not know of any modern piece of sculpture that is of such absolute beauty, an absolute purity." Like most sculptors for two generations or so after Rodin, however, Maillol reacted against the great master. In place of the older man's agitated surfaces, the younger valued smoothness. Instead of movement, he emphasized solidity and stillness. Like the modernists after the turn of the century, he preached the virtues of direct carving, which he believed to be the foundation of all sculpture; but he became a modeler in later years. "There is something to be learned from Rodin," he once said, "yet I felt I must return to more stable and self-contained forms" stripped of all psychological details.

Maillol spoke of his sculpture as architecture, a balancing of masses, built up of units, found in the natural human body, that can be simplified and emphasized. Moreover, he saw sculpture so akin to architecture that it properly belonged in an architectural setting. Ideally, a statue should be made for a particular site. Some of his own works have found a happy and congruous setting in the broad open courtyard formed by the wide-spreading wings of the Louvre.

In 1972, on a visit to that museum, I had an opportunity to observe the reputed Japanese prudery about display of the human body in works of art. I had watched two parties of Japanese tourists, including some nuns, as a guide led them through the halls of Greek nudes. Apart from an occasional leer and a nudge in a neighbor's ribs by one or two men, the Japanese scrutinized this display of marble flesh with seeming interest but bland composure. Emerging from the museum, I found a Japanese family of three—mother, father, and adolescent

son—before one of the Maillols on the lawn. Mother took photographs as first father and then son leaned against the opulent nude and cupped a hand over a breast.

Maillol would have approved. He was, in the contemporary phrase, a "haptic" sculptor who perceives the shape of things by a sense of touch. He is said to have commented that he liked the shapes to fill the palm of his hand. And after long work to perfect a statue of a nude woman, he knew he had finished when he felt an irresistible impulse to slap his creation on the buttocks. But he was also concerned, as we have noted, with the expressiveness of form and with the simplification and balancing of masses.

Maillol was one of the rare all-round artists—sculptor, painter, engraver, potter, maker of cartoons, weaver of tapestries. He turned full time to sculpting only in his late thirties. *Pomona with Lowered Arms* [10], although not made until 1937, is a variation of a "Pomona" made in 1907. She is characteristic of Maillol's early female figures, based on the solid full-fleshed women he knew and admired in Banyuls. In his later years, however, he favored a slimmer, more youthful figure. When he was seventy-three, Maillol and his wife more or less adopted a girl of fifteen, Dina Vierney, who became his favorite model, secretary, pupil, and confidante. Through her he kept in touch with his friends in France—Paul Bonnard, Henri Matisse, and Raoul Dufy—after the Nazis had occupied the country. She was the model for the *Three Nymphs* [11], of which three casts exist in bronze and three in lead. An earlier work, with the freshness and grace of youth, is *Île-de-France* of 1925 [9].

NATURE ABSTRACTED

Henry Matisse (1869–1954) was a contemporary and close friend of Maillol. Much more famous as a painter, he nevertheless turned occasionally to sculpture, usually in small-scale works. He was more venturesome than his friend, who, he thought, did not like risks. Instead of Maillol's massive and solid

figures, he favored slender and sinuous shapes, boldly distorted
from their appearance in nature. And, far more than Maillol, he
experimented with a reduction of figures to simple elements
—with "abstraction," as we have come to call it—that anticipates
a strong trend in twentieth-century modernism.

As a young man Matisse was piqued when he visited Rodin
to show him some drawings he had made. The patriarch treated
him kindly but offhandedly, telling the young artist that he had
"facility of hand" (which Matisse did not believe), and suggesting
that he come back when he had made more detailed drawings.
He never returned. He first seriously tried his hand at sculpture
in 1900, when he was forty-one. He said that his method of work
differed greatly from Rodin's. The older sculptor to some extent
regarded feet, hands, arms, and legs (his "giblets") as separate
entities, to be worked over in detail by themselves, perhaps while
detached from the figure of which they would eventually be-
come a part (or perhaps held in reserve for some future work,
not yet even conceived). Matisse insisted that he wanted, from
the outset, to see the entire configuration and work on it as a
whole, that he was interested in "the general architecture of a
work. . . , replacing explanatory details by a living and suggestive
synthesis."

His second piece of sculpture, *Le Serf (The Slave)* [6], begun
in 1900 and finished in 1903, bears a strong resemblance to
Rodin's *St. John* [5]. The posture is much the same, and the sur-
face quality similar, although more roughly modeled than Ro-
din's. Matisse even used as a model the same Italian peasant who
had posed for *St. John*. But it is half the size and the arms broke
off before it was cast in bronze. The topheavy head and solidly
planted feet (without any apparent interest in giving the feeling
of a walking man) have quite a different impact from the saint's.
There followed a number of small female nudes, in which he
seemed to want to work out problems of three-dimensional form
and use the solutions in his paintings. Early in 1907 he was work-
ing on his famous painting of the "Blue Nude" and a modeled

figure called "Reclining Nude I," both of which can be seen in
fitting proximity in the Baltimore Museum of Art. He started to
model the statuette first, but when some of the clay fell, turned to
painting the figure, which in turn became the model for the
finished bronze.

Matisse's transitional role between the old and the new
sculpture is best seen in two series he made, each developed
from one subject. Between 1910 and 1913 (after, it should be
noted, Picasso had modeled his *Head of a Woman* [48]) Matisse
made five heads of *Jeannette* (his model was named Jeanne Vade-
rin), which can be seen in the Museum of Modern Art in New
York. The first version is a more or less traditional portrait of a
woman with her hair thickly piled [13]. Progressively through
the series the features are simplified and distorted. In the fifth
and last [14] the mop of hair has not only been wholly removed,
but the cranium has been pared down so that the "mask"—the
face—stands out as an independent object. A long cylindrical
nose rises into an almost spherical forehead, with bulging eyes
on each side, like those seen on certain African masks.
Jeannette's head has become a wigmaker's dummy, or one of
those Egyptian heads (some dating back to the fourteenth cen-
tury B.C.) that have, back of the mask, only a knob to which the
cranium and hair can be separately attached. Much later, in the
1930s, Picasso dealt with the face of his model (his mistress,
Marie-Thérèse Walter) in a similar way, as if to say: "the woman I
have in mind has a prominent brow and noble nose, and these
will be what I emphasize."

Picasso and Matisse (and, as we shall see, Constantin Bran-
cusi and Naum Gabo) treated the head as a separate object. It
was no longer part of the familiar portrait bust, carved or mod-
eled to express the individuality of the subject, real or imagined.
The head was used as a means for experimenting with new ideas
about form—broken into jagged surfaces or intersecting planes
that violate the usual boundaries between outer space and inner
solid, or drastically distorted, or smoothed and simplified into a

featureless ovoid (as in Brancusi's works). The head, like any other part of the human figure, was something for the sculptor to "play around" with.

Matisse made the other series, four *Backs*, over a period of twenty years, between 1909 and 1929. These figures, of a standing woman seen from behind, were done in relief. They can be seen in London's Tate Gallery, in the Sculpture Garden of New York's Museum of Modern Art, and the Hirshhorn Sculpture Garden in Washington. Again, the artist started with a roughly and powerfully modeled, but naturalistic, woman's back [15]. In the last [16] the figure has been reduced mainly to two broad and almost symmetrical cylinders, separated by a third narrow and tapering one for the ponytail, the whole being rescued from complete geometrical abstraction and symmetry by a bulge, on one side, of a "hand," and on the opposite of an arm upraised and bent at the elbow.

By the time Matisse made his studies in reduction, in the *Jeannettes* and the *Backs*, other modernist sculptors were at work, whose ideas he could take and develop in his own way. But he stands among the bridges from old to new—most strikingly, perhaps, in the small and sinuous statuettes like *The Serpentine* [95]. These probably owe something to his interest in African art, a matter to which we will turn later. Matisse's starting point for this graceful little piece was a photograph of a rather dumpy nude model who had assumed a "classical" pose, leaning against a pedestal with a fingertip coyly pressed against her mouth.

AN AMPLITUDE OF WOMAN

Rodin, Degas, Maillol, and Matisse were anchored in tradition in one respect: preoccupation with the human figure. All departed from earlier standards by distorting or simplifying that figure in various ways, ignoring the accepted canon that the representation must be close to what the eye sees, with lifelike proportions and resemblances to the model. Tradition also

permitted—indeed, required—a measure of idealization, correction of imperfections to bring the image into conformity with Greek ideals of beauty. And there had to be a certain nobility of theme. Even the departures Rodin made from these canons, (which today seem not at all radical) were regarded with distaste by those wedded to tradition. Distortion, simplification, freedom from frill, depiction of ordinary people in workaday attitudes, concern for the special formal possibilities in sculpture—in these respects the first innovators departed from tradition.

One younger sculptor who also departed from the strict canons, but was not ready to make a radical break with the past, was Gaston Lachaise (1882–1935). His life was a long love affair, with the woman who became his wife and with Woman —mature, amply fleshed, and cushiony—whom he celebrated in sculpture. Lachaise was the son of a cabinetmaker from the Auvergne, and began his artistic training at the age of thirteen in Paris (where his father did the woodwork for Gustave Eiffel's private suite in the Tower). At some time before 1905, while he was studying at the École des Beaux-Arts, he met and fell in love with Isabel Nagle, Canadian-born, ten years older than he, married to a wealthy older Bostonian, and fluent in English and French. Lincoln Kirstein, among others, has told the sculptor's story. Forsaking his education and working for the glassmaker Lalique, Lachaise saved enough money to come to America in 1906, and finally won Isabel as his wife about 1913 (there have been conflicting reports about the year they met and the year they married). He assisted other, more established and traditional sculptors in Boston and New York. A prodigious worker, he began to create his own sculptures in the few hours he could call his own.

In 1913 he exhibited one of his ample ladies at the famous Armory Show in New York (of which we will hear more later). His contribution was a small figure in clay; Lachaise could not afford to have it cast in plaster or bronze. After many years of work he exhibited his first masterpiece, in plaster, in 1918. It was

not cast in bronze until ten years later. This was his "Standing
Woman" (also called "Elevation"), a paean to mature woman-
hood. She is a full-fleshed woman standing on tiptoes, massive
and yet astonishingly light. She did not please those wedded to a
more restrained tradition. Gerald Nordland, who later became
the authorized biographer of Lachaise, reported the reaction of
Daniel Chester French, the American sculptor. Lachaise's "vi-
sion is monstrous," French said, shaking in rage, to the owner of
the gallery where the lady was on display. "How can you show
these things?"

Much the same figure emerged in Lachaise's *Standing
Woman* of 1932 [20], except that now her feet are solidly planted,
and her hands are firm against her hips. She is more massive
than before, even more than his earlier version a symbol of
Eternal Woman. "Simplify and amplify" was the guidance
Lachaise gave a student. Simplify and amplify he himself did, in
the two "Standing Women" and other versions of his archetypal
female. In one sculpture, developed through many versions, she
is lying on her side, an earth-goddess, part of the earth itself,
with mounds of flesh flowing into the ground. He called her
"The Mountain." (A small version in bronze can be seen in New
York's Museum of Modern Art; a massive version in concrete,
five feet long, is in a private collection in Lenox, Massachusetts.)
The same identity of woman with cosmos is suggested by
Lachaise's *Floating Figure* [17], completed in plaster in 1927.
Kirstein reports that the sculptor had become fascinated by
contemporary theories of space and time, and by imagined
curves of the horizon, of planetary orbits, and of wheeling galax-
ies. The massiveness of breasts, buttocks, and thighs prepares us
for some astonishing fragments that Lachaise made, in which
these features are enormously exaggerated. Toward the end of
his life most of Lachaise's work related to a sculpture called
"Dynamo Mother," completed in 1933. It is a brutally candid
piece, in which the female figure rears back in a sitting posture,
arms locking the knees of legs that are held apart and bent back,

revealing an orifice that seems about to become a channel for birth.

Lachaise's obsession with amplitude of womanly flesh leads us to wonder what Isabel looked like. A photograph taken in the 1920s shows her walking along a beach in Maine. She is wearing an ankle-length short-sleeved shift and a scarf wrapped around her head. It is impossible to judge her height, equally impossible to miss the thick upper arms and splendid bosom. It was, then, astonishing to read an impression of her reported by a critic who reviewed an exhibit of Lachaise's work in New York in 1973. Mme. Lachaise, he said, was a "tiny lady—French, pert, and chirpy." Inquiries made of people who saw her often indicate that the description is wrong on all counts. Not unusually tall, she was certainly not tiny, and apparently liked to emphasize a certain statuesqueness by the clothes she wore—long robes, caftans, and furs. All agree that her figure was "full."

TRADITION REVISITED

Of the more radical modernists whom we will meet in later pages, several returned, at least on occasion, to more or less traditional modes of sculpture. Alexander Archipenko and Henri Laurens, who early in their careers experimented with novel forms, later turned to making much more naturalistic human figures. Jacques Lipchitz, for a long time an experimenter with angular, almost architectural forms and openwork "transparencies," favored in his later years rounded human forms. Far from classical models, they were clearly rooted in the tradition in its more extravagant baroque manifestations. Late in the Second World War the great innovator Henry Moore carved some figures with strong classical overtones, most notably in *Madonna and Child* [42], which was created for St. Matthew's Church in Northampton, England. He was accused by modernists of having defected to Greece and Rome, and welcomed by traditionalists as a convert to the true sculptural faith. Moore

soon demonstrated that his years of inventiveness and experimentation were by no means over. He has, however, suggested that it is a healthy exercise for a sculptor to go back to classical sources on occasion, and has said that life-drawing is "the most exacting form of concentrated activity that exists."

If it is best to approach modernist sculpture as a new form of art, not to be compared with works produced in the tradition but to be appreciated on its own terms, it is also necessary to realize that the new grows out of the old, however wide the generation gap may be. There are indeed bridges, and a certain amount of traffic back and forth.

Even so restless an innovator as Pablo Picasso (1881–1973) went back to the further bank occasionally—more often in his painting and drawing than in his sculpture. The three-dimensional work that he himself regarded as his most important is also the least radical in its departures from the tradition. "This big old man—I did him in February," Picasso told his friend Brassai, the Rumanian photographer, in 1942. He pointed to the tall plaster figure that is now known as *Man with Sheep* (or *Man with Lamb*), a casting of which stands in the Philadelphia Museum of Art [12]. A bearded man (Picasso once said that he always thought of his bearded father when drawing or painting a man), naked, precariously balanced on thin legs, with feet planted together, grips a struggling sheep—a stolid-faced father figure contrasted with a violently twisting animal. The pair suggest an ancient theme, familiar from early Greek sculpture as the "Moscophoros" (Calf-Bearer), and from early Christian art as the Good Shepherd, of a man offering an animal for sacrifice. Various meanings have been read into Picasso's version: it is Adam, first man and symbol of all men (the absence of genitals is supposed, in this view, to emphasize his primordial innocence, before the creation of woman); it is Man struggling with Nature, especially his own nature; it is the totem-worshiper, a universal archetype, revering the animal on which he depends

for life, yet needing to destroy it, for his sustenance or to appease the gods, or both.

Picasso, it seems, did not say what he intended by this pair of tense beings. For a year he made many preparatory drawings —more than a hundred, according to his friend and secretary Jaime Sabartès. He began with a large etching of a bearded man surrounded by others, offering a lamb and other gifts. In some versions the shepherd was young and beardless; in others he was older, with a stubbly chin. In some the shepherd was comforting a trusting lamb, clasped to his bosom. The idea clearly had changed by the time Picasso was ready to model the statue, a feat he performed in one afternoon. The precariously balanced clay figure (shown in profile in the illustration) threatened to collapse, and he called for help to lash it to the beams with a cord. He decided to cast it in plaster immediately, and did so that same afternoon. Later, when Brassai was turning the fragile plaster piece to photograph it from several points of view, the sheep's "free" foot broke off in several pieces. Picasso accepted the accident calmly and said he could easily redo it. Even in bronze the figure threatens to fall.

Picasso modeled *Man with Sheep* quickly with balls of clay, and individual lumps are still evident. He intended, after that hectic afternoon, to return to the piece and work on it more, especially the legs and feet. "In the end," he told André Malraux, "I left it as it was. Now it's too late. He is what he is. If I were to touch it now, I would risk ruining it completely."

CHAPTER

2

Curves of Nature

V ISIBLE nature, by and large, favors curves. There are, to be sure, some natural angled shapes, especially in inorganic matter—in certain geological formations, for example, and in mineral crystals. And, at a microscopic level, we find such angled forms as living diatoms and the structure of inorganic snowflakes. Generally, however, when we see with unaided eyes a true straight line or an angular flat form or a solid with plane surfaces meeting at angles (a polyhedron), we can be fairly certain that humankind has been at work.

As we have already noted, some modernist sculptors have continued to carve or model more or less faithful representations of rounded creatures of one sort—humans—that had always been a major preoccupation of traditional sculpture in all parts of the world. These sculptors stuck more or less closely to the traditional precedents and, at least in the West, were strongly drawn toward naturalism. They might simplify and distort, but their images were unmistakably human.

The group to which we now turn carried the simplification

much further, until the connection with known forms was attenuated almost beyond recognition. Unlike some of their modernist brethren who were drawn to the angular shapes of an industrial world or the pure forms of geometry, this group favored the curves of living things. Some, with thoughts of the unity of all being, and some more playfully, combined forms seen in nature into new creations. Some sought to reduce natural forms to basic geometric solids. But their geometry, befitting the subjects, was that of the sphere or ovoid, not of the cube or other polyhedron.

FROM BEEFSTEAK TO EGG

Constantin Brancusi (1876–1957) was the first to break decisively with the tradition of naturalistic figures. In 1904, at the age of twenty-eight, having gone to art school in his native country, this son of Rumanian peasants made his way to Paris—mainly on foot, it is said. Two years later his exhibited work caught the attention of Rodin, who offered him a job in his studio. As we have seen, however, Brancusi did not stay long. And at about the same time he turned away from "beefsteak" art. "Michelangelo and Rodin worked in beefsteak," he would say, plucking at the flesh on his arm. He was one of the first sculptors to reject what he called "anatomies, representation, and copies," and to seek what he regarded as the underlying essences. By a familiar law of overcompensation, he not only left Rodin but also turned against him, artistically, seeming to find pleasure in using famous Rodin titles ("The Kiss," "Prodigal Son," "Danaide," and "Adam and Eve" among them) for radically different works. At the same time he owed certain debts to Rodin. Like the older man, for example, Brancusi was much interested in optical effects, in the play of light over curved forms. In place of Rodin's rippling surfaces, however, Brancusi used painstakingly smoothed forms in highly polished marble or bronze. In most of

his works he avoided holes and deep cavities because they cast shadows—the very reason some other modernists favored such hollows.

In 1913 five of Brancusi's revolutionary works appeared in the International Exhibition of Modern Art, at the Armory of the 69th Regiment in New York City. There the painting and sculpture of Europe's avant garde was unveiled to a startled American public. It is usual, in accounts of the famous Armory Show, to say that things would never be the same in American art. Let it, then, be said. But it did not immediately win over a large American public to the new art. That took much longer.

John Quinn, a New York lawyer and collector who was one of the main organizers of the exhibition, later acquired many Brancusis. "The more one has, the more one wants," he wrote to his artistic adviser and agent in Paris. At his death Quinn owned twenty-seven, which have since gone to fatten several major collections in the United States. The Armory pieces included a plaster cast of Brancusi's first version of *The Kiss*—a roughly cubic mass of stone. The heads and upper bodies of a man and woman, locked face to face, are indicated by shallow incised lines [21].* It was a motif that Brancusi often used later, with variations, culminating in the "Gate of the Kiss" (an answer to Rodin's "Gates of Hell"?) in his native Rumania, where frontally joined couples, highly stylized, became rounded phallic columns.

More typical of Brancusi's later figures, when he had adopted curved solids as his principal vehicle, was his *Mlle. Pogany*. A plaster cast of the first version was also at the Armory —a smooth ovoid with the barest suggestions of facial features (apart from the huge round eyes) and of forearms with hands joined behind one ear [22]. Sidney Geist, the authoritative artistic biographer of Brancusi, has recorded a letter Miss Pogany

*An unknown versifier made the following comment:
> He clasped her slender cubi-form
> In his rectangular embrace
> He gazed on her rhomboidal charm
> With passionate prismatic face.

wrote much later. She first met the sculptor at meals in a Paris boarding house, she said. One day he took her to his studio to see what turned out to be a study he had made for this "portrait," carved without her knowledge. "It was," she said, "all eyes." Although it had no features recognizably hers, she sensed that she had been the model. Brancusi later made several versions of the head.

There followed a series of similar ovoid carvings—marble heads of children, "Newborn," and "The Beginning of the World"—at first with faintly modeled features, and later almost bare egg shapes, slightly asymmetrical. To another smooth marble ovoid he attached a pair of lips, an oval topknot, a little fan-shaped protuberance at the nape, and the title *Blond Negress*. A bronze version stands in New York's Museum of Modern Art [23]. Can anyone see it without an inward chuckle—this highly simplified head, almost bare of features, but wittily and unmistakably suggestive of his subject?

A more elaborate, but still simple, combination of curved forms was Brancusi's marble "Princess X." The sculpture was rejected, to Brancusi's indignation, by the Salon des Indépendants as "obscene." The work consists of two globes from which a curving column rises and is topped by a bulbous shape. From the title we may suppose that he intended to suggest a bust of a woman, but it could equally well be regarded, by anyone looking for correspondences with natural forms, as male genitals. The managers of the exhibition evidently chose the second interpretation. A contemporary critic reported that the ambiguous sculpture was evicted on the morning of the private showing that was to open the exhibition, because "the Minister is going to be here, and we cannot think of showing him *that*!" A somewhat similar carving, this time in wood, appeared in Brancusi's *Eve*—the top half of *Adam and Eve* [27].

According to persistent reports—part of the Brancusi legend—this rejection by the Salon accounted not only for his refusal for years to exhibit his works in Paris but also for his

withdrawal into an almost monastic life. But some have suggested that his self-imposed isolation, beginning in the middle 1920s, was caused rather by the death of several close friends within a short time and by deteriorating health. He lived, however, to be eighty-one.

Brancusi's curving marbles and bronzes (he usually made no more than one in each material of a given work) combine elegance, economy, and simplicity. Many have a witty ambiguity. Most are joyful, peaceful, and restful—free of the anxiety and conflict that mark much sculpture of this century. Brancusi was one of the makers of happy objects. Although personally rather withdrawn, especially in the last third of his long life, he was of a mystical bent, and, according to his own infrequent statements, thought of himself as searching for the essences behind appearances; in sculptural terms, this meant reducing observed objects to their simplest, purest forms.

It is known that Brancusi read Henri Bergson, whose *Creative Evolution*, published in 1907, influenced many writers and artists. Bergson sought to reconcile science and philosophy with the message that intuition was a distinctive human capacity, as important as intellect and reason and that humankind has an *élan vital*, a "life force," that can guide its use of the data supplied by empirical research and can infuse inert matter with human meanings. Brancusi was also drawn to oriental mysticism, particularly that of the Tibetan saint Milarepa.

The best known of Brancusi's sculptures is a series whose motif is a bird. He carved his first in marble in 1910 and titled it *Pasarea Maiastra (Magic Bird),* from a Rumanian fairy tale in which the bird Maiastra guides a lover to his imprisoned princess. Now standing in the Museum of Modern Art in New York, this version has a plump breast and distinguishable tail, legs, neck, and head with open beak [25]. Later versions became progressively taller, more slender, and stylized. A bronze *Bird in Space* made about 1928, also to be seen in the Museum of Mod-

ern Art, is one of the last [26]. Altogether Brancusi made at least twenty-seven versions of the bird in marble or bronze.

These were not exercises in depicting feathered friends. The last birds, made for the Maharajah of Indore, in black and white marble, were intended to be shown, along with a Buddha-image, in a Temple of Contemplation in the prince's Indian state, but the project fell through. After finishing these, Brancusi had something to say about what he had been trying to do in his long series. "The height of the Bird," he wrote, "tells nothing in itself. It is the inner proportions of the object that do everything." With minor variations in height, thickness, curvature, and features he sought the "right measure," and in his last birds "I approached this measure to the degree that I was able to rid myself of myself." And, at another time: "All my life I have only sought the essence of flight. Flight! What bliss!"

Bird in Space became the subject of a famous trial. Edward Steichen, the photographer, had bought the gleaming bronze object in Paris for $600. When it was brought to New York for a Brancusi exhibition in 1926, the Customs official classified it as a manufacture of metal, subject to a duty of 40 per cent of assessed value. Steichen and Brancusi protested that it was an original work of art and admissible duty-free, and took the matter to court. Eventually the Customs Court agreed with the indignant artist.*

In all his work, after he turned away from naturalism early in the century, Brancusi reduced natural objects to bare essentials. But those who called his work "abstract," he said, were fools: "What they think to be abstract is the more realistic, because what is real is not the outer form, but the idea, the essence of things." A thought at least as old as Plato, it is shared by most of Brancusi's modernist colleagues. But where the Greeks found "reality" in the generalized idea behind its varied and imperfect

*A fuller account of the case appears in *Note on Sculpture in the Customs Shed* (see pp. 125–142).

manifestations apparent to the senses—above all in the idea of a perfect human figure—Brancusi and most other modernists sought to find and express reality in simplified essential forms.

Brancusi, as we have already noted, was a direct carver, chiseling the marble without benefit of models or pointing (copying) machines. It was part of his protest against Rodin and other modelers who fashioned their works in clay and left it to assistants or technicians to carve marble replicas with the help of copying machines. As we have already noted, Brancusi regarded direct carving as the true road to sculpture, "but also the roughest for those who don't know how to walk." Jacques Lipchitz was also one of the direct carvers, especially in his younger days, but usually worked from a clay or plaster sketch. As a young man in Paris he heard a continuous tapping from a neighboring studio, and learned that it was Brancusi, then carving *The Kiss* [21]. But Lipchitz later said he did not like Brancusi's work: "it is always better to work from a clay sketch in which the idea can be caught quickly and immediately." It was a compromise with which purists would not agree.

Brancusi was one of the least verbal of the modernists; at least he said little for publication. The Brancusi legend, however, includes a collection of pithy, ambiguous, occasionally obscure statements, some of which have already been noted. One aphorism, much quoted, is that "nude men in sculpture are not as beautiful as toads." It might seem to be one of those statements with which the avant garde tried to shock the tradition-bound out of their accustomed attitudes. One variation puts the apothegm in a different context. The sculptor was speaking of his *Leda*, an ovoid form (the bird's body) from which an elongated pyramidal form arises at one end [24]. From the title we might suppose that it is Jupiter transforming himself into the swan of the Leda myth. But Brancusi said that "it is Leda, not Jupiter, changing into a swan. A man is as ugly as a frog; a swan has exquisite curves, like those of a woman's body."

The *Leda* is a striking example of the ambiguity that marks

much of Brancusi's work. There is the reversal of the Leda story, not so clearly executed that the artist's intention could be known without its being told. Quite apart from mythical associations, the forms have an equivocal impact. The long wedge can be seen to be growing out of the ovoid body or thrusting into it. The *Leda* could be a depiction of an act of fertilization, and was, Geist reports, labeled "Fecundity" in one Rumanian journal in which a reproduction appeared. And the whole is precariously balanced. This is not the only Brancusi sculpture that leaves us wondering how far he could tilt an upright form from its axis without causing it to topple. For an artist who wanted to be "true to the material," Brancusi sometimes set surprising tasks for marble, and the heavy wedgelike protuberance in *Leda* at one time broke at its joint with the ovoid body.

Brancusi is famous for his careful attention to the surface qualities of the material he worked with and his insistence on perfect finish in the highly polished marbles and burnished bronzes. He was equally skilled at working in wood and respectful of its special properties. In his works in wood the influence of African sculpture is most evident. Two of these are *Adam and Eve* [27] and *Socrates* [28]. We will return to them in a later chapter.

SYMBOLS OF GROWTH

Jean Arp (or Hans—he used the French and German versions of his name interchangeably) was born in 1886 in Strasbourg, capital of Alsace, then under the German flag, and died in 1966. Ten years younger than Brancusi, he too thought of himself as searching for fundamentals—cosmic forms, as he put it, behind surface appearances. Like the older Rumanian, he too had a streak of playfulness and wit that has sometimes put off more somber artists and critics.

A bright but not diligent student, he began drawing with crayons at the age of eight, carved a wooden Adam and Eve at ten, and was writing poetry in the manner of the German

Romantics at fifteen. At eighteen he entered art school, first at Strasbourg and then at Weimar. As a young art student, he later recalled, he began looking for "new constellations of form such as nature never stops producing. I tried to make forms grow. I put my trust in the example of seeds, stars, clouds, plants, animals, men, and finally in my innermost being." His teachers, predictably, tried to put a stop to his unacademic experiments and set him the usual exercises of copying flowers and bowls. But in the years before and after the First World War he continued his search. In travels to Paris and Munich he came to know the work of avant-garde artists, and sometimes the artists themselves.

Early in the war, in danger of interment in Paris as a German national, Arp moved to Zurich in neutral Switzerland, a sojourn that proved to be a major turning point in his life. There he became a part of the dadaist movement (of which more will be said in Chapter 5), and there he met his beloved Sophie Taeuber, his artistic collaborator and later his wife. In this period he worked largely in forms akin to painting—colored collages and flat reliefs made by combining two or more wood or metal cutouts, one on top of the other. But from the beginning of his days as an artist he was preoccupied with the shapes of growing things, simplifying and combining them into new creations that sometimes barely intimated their natural antecedents.

As early as 1917 he had found, he wrote, "the decisive forms." He drew things he had seen washed up on the shore of a lake in Switzerland—broken branches, roots, grasses, and stones. "Finally I simplified these forms and reduced their essence to moving ovals, symbols of the growth and metamorphosis of bodies." In the years that followed he made shallow reliefs or cutouts of cardboard pasted on backgrounds, sometimes painted. "Shirt Front and Fork" (1924) suggests these homely objects, but also a tooth, a skull, a hand, and a grazing prehistoric animal. "Head-Moustache and Bottles" (1929) sug-

gests not only its titular components but a bird, a toy balloon with goblin head, tenpins, and phallic forms.

Not until he was forty-four, in Paris in 1930, did Arp turn to "hewing" (*hauerei*, as the Germans aptly called sculpting). He had earlier avoided it, in part because it was so intimately bound to the old tradition in art that he wanted to reject. Now he was ready to translate his "biomorphs"* from two dimensions into three.

Arp threw himself into the new undertaking, producing prodigiously for the next twelve years until Sophie's death in Switzerland early in 1943 stunned him into five years of abstinence from chisel and clay. Then he resumed work, and lived until 1966, when he died in Switzerland in his eightieth year.

"We do not want to copy nature," Arp wrote. "We want to produce, not reproduce. We want to produce like a plant producing fruit." His was not, he said, "abstract" art; it was "concrete." "Where concrete art enters, melancholy leaves, dragging its grey valises full of black cares." And, at another time: "Concretion designates solidification, the mass of the stone, the plants, the animal, the man. Concretion is something that has grown."

Arp's free-standing sculptures are carved or modeled with much of Brancusi's economy and simplicity, but they are usually more complicated than the older artist's. Starting from basic shapes of two or more natural objects or beings, he often merged them into one figure. In *Growth* [29] we can see two joined bones, or a growing and budding stem, or two torsos, the eye being drawn to the buttocks of the lower and breasts of the upper. It evokes many familiar forms—some skeletal, some vegetable,

*The word is not Arp's. "Biomorph" was apparently first used by the British anthropologist Alfred Cort Haddon in his *Evolution in Art,* published in 1895, to distinguish the representation of a living thing—a biomorph—from a design derived from implements and utensils—a skeuomorph—such as a pattern based on weaving, wattling, binding, or timbering. In the contemporary art lexicon the term designates organic forms, in some way originating in living objects, singly or in combination.

some of human flesh, muscle and bone—that shift subtly and gradually as the observer changes his point of viewing. A similar ambiguous blending can be seen in Arp's *Human Lunar Spectral (Torso of a Giant)* [30]. His *Floral Nude* [31] is both an arboreal and a human trunk. His "cosmic forms," Arp wrote in 1950, "englobe a multitude of forms," among them eggs, buds, shells, human heads, breasts, "a planetary orbit, and stars in their courses." In *Sculpture Classique* [32] he returned to a single simple Brancusi-like figure that is unmistakably an armless Aphrodite.

In 1961 Arp began a series of more abstracted geometric forms, called *Ptolemy*, of curved tubes growing into each other within an oval shape. "Ptolemy III" suggests a skull. *Ptolemy I* [33] evoked for Sir Herbert Read, "the ventricles of the heart. . . . It seems to beat with an inner life, and at the same time to rest in eternal stillness." The critic guessed that the Ptolemy Arp had in mind was the second in the Hellenistic dynasty in Egypt who was patron to the geometrician Euclid.

Arp, a poet and prolific writer, explained the process by which his ideas for a particular sculpture might evolve. Some detail in one work, "a curve or contrast that moves me," might become the germ of new works in which the curve or contrast would be emphasized and brought into new forms. From these another set of ideas would be selected and further developed, "until the original forms have become secondary and almost irrelevant." He continued the process, sometimes for months, sometimes for years, "to work out a new sculpture. I do not give up until enough of my life has flowed into its body. . . . It is only when I feel there is nothing more to change that I decide what this is, and it is only then that I give it a name."

He was one of the creators of "happy" sculptures. As full of anxiety as any sensible being in our era, or as any of the artists who prefer tense, angular, violent forms for expression, he took a more hopeful view than most and sought a reconciliation of all beings in a natural order. He was, we are told, a gentle and peaceful man, and a lover of nature.

WOMAN–MOUNTAIN

"Everything has dequesced!" The word was clear in my mind when I awakened from the dream. Sticks, stones, bones, and less clearly identifiable matter had rushed together and merged into a solid wall. The dreamed word, presumably, was a combination of "deliquesce" and "coalesce," of melting and fusing. And the dream was one that Carl Jung probably would have classified as "cosmic." According to the prevailing canons of interpretation, the material must have had some source in recent experience, quite apart from any deeper personal meanings.

I had recently been reading the myth of the Hindu Great Goddess, to whom all other gods, helpless before a demon who had won control of the universe, had ceded their weapons and fiery powers. They swirled together in one huge flame from which the Goddess emerged, armed and ready to defeat the demon. Even more recently I had been looking at and reading about Henry Moore's reclining figures, in some of which the human form is merged with ranges of hills or with seaside escarpments and grottos carved by the waters. And I had been reading of the English sculptor's fascination with the natural forms of bones and shells.

Henry Moore, born in Yorkshire in 1898, is perhaps the most impressive exemplar of the trend in modernist sculpture toward the identification of natural forms, including the human, with each other—a merger of their characteristics into a new imagined figure that suggests each component but copies none. Here, indeed, are acts of creation.

There is an obvious kinship with Arp's concretions, signifying, in Arp's words, "the natural process of condensation, hardening, coagulating, thickening, growing together. . . ." Moore, it has been reported, has disclaimed any direct, conscious influence by the older sculptor. He began, in fact, to create his own composites of nature a few years earlier than Arp, who

seriously began to make figures in the round in 1930, although his ideas of protean living forms had much earlier been expressed in flat reliefs and assemblages.

Like that of many other artists, Moore's work has concentrated on a few themes, developed with many variations in meaning and form. One of these is the reclining figure, and another, mother and child. "You have to choose the one particular idea that will hold everything you want to do," he has said —like choosing a wife and deciding to make a life with her. Both themes, he observed at various times, became "obsessions" with him. Although in 1943, when he was creating the Northampton *Madonna and Child* [42] for St. Matthew's Church, the mother-child theme was perhaps the more fundamental obsession, the reclining figure has proved the most long-lived, persistently recurring through his long productive life.

The inspiration for an early reclining figure came from a compact square-cut monolithic image of the Mayan Rain Spirit, *Chac Mool*, which reposes in the National Anthropological Museum in Mexico City [35]. He was, he has said, much moved merely by the photograph, and even more deeply impressed when he saw a cast of it in the Musée de l'Homme in Paris: it at once seemed to him "true and right." "Its 'stoniness,' by which I mean its truth to material, its tremendous power without loss of sensitiveness, its astonishing variety and fertility of form invention" were among the qualities that attracted him.

A *Reclining Figure* suggested by *Chac Mool* was carved in 1929. The stoniness and power of the Mayan Rain Spirit are evident, but the stiff and compressed male has become a more sinuous female [36]. The rigid and symmetrical body has become a more complicated and natural composition, with legs apart and arm thrown behind the head. There is already more than a hint of the human body as landscape. From this beginning Moore went on to still more complex and powerful combinations of human and topographical features—forms both stable and static (qualities Moore has highly valued in sculpture) and un-

mistakably human, but, in his words, "giving something of the energy and power of great mountains."

Britain's artistic establishment predictably disapproved of Moore's break with the tradition—a break much more evident in some of his other sculpture of the late 1920s than in *Reclining Figure* of 1929. "Bolshevism in modern art," said the National Society of Art Masters of his show in the Leicester Gallery in 1931. Among newspaper critics the *Morning Post*'s was especially virulent: "The cult of ugliness triumphs. . . . it is almost impossible to believe that [one of his more abstract reclining figures] came from the hands of a man of normal mentality." It was a scandal, the *Post* critic added, that such a man was allowed to pervert young students by teaching at the Royal College of Art. And the Old Students' Association of that bastion of academia passed a resolution asking for his dismissal. The next year he did in fact move to the Chelsea School of Art, thus sparing the managers of the Royal College the embarrassment of having to pass upon his reappointment. Within a decade he was to become one of Britain's most respected sculptors, and soon was recognized throughout the world as one of the greatest of his century.

DISCOVERY OF HOLES

The year 1932 has been called the Year of the Hole for Henry Moore. Others had used the hole before him, but now it began to be centrally important in his work. We are not now speaking of holes that appear in naturalistic sculpture, like those formed by arms and legs bent at their joints to touch other limbs or the torso. "The Hole" may be a shaped void corresponding to a solid shape, such as a concave cuplike form in place of a convex breast. Mass becomes empty space, much as dark areas are transposed into light in the negative of a photograph as compared with the positive print.

Alexander Archipenko (1887–1964) used empty spaces and concavities in this way as early as 1912. Working alone in Paris—he did not know Matisse, Picasso, André Derain, or the

other modernists—the young Russian developed a personal style. By 1912 he had arrived at the idea of the "counter-volume," the depression that looks like a projection. His use of it is illustrated in the *Woman Combing Her Hair*, which is in the National Gallery of Art in Washington, D. C. [37]. In an essay, "The Concave and Void," he wrote that "there is no concave form without a convex. Both elements are fused into one significant ensemble. In the creative process, as in life itself, the reality of the negative is a spiritual imprint of the absent positive." With or without the spiritual overtones, the device caught on, and was developed by other artists. It became Archipenko's major contribution to the art of sculpture. But he did not approve of drilling "meaningless holes into a statue or digging senseless cavities if they are not symbolical or associative."

Perhaps he had Jacques Lipchitz's early experiments in mind. In his *Man with a Guitar* [38] Lipchitz drilled a hole, somewhat arbitrarily and incongruously, through the abdomen. He did this, he said, because he wanted it as an element that would make spectators conscious that this was a three-dimensional object. It was, he added, an "assertion that this object is finally a work of sculpture and not actually a human figure."

Henry Moore developed the hole on a grander scale, to suggest entire body cavities—thorax, abdomen, and pelvis—and to create a balance of solid forms and empty spaces. Moore has explained his use of the hole. First, he pointed out, it was "true to the material" of stone; holes of studied size do not weaken the stone, which, on the principle of the arch, can remain as strong as it was before perforation. Further, carrying through on Archipenko's replacement of solids with voids, he was emphasizing the three-dimensional quality of sculpture: emptiness, paradoxically, gives a sense of its opposite—mass. Then, too, there is the "mystery" of the hole—"the mysterious fascination of caves in hillsides and cliffs." He seemed to be foretelling his later and bolder use of empty spaces as human forms merged

with landscapes. Eventually the legs of a recumbent woman came to suggest an escarpment pierced by a cavern, eroded by the action of the sea [41].

Before opening out his reclining figures in stone, Moore had done the same thing in wood, an easier material to work for this purpose. One in elmwood, done in 1936, is now in the Wakefield City Art Gallery and Museum in England [39]. In this and many others Moore solved a problem that has worried sculptors who are dissatisfied with the architecture of the human body, with its massive torso to which a relatively small head and spindly limbs are attached. Moore has made the arms and legs flow back into the body or into each other, and has used open spaces to give a rough balance between the upper and lower halves of the human body. Another carved in elmwood is the *Cranbrook Reclining Figure* (so called because the Cranbrook Academy of Art in Michigan once owned it), executed in 1945–46 [40]. The latest of the reclining figures—the working model is illustrated here—is that commissioned by Lincoln Center for the Performing Arts in New York [41]. The completed work, executed in bronze, in two huge pieces (1963–65), towers more than nineteen feet above one section of the Center's plaza. Here rolling hills have become mountain crags. The "legs" are a seaside escarpment, eroded by the action of the waves. From one point of view the higher piece is the upper body of a woman with legs spread in invitation, which a projection from the other piece seems about to accept. Photographs are always inadequate to give correct perceptions of a three-dimensional work meant to be seen from more than one point of view. They are seldom as inadequate as when we are looking at a complicated and ambiguous sculpture like that in Lincoln Center which changes with each step taken around it.

PROTECTIVE MOTHERS

Another of Moore's favorite, even obsessive, themes has been mentioned—mother and child. A well-known example is

the Northampton *Madonna and Child* [42]. During the Second World War, when sculptors' materials were hard to obtain, Moore turned to drawing. Late in 1940, as an official war artist, he began the series known as "Shelter Drawings" that showed Londoners' lives in the Underground, where they sought refuge from air raids. These depictions of huddled humanity, tubular figures within larger tubular caverns, roused his interest in the use of drapery. When he could begin to work on sculpture again, the new interest carried over and in the Northampton *Madonna* he carved drapery in stone for the first time. In this and some other sculptures of the period the roundedness of human beings becomes much more naturalistic than in his earlier works.

The Northampton *Madonna*, however, could never be mistaken for a Greek or Roman statue. Moore was clearly interested in certain formal effects. Four rounded knobs stand out—the mother's head, the child's, and the mother's knees. A shallow curve is repeated in the necklines of the two garments and in the skirt stretched between the knees, and again, with variations, in the few fold lines of the lower skirt.

Moore had been uncertain about undertaking a commission to execute a religious theme, realizing that he should impart to a Virgin and Christ Child qualities beyond those found in his other works on the mother-and-child theme. And he disapproved of the general level to which church art had fallen. He managed, as it turned out, to express the human, and beyond-human, qualities he sought—nobility, gentleness, dignity, austerity—along with the formal qualities that interested him as a sculptor. Soon thereafter he enlarged the family group to include the father. Moore himself became a father in 1946, with the birth of his daughter, Mary. During and after the war, Moore made several groups of parents with children or of husband and wife, including the austere, attenuated *King and Queen* [44], who gaze out over the moors of a Scottish estate and also greet the visitor to the Hirshhorn Sculpture Garden in Washington.

One offshoot of the mother-and-child theme, at first sight seemingly unlikely to stem from such a root, is the series of *Helmet Heads* [52]. Moore made the first of these, appropriately, during the war. They suggest mechanized, militarized man, somewhat reminiscent of Jacob Epstein's *Rock Drill* [53]. But in most of the series a separate figure is enclosed within the casque, and what seem to be two eyes attached to the helmet are really antennalike protuberances from the internal forms. They might be vulnerable human beings within protective armor or unborn babies in the womb. Moore lated developed the theme in a series called *Upright Internal and External Forms*, culminating in the elmwood figure, nearly nine feet high, carved in 1953–54 and now in the Albright-Knox Gallery in Buffalo [34]. He wanted to use wood, Moore said, because it "is alive and warm and gives a sense of growth." The idea behind the sculpture is that of a "sort of embryo, being protected in an outer form, a mother and child idea, or the stamen in a flower—that is, something young and growing protected by an outer shell." Erich Neumann, who made extensive psychoanalytical studies of Moore's work (of which more will be said later), saw in the *Upright Internal and External Forms* a mummy-shaped sarcophagus, "showing the mother goddess as the sheltering womb that holds and contains the dead man like the child again, as at the beginning." For him the sculpture was a tangible symbol of mother and child, body and soul, world and man.

SHELLS, BONES, AND PEBBLES

Picasso claimed "an absolute passion" for bones. He collected them eagerly, and had whole skeletons of bats and birds, and skulls of dogs and sheep—even of a rhinoceros. They all, he thought, gave the impression of having been modeled in clay: "on any piece of bone at all, I always find the fingerprints of the god who amused himself with shaping it." Arp was a fascinated collector of pebbles and shells. Like them, Henry Moore has

been fascinated by the variety of natural forms, and late in the 1920s began examining and collecting shells, bones, and pebbles. He has often incorporated them into his ideas for sculpture. Pebbles, to him, "show nature's way of working stone," and "bones have marvelous structural strength and hard tenseness of form" with subtle transitions from one shape to another.

Moore's heads are often only vaguely suggestive of the human. They are much more akin to seaworn pebbles and to knuckle bones. He explained the vestigial cranium on *Seated Woman* [45] by saying that the head must be small in order to emphasize the massiveness of the body—the reordering of the human architecture to which we earlier referred.

In many of his later sculptures Moore shifted from the roundedness of earlier composites of human figures with landscapes to the sharper and more jagged qualities of natural bone structures. One of his Upright Motives that has come to be known as the *Glenkiln Cross* [47] (1955–56) has an obvious origin in bones, although Moore developed them into a much more complicated composition—part human body, part wayside crucifix, part ancient monolith. The torso of the Lincoln Center *Reclining Figure* [41] was developed from a bone, and *Standing Figure: Knife Edge* [43] even more clearly so, while at the same time suggesting the "Venus de Milo" when seen from the front. She seems to have come straight from the butcher's cleaver.

We have arrived, with these jagged structures, at a point far removed from Brancusi's simple curved surfaces or Arp's more complex ones. Moore's work is far more complicated, formally and psychologically, than that of the earlier sculptors. Yet a faithfulness to natural organic forms (however much mutated and transformed and combined) and a deliberate ambiguity in the new forms they created (usually playful and amusing with the first two, more portentous with Moore) marked the work of all three.

CHAPTER
3

Machines,
Angles, and Orbits

AT THE turn of the century the West was prospering as never before. Within the previous thirty years real wages had risen by nearly half and the world's railway mileage had quadrupled. The encouraging statistics of material wealth piled up. There were, to be sure, wasps among the roses, troubling doubts about the squalor of industrial cities, human costs, and mounting rivalry among European nations that could easily lead to war. On the whole, however, the prospect seemed bright. The cause of the rapid changes, it was widely recognized, was science linked to technology. Indeed, science had become a new god.

Artists were slow to come to terms with the industrial age. Their traditional concern, of course, was "beauty," and in the Western world there was an ancient prescription for that quality: follow the Greeks and the followers of the Greeks. Not surprisingly, many of the modernists of the dawning century, in rebellion against forms of art that had so little to do with their new world, made the technical knowledge and tools that now dominated that world a major concern. Some pitied or mocked at

robot man. Some found beauty—or, what came to concern them more and more, power and vitality—in the new machines. Some borrowed the methods and theories of technology to fashion aesthetic objects, with no utility beyond that of stirring some shade of emotion in the observer. Some were fascinated by the new materials that had become available, and turned from marble, bronze, and wood to iron, steel, and plastics.

EARLY EXPERIMENTS

For the first decade or so there was a good deal of milling about, as individual sculptors tried out new ideas of form and theme before settling down to their own lines of development. Some, like Picasso—compulsive creators and restless experimenters—never settled down. Let us recall that these pioneers of a new sculpture were few in number. In the early part of the century most of them worked in Paris, where they knew each other, were aware of what the others were doing, and sometimes borrowed each other's ideas.

Among the movements of the time that had some influence on the sculpture was cubism. This initially had little to do with the industrial age, but it helped generate ideas that were more strongly linked to science and technology. The term cubism came into use in modernist art through the paintings of Georges Braque and Picasso about 1907. There is some dispute about the origin of the term,* but little about the intention of the painters whose work first gave rise to it. They wanted to give the effect of three-dimensional form on a flat two-dimensional surface, not by the traditional use of chiaroscuro and perspective, but by cutting up the surfaces of a solid form, as it were, and laying the pieces out flat, to make the viewer conscious of an object from all sides, as if he were walking around it or turning it over in his

*One version is that the critic Louis Vauxcelles, seeing paintings made by Braque in 1908, wrote of the artist's manner of reducing everything "to geometric outlines, to cubes." A bit later the same hostile critic referred to Braque's "bizarreries cubiques."

hands. After some years of experimentation with this mode of painting about all that Picasso himself retained of it was the technique of presenting several points of view on one surface, rather like a Mercator projection of the globe.

There would seem to be little point in reversing the visual trick and putting the two-dimensional pieces together again in a physical form that has depth as well as height and width—that is, a sculpture. But some sculpture of early in this century has been called cubist. The term has been used to cover so many ideas that it ceases, in sculptural terms, to have much meaning: almost anything angular; almost anything massively solid and also angular; a form that exposes inner space within its outlines; a construction made mainly of straight lines.

It is often said that cubist sculpture was born in Picasso's *Head of a Woman* (1909)[48] which was exhibited in the Armory Show of 1913. In it the impression of depth and interior space was accentuated by breaking the surface into facets separated by deep sharp furrows, somewhat like the segments in Picasso's and Braque's cubist paintings. "I thought," Picasso once told a friend, "that the curves you see on the surface should continue into the interior." The agitated surfaces of Rodin have been much more broken up and exaggerated, in ridges and ravines, to emphasize the play of light and shadow. They also suggest the jowls, dewlaps, sunken cheeks, bags under the eyes, and neck muscles of an old lady. The model for the head was not an old lady—she was Fernande Olivier, Picasso's mistress at the time —but he was experimenting with forms, not trying to execute a likeness. Before modeling the head, Picasso had worked toward the final version in many drawings and paintings. One cast of the *Head* stands in Chicago's Art Institute, next to a painting and a crayon-and-gouache drawing of such a head, both done in 1909, that illustrate in two dimensions what Picasso was trying to do in three. After this experiment Picasso abandoned sculpture of the human figure, or of parts thereof, for nearly twenty years.

A few years later, in 1916, the Russian sculptor Naum Gabo

made a much more radical (and, as it turned out, more
influential) experiment with a *Head*, showing only the outline as
the edge of intersecting flat planes and giving the impression of
surface contours as well as interior space. (Space, as we shall see,
was a sculptural material for him.) A celluloid version of this
work, in New York's Museum of Modern Art, is one of the
earliest sculptures in the material, and grandsire of the many
contemporary geometric forms made of plastics. A much larger
version in iron stands in the Tate Gallery in London [49]. Begin-
ning in 1913 Henri Laurens (1885–1954) also produced com-
positions in which, as in the Gabo *Head*, intersecting planes were
used to indicate contours and interior space [50].

Jacques Lipchitz (1891–1973), the Lithuanian-born sculp-
tor who moved to Paris in 1912, soon made his own first "cubist"
works. In these the human body is transformed into geometric,
usually sharp-edged, solids, as in *Man with a Guitar* (1915) [38]. "I
had to work toward cubism in sculpture entirely on my own," he
later said—not quite correctly. He thought that angular forms
give more sense of the third dimension than light falling evenly
over curves. (Brancusi thought the opposite.) Lipchitz moved
for a time toward increasingly simplified forms, some of which
seem more like models for buildings than suggestions of human
shapes, although he did not wholly forsake things seen in nature
as his sources. A kinship to architecture, to the massive construc-
tions of skyscrapers, is one of the attributes of cubism as inter-
preted by Lipchitz that was carried over into the work of others.

Heavy and solid (but not necessarily large) masses have
enjoyed favor among some modernists because they are "true to
the material" (usually stone of some kind). Brancusi was earliest
of all to make the blocklike carving that was literally a cube—*The
Kiss* [21]—but that had nothing to do with "cubism" as a move-
ment. (Because the term helps so little in understanding trends
in modernist sculpture, there will be few occasions to use it from
this point on.)

THE BEAUTY OF SPEED

Apart from the gestures toward the angular world of technology, sculpture's earliest accommodation of the machine age came, curiously enough, in two of the least industrialized of the major European nations—Italy and Russia. In the Mediterranean peninsula it took the form of the short-lived movement called futurism which called for a revolutionary attitude toward life and art. Politically it was a precursor of Fascism, demanding that Italy become a nationalist industrial power and expand her unimpressive colonial holdings. Artistically it preached that Italy must rid herself of an addiction to the ancient past and create a new art based on and exalting dynamism, machinery, speed, and war.

> We declare that the world's splendor has been enriched by a new beauty: the beauty of speed. A racing automobile, its hood adorned with great pipes like snakes with explosive breath, . . . a roaring automobile, which seems to run like a machine gun, is more beautiful than the "Victory of Samothrace."

So wrote the poet and novelist Filippo Tommaso Marinetti, one of the chief spokesmen for futurism, in *Manifeste de Futurisme*, published in Paris in 1909. Umberto Boccioni (1882–1916), futurism's most substantial sculptor, issued his personal manifesto in 1912 to denounce the "pitiable barbarism, clumsiness, and monotonous imitation" of sculpture in Europe, "dominated by the blind and foolish imitation of formulas inherited from the past." Sculptors everywhere were committing the same errors, copying nudes and studying classical statuary "with the simpleminded conviction that [they] can find a style corresponding to the modern sensibility without relinquishing the traditional concept of sculptural forms."

A bronze cast of Boccioni's best-known statue, *Unique Forms of Continuity in Space*, stands in New York's Museum of Modern Art [55]. Here was an attempt to give the impression of movement, with swirling draperies used rather like the little lines made by cartoonists to indicate that a character is running or jerking his head about. In Boccioni's own words, he wanted to capture, "not the construction of the body, but the construction of the *action* of the body."

By 1916 futurism as a movement was moribund; it was revived after the war, in its political aspirations but not in its art, by Fascism. In the words of George Heard Hamilton, a friendly chronicler of modernist sculpture, the futurists' "recognition of the inherent restlessness of modern life expressed in man's obsession with technology added a new psychological dimension to modern art." That dimension would endure.

Among those influenced by futurism was the French sculptor Raymond Duchamp-Villon (1876–1918), brother of the more famous Marcel Duchamp (see pp. 78–80). "The power of the machine imposes itself, and we can scarcely conceive living beings any more without it," he wrote to a friend. "We are strongly moved by the rapid brushing by of men and things, and accustom ourselves without knowing it to perceive the forces of the former through the forces they dominate." In Duchamp-Villon's best-known work, *Horse* (1914) [54], the dynamic machinelike form renders the animal barely discernible. He had seen an exhibition of Boccioni sculptures the year before.

Jacob Epstein (1880–1959), a New Yorker who made his life and career in England, and was eventually knighted, is known as a more conventional sculptor—one of the best of those who continued to work mainly within the tradition. But he too was briefly drawn to machines in his experimental thirties. He took an actual rock drill, and on it mounted what he later (after his enthusiasm for technology had waned) called "a machinelike robot, visored, menacing, and carrying within itself its progeny,

protectively ensconced. Here is the armed, sinister figure of today and tomorrow." His *Rock Drill* of 1913 [53], although fearsome, is also witty. Some find in it a little of the poignancy of Henry Moore's much later *Helmet Heads* [52], with a note of pity for mechanized and militarized man.

Quite apart from his interest in dynamism, Boccioni preached another message that found wider acceptance among later sculptors: in "the intersection of the planes of a book with the angles of a table, in the straight lines of a match, in a window frame, there is more truth than in all the tangles of muscles, in all the breasts and thighs of the heroes and Venuses which arouse the incurable stupidity of contemporary sculpture." The angle should triumph over the curve, Boccioni thought, and modern manmade objects over the imagined and idealized beauties of the ancients. A similar but more rigorous thesis was soon to be pronounced in Moscow by two brothers—Antoine Pevsner (1886–1962) and Naum Gabo (1890–). The latter changed his name to avoid confusion between them, but they have nevertheless remained paired in art history as uncompromising apostles of pure geometric form.

SPACE AND TIME REBORN

ABOVE THE TEMPESTS OF OUR WEEKDAYS,
ACROSS THE ASHES AND CINDERED HOMES OF THE PAST,
BEFORE THE GATES OF THE VACANT FUTURE,
WE PROCLAIM TODAY. . . .

The placards posted on August 5, 1920, at certain street corners in Moscow, still caught up in civil war and facing near-famine, had a different ring from the usual decrees and government orders. Clusters of people around the notice boards, expecting to read a new decree on rationing, found instead the *Realist Manifesto* of the brothers Pevsner which proclaimed, not a new price of bread, but a new philosophy of art that has come to be known as constructivism:

Space and time are reborn to us today. Space and time are the only forms on which life is built and hence art must be constructed. . . . We construct our works as the universe constructs its own, as the engineer constructs a bridge, as the mathematician his formula of the orbits.

Their message to sculptors was that they must explore space—treat space as a material to be shaped: "you sculptors of all shades and directions, you still adhere to the age-old prejudice that you cannot free the volume of mass. . . . * we take four planes and we construct with them the same volume as of four tons of mass." And the artist should suppress his desire to express personal thoughts or moods, seeking instead the reality behind surface appearances. In practice, this meant production of forms notable for their openness, with space defined by thin shells of material or one-dimensional strings and wires. Gabo made the involuted networks or intersecting planes even more insubstantial by the use of transparent plastic materials [56, 58]. In 1937 he wrote that the "volume of mass and volume of space are sculpturally not the same thing." They are, he insisted, "two different materials . . . both concrete and measurable," and "the perception of space is a primary natural sense which belongs to the basic senses of our psychology."

Gabo was one of the few early modernist sculptors who is known to have studied seriously the scientific discoveries made early in the century. His father, a businessman, sent him to Munich in 1909 to study medicine, but he found himself more

*In the contemporary lexicon of sculpture "volume" is ambiguous. Usually it refers to a more or less self-contained unit of form—a head or chest or upper leg in a human figure—combined with others to form the composition that is the total sculpture. Some simple forms, like Brancusi's *Mlle. Pogany* [22] or *Blond Negress* [23], are single-volume sculptures. Sometimes the word is used in its more familiar sense of "quantity." "Mass" refers to the solidity and bulkiness of the material of which most sculpture is made. The Pevsner brothers were talking about replacing solids (mass) with voids (space), yet giving the effect of the same "volume" (perhaps in both senses mentioned above)—for example, in the Gabo *Head* [49], in which the usually solid form is mostly space.

attracted to physics, mathematics, and chemistry—and to the arts. It was a period of revolutionary scientific discovery. The old certainties of physics were being toppled. Ernest Rutherford had suggested that the atom with its electrons revolving about a nucleus, was a tiny solar system. Solid matter, it seems, should be thought of as empty space. Within the first decade of the century Max Planck had announced his quantum theory and Albert Einstein his theory of relativity, while Hermann Minkowski postulated a world of four dimensions, adding time to the familiar three of space. Nothing material was enduring or precisely definable; physical things were but a shifting series of events, continually changing.

There is little evidence, so far as I am aware, that the sculptors of the first quarter of the century, apart from Gabo, closely followed the new theories of physics, which remained arcane to the general public. It is hard to doubt, however, that in one way or another the notions of atomic particles in varying orbits and of a universe folded in upon itself reached their minds and affected their ideas of reality. Certainly later on in the century the new hypotheses had passed into general knowledge, however imperfectly, with an impact on the creative minds of those making sculpture.

Meanwhile, in Russia, the Pevsner brothers and modernist art generally were not long welcome. Although Leon Trotsky was at first sympathetic to their experimental ideas, the hardships, shortages, and civil strife of the early 1920s made art that was not harnessed to the needs and wants of the state an expendable luxury. Lenin's government was mobilizing all its resources simply to survive. In 1921 Pevsner and others in the cultural avant garde found their studios closed. (Later, with the rise to power of Stalin, the "leftist deviations" of modernism were utterly banned; only "socialist realism" was acceptable.) The brothers made their way separately to Berlin, where constructivist art was introduced to the outside world in a Russian exhibition in 1922. The work of the two, then and later, was to

influence many younger sculptors profoundly. The curving shells of thin metal or plastic, or structures of wire, intersecting in geometric patterns, and the preoccupation with "shaping" space have been much copied and further developed through the century. Gabo and Pevsner have had a numerous and vigorous sculptural progeny.

Gabo worked mainly with translucent materials and tenuous wires. Of two variations of *Linear Constructions*, one, in Chicago's Art Institute, is made of nylon threads and lucite [56]; the other, in the Hirshhorn Sculpture Garden, of aluminum with steel wire [57]. *Translucent Variation on a Spheric Theme*, in the Guggenheim Museum [58], is an example of his geometric figures in nearly transparent plastics, heightening the feeling of space that he sought to evoke. He had come to believe that the "visual character of space" is not angular, but is best expressed in spheric forms. Pevsner's *Twinned Column* [59] and *Column of Peace* [60] are built up from bronze rods.

Among the better known of their descendants is Richard Lippold, born in 1915, who extended the use of wires into huge but airy constructions. *Flight* [62], in one of the lobbies of the Pan Am Building in New York City, is made of stainless-steel and rolled-gold wire. Rising three stories high, its "rays" surround a central globe from which other arrays of wire converge in conical forms to create a star.

VIRTUAL VOLUME

A contemporary of the Russian brothers, Hungarian-born László Moholy-Nagy (1895–1946) had an even broader influence, although relatively few of his works are identified as "sculptures." He came to the United States in 1946, and there, inevitably, he was nicknamed "Holy Mahogany." His interests and influence ranged across a spectrum—metalwork, industrial design, typography, stage design, photography, painting, sculpture, and experiments with light.

The experience of space, he said, is a biological function like the experience of colors or tones. Accessible to everyone, the capacity to experience space can be developed by practice and suitable exercises. By the use of translucent plastics and thin metal rods or wires, the impression of mass can be conveyed in constructions that are largely voids, or space. In his words, "sculpture is the path both from material volume to virtual volume,* and from tactile-grasp to visual grasp. Sculpture is the path to the freeing of a material from its weight, from mass to motion." In short, a sculpture that appears to be massive and heavy may not be so in actuality. And the viewer gets this impression, not by the sense of touch—"tactile-grasp"—that is usually regarded as one of the distinctive qualities of sculpture, but by that of sight. You can even produce this effect with light beams, which have no weight at all and are not tangible. Moholy-Nagy was one of the earliest experimenters in this use of light: in the 1920s he built a "Light-Display Machine" (or "Light-Space Modulator"), the precursor of what have come to be called environmental light-machines. One of his last works is *Dual Form with Chromium Rods* [61], made of bent chrome rods penetrating a plexiglass plate.

DRAWING IN SPACE

Other sculptors were experimenting with their own ways of "showing" space, of treating space as a material to be shaped. Gabo, Pevsner, and Moholy-Nagy used geometric designs not founded on observed objects. The group we are now to consider, however, was interested in depicting observed figures—reduced and simplified, sometimes almost beyond recognition, but with some connection to what is seen in the world about us.

*Moholy-Nagy seems here to be using "volume" in the sense of "quantity"—the amount of external space displaced by the object—rather than of a self-contained form.

Beginning in 1925 Jacques Lipchitz began opening up some of his figures, leading to what he called "transparents." "Seated Man (Meditation)" (1925) is a small figure in which an S-shaped bar—the man's body—seated on a cubic stool is topped by an octahedron, or double pyramid, with a thick arm balancing the composition, bent so that the forearm rests on the knee and the hand holds up the chin. A somewhat later sculpture is similar —the 1928 *Reclining Nude with Guitar* [63]. These figures represent a stage in Lipchitz's own development of his "cubist" style, a certain opening-up of the solid, monumental, almost architectural sculptures he had been making. But Archipenko had created similar forms long before like his *Boxing*, dated 1914 [103], and Gabo and Pevsner had been much bolder in "playing with space," as Lipchitz put it. He went on to make a number of small figures, often with musical instruments, of thin flat bronze planes and rods or strings. "Among artists," Lipchitz said, "these pieces [the transparents] were extremely successful; Picasso liked them very much and one day spent half an hour studying a piece" at a gallery where Lipchitz was exhibiting.

In 1927 Lipchitz made a monumental work in bronze, *La Joie de Vivre* [64]. Standing seven and a half feet high, it is a dancing figure, strumming a large guitar, an interesting combination of massiveness and openness—the biggest of his "transparents." The statue was destined for a garden in the south of France, and since it was meant to be seen from several points of view, Lipchitz suggested that it be mounted on a rotating base, operated by a machine in the pedestal. Lipchitz considered the experiment a great success and reported that the motor ran perfectly, turning the figure completely once every four minutes.

His comment about Picasso's viewing of his small transparents implies that the Spanish master got his own start in making openwork constructions in this way. That may be so. Picasso readily admitted that he borrowed ideas from others and developed them in his own way. In any event, about 1928 Picasso,

with the collaboration of his compatriot and friend Julio Gonzalez, began fashioning somewhat similar constructions, this time in iron. Soon Gonzalez was making them on his own. Their contribution to the development of modernist sculpture in the form of welded-iron figures is of major importance.

Before we turn to that development, one additional, and later, manipulation of space should be noted. This took the form of strings or wires used to mark off or emphasize certain areas of space in what was otherwise a more conventional mass of sculpture. In the late 1930s Henry Moore made a number of stringed objects. Some critics have suggested that the idea of these figures came to Moore from mathematical models, made to illustrate in concrete form various mathematical propositions, that he had seen in the Science Museum in London. Gabo was also then using raylike lines. Moore's stringed figures combine the Russian-born constructivist's strings, used to define space, with the biomorphs that are more characteristic of the English sculptor's work. They were made in the years when he came closest to complete abstraction, when the references to living forms were at their most obscure. Lines are strung from the protuberances (usually circular or oval) of a solid object, forming a transparent skin over the cavities beneath or behind the insubstantial covering. Some critics have found formal virtues in the use of the device: contrasts between the wavy surface of the body and the string, which, as one has put it, "literally pulls together what would otherwise be a group of disconnected episodes"; contrasts between the string's "tautness" and the "curvilinear contours of the mass"; the effect of "containing the space on its open side while allowing it to remain visible"; provocation of "movement of the spectator's eye along the string's length, thereby "increasing his awareness of the space within the sculpture." These formal delights are probably accessible only to those who have attained the highest peaks of sensibility, while we museumgoers roam about in the foothills below. In some of the figures the lines of the strings do give additional meaning—even

a touch of wit—to a sculpture that has clear associations with experience. In a "Mother and Child" of 1938, showing highly stylized heads and upper bodies, strings "look" from the mother's eyes to the child's head, and from the baby's eyes to his mother's breasts.

Moore's contemporary and compatriot, Barbara Hepworth (born in 1903), began using strings at about the same time, threaded through geometric hollowed-out forms. One of her best known is *Pelagos* (1946) [105]. From the studio in her house in St. Ives, Cornwall, she could look out to sea, across arms of land to right and left. This view gave her the idea for the wooden hollow sphere with painted interior and strings stretched across the "channel." Hepworth has said that the strings in this and other figures of that period expressed "the tension I felt between myself and the sea, the wind or the hills."

CHAPTER
4

The New Iron Age

T IS time, said Julio Gonzalez (1876–1942), that iron "cease to be a murderer and the simple instrument of super-mechanical science. Today the door is wide open for this material to be, at last, forged and hammered by the peaceful hand of the artists." Little known to the general public, Gonzalez should be regarded as patron saint by the later generations of sculptors who embraced enthusiastically this new way of making three-dimensional forms. The techniques and materials he espoused could be, and have been, adapted to a wide variety of sculpture.

There were, as we have noted, some earlier modernist works in which iron was used—some of Henri Laurens' cubist constructions, for example, and some work of the Russian constructivists. Shaped pieces of sheet iron were fitted together or used with other materials. But Gonzalez was the inventor of "drawings in space" and the first major artist to substitute the acetylene torch for the carver's chisel and the modeler's manipulation of clay. Gonzalez and Picasso together, that is. For Gonzalez's first works of sculpture (as distinct from decorative

ironwork) produced by the new techniques were made in collab-
oration with his fellow Spaniard. Gonzalez entered the field by
serving as metalcraftsman for Picasso's concepts and designs as,
in a long tradition, a stonecarver copies the "artist's" plaster
model. During this period of collaboration, from about 1928 to
1932, he emerged as an artist in his own right.

One product of their joint efforts was a construction of rods,
originally intended to be enlarged as a monument to the poet
and friend of many modernist artists, Guillaume Apollinaire.
The commission planning the memorial thought it too uncon-
ventional to serve as a monument even to so stout a defender of
the avant garde as Apollinaire. At last the model was executed in
metal, full-size, for the Museum of Modern Art in New York,
and now stands in its Sculpture Garden. The *Monument* [66]
looks like a jungle-gym from most points of view. From certain
angles, however, the form of a driver or charioteer can be made
out (one big oval of steel serving as body, a small one as head),
holding the reins in front. Neither Picasso nor Gonzalez, how-
ever close to complete abstraction he might seem to come, ever
departed wholly from a natural figure in his sculptures.

Julio Gonzalez came of a large family of artists in Barcelona,
mainly engaged in decorative metalwork in a land where the
Moors had started a long tradition of working in wrought iron.
Julio studied painting in the Barcelona School of Fine Arts at
night, after helping his father in the family metalshop. With his
brother Juan he went to Paris about the turn of the century.
There he met Picasso and Brancusi, who were among the few
friends he continued to see in a long period of deep melancholy
that followed his brother's death in 1908. He turned from paint-
ing to metalwork, principally masks and heads hammered in
bronze and silver.

Only in 1926, at the age of fifty, did Gonzalez find what his
daughter described as his "true path"—sculpture—mostly, at
first, in small-scale figures. Then came his period of collabora-
tion with Picasso, and he began his own series of airy, elegant,

and witty (if somewhat obscure) works. Like the Russian con-
structivists, he had an almost mystical approach to space. His
aim, he said, was to use the techniques and materials available to
the modern artist "to project and design in space . . . to construct
with it, as though one were dealing with a newly acquired
material."

The *Head* (1934–35) is scooped out, its solid elements giving
the barest hints of the natural form they are meant to suggest
[70]. A tapering tubular arc describes the skull, ending at the top
in little rods suggesting hair and at the bottom in stylized jaw and
teeth. A circular flat plate, made up of welded fragments, is a
vertical cross-section of the face, and two antennalike rods indi-
cate the eyes. Here is displacement of a solid by a void with a
vengeance. *Woman Combing Her Hair* (1936) is even harder to
decipher, but no one can fail to see the curve of the buttocks (or is
it, on the convex side, a somewhat protruding abdomen?), an
arm reaching up, and iron strands of hair, some tangled, some
combed out [71]. Her posture, and the substitution of voids for
solids, are similar to those found in Archipenko's sculpture
bearing the same title [37]. It was Gonzalez, let us recall, who said
that artists should demand of spectators that each "according to
his capabilities, try to elevate himself to the work of art. If they
don't succeed at the first try, let them persist, even several times."
It is a common, if usually unstated, demand, from most moder-
nists. The viewer, of whom it is asked, must decide for himself
whether the reward promises to be sufficient to justify the
effort—repeated efforts.

Concerning French critics' lack of background, at that time,
for appreciation of the welded-iron creations of Gonzalez,
Henry Moore has commented that they paid little attention to
the collections of primitive art in the Musée de l'Homme, and
did not know what was happening after Gonzalez there saw the
statue of the war god *Ogoun* from Dahomey. The image of *Ogoun*
was made entirely from iron fragments of European origin [69].
His body, of thin rods, is dressed in a sleeveless tunic from

shoulder to mid-thigh, and under the tunic he wears an iron loincloth. His right hand once held a bell, his left a big sword. Ogoun was, to the Fon and Yoruba people, the god of war, of metals, and of all who use iron objects. The emblems on his headdress include a fishhook (for thunder), a dagger and spear (attributes of a soldier), a snake (symbol of the rainbow god), and a knife and hoe (attributes of farmers). He is now also the god of chauffeurs and mechanics.

The use of "found objects" has become characteristic of a large number of modernist and contemporary sculptors. It began in the 1910s with the collages of Picasso and others, who might use bits of newspaper, and other ordinary materials (including, on one occasion, a cane chair seat) in more or less flat reliefs. One aim was to blur the line between "life" and "art" by incorporating humdrum objects from the workaday world in new creations. Sometimes, in later sculpture (as in the Fon figure of *Ogoun*), common objects might be used as symbols or attributes, just as Christian artists, for example, identified St. Mark by a lion or St. Peter by keys. The symbols substitute for words.

By the late 1920s, during his period of collaboration with Gonzalez, Picasso was using metal "found objects" with a different purpose. They were thrown together in unexpected conjunctions, producing visual metaphors—amusing but also sobering as a reminder of the deceptiveness of surface appearances and of the odd correspondences and uniformities found in visible matter. He collected and used fragments of machinery, utensils from the kitchen or garden or table, and whatever else he might find in a rubbish heap or vacant lot that seemed a candidate for metamorphosis. In "Head" (1931) the back part of the cranium is a colander, the remainder assorted junk. Some twenty years later he created a bull's head from the saddle and handlebars of a bicycle. And he used two toy automobiles, from his son's store of playthings, to make the head of *Baboon and Young* [88], and, apparently, a child's ball for the body.

How many country and suburban gardens now bristle with

figures constructed from rusting parts of automobile engines and other machines? A multitude has joined Picasso in sifting through junk piles for objects that would suggest, or fit, an imagined construction.

FROM IRON TO BURNISHED STEEL

An American painter, then twenty-six years old, was impressed and excited by photographs of Picasso's and Gonzalez's welded sculptures reproduced in the French publication *Cahiers d'Art*. Born in Decatur, Indiana, David Smith (1906–1965) was the son of a telephone company official and a teacher. Passionately independent from an early age and an indifferent student, he dropped out of college to study art in New York, but only after a summer working in the Studebaker plant in South Bend, Indiana, which he always afterward referred to with pride. That experience, he felt, gave him a feeling for tools, industrial forms, and the life of a manual worker.

At the Art Students League of New York he studied painting. It had not occurred to him until he saw the Picasso-Gonzalez works in photographs that "art" could be made of welded iron and steel. Metalwork was *work*; art was made of oils and other traditional and respectably useless materials. He made his first steel sculpture in the summer of 1933 with borrowed equipment. In 1935 he decided to abandon painting and devote himself to the newly found medium of welded iron or steel. But much of his sculpture was to be "painterly"—almost two-dimensional in effect and meant to be seen from one point of view. A trip to Europe in 1935–36 rounded out his self-education and confirmed him in his choice of new materials and techniques that was to make him the first major American welder. Through the 1940s his iron figures were often highly personal statements, packed with private meanings that only an interpretative text could decipher. He was an admirer of James Joyce's *Finnegans Wake* and made much the same use the Irish

novelist did of plays on words and free assocation, but expressed
in pictorial rather than verbal terms.

Beginning in 1942 Smith was a welder in the American
Locomotive Company in Schenectady, New York, helping to
make M-7 tanks—a task into which he seems to have thrown
himself with zest. He had little time for sculpture in those war
years, but emerged with the full range of skills of an industrial
metalworker. He could braze, silver-solder, and arc-weld iron,
draw, spin, forge, chisel, grind, file, and polish steel. After the
war he built up the primitive studio he had established in the
1930s at Bolton Landing on Lake George, New York, making of
the "Terminal Iron Works" a well-fitted plant for working in
metal, with welding shop, painting studio, and storage space,
and open fields for the display of his works.

In the 1950s Smith turned to a more public and monumen-
tal style, less laden with private symbols. *Australia* was one of the
major new works [68], a welded "drawing in space" of the kind
Picasso and Gonzalez had originated. The important element is
the series of lines defining the figure, which is nevertheless
clearly sensed as a three-dimensional object. Close students of
Smith's life and work have differed as to the object to which
Australia refers. Rosalind Krauss, for example, finds in it a kan-
garoo, the aboriginal totem animal of Australia. Edward Fry says
it is a huge insectoid bird, and that the work is named *Australia*
because something like this creature appears in prehistoric Aus-
tralian cave drawings, of which Smith had received photo-
graphs. Others have seen in it one of the rabbits with which, it is
well known, the island-continent has been infested. Having
spent a wretched month in a malarial swamp near Brisbane in
1942, I incline to the insect theory, and can attest that many of
the flying creatures are of prodigious size.

Our interest in the welded-rod creation, however, lies less in
what it represents than in its exemplification of a new kind of
sculpture. Like Gabo and his followers, Gonzalez and Smith
were bringing a new lightness and airiness to a form of art that

was traditionally, by definition, solid and massive. But where Gabo rejected natural figures as models, Gonzalez and Smith embraced them—simplifying, distorting almost beyond recognition, but not severing the link with what can be observed about us. Smith's particular contribution at that time, around 1950, was more complicated drawings in space than others had yet essayed, even to the point of welding a "picture frame" within which the "painted" objects are outlined.

Smith soon moved on to the series of monumental figures for which he is most famous. Earlier he had used objects found in hardware stores or industrial scrap heaps, or components he had fashioned himself, to make his compositions. Now he turned more and more to the heavier iron and steel materials commonly used in industry and construction—rails, I-beams, circular ends of metal drums, and the like. At about the same time Abstract Expressionist painters were creating large-scale works, often using common industrial materials—latex paint, for example, and duck fabric. Smith's constructions retain, for the most part, a vestigial connection with the human body. Often the "torso" is a flat circular form, the head a less readily decipherable construction, and the legs a tripod. There are ten of the "Tank Totem" series, seven in the "Zig" (we are told the name came from "ziggurat" or from the use of zigzag elements —take your choice), and twenty-five in the "Voltri-Bolton" series. (Voltri is the town near Genoa where, in June 1962, Smith produced twenty-four sculptures for exhibition that summer at the arts festival in Spoleto; Bolton Landing was the site of Smith's home and studio at Lake George.) The last and most famous of the series were the twenty-eight monumental works of burnished stainless steel known as *Cubis*. These angular constructions have a kinship, in one respect, with some of the constructions Arp made late in life. Arp placed face to face two flat surfaces of bronze cutouts having the same outline, separated but also connected by a narrow band of metal, forming an irregularly shaped box. But he remained faithful to organic

forms. In outline his figures, smaller than Smith's and similar to the reliefs of his early days, may be plants, or human bodies (seated and bent over their knees, or kneeling), or other biomorphs not readily decipherable as known objects [72]. Smith, on the other hand, had adopted strictly geometric forms, usually angular but occasionally with a cylinder or drum-form among the straight-edged boxes.

Some observers and critics see in the *Cubis* a continuing link with human figures, even if only in the form of stylized, simplified, "abstract" gestures, like those of walking, throwing, or drawing a bowstring. For some, the lightness of objects so obviously heavy has a striking impact—lightness enhanced by the swirls on the bright surfaces caused by the brushes of burnishing tools. The *Cubis* should be seen in full sunlight on a bright day, or with spotlights trained on them in museums. David Smith was one of the talkative sculptors. Indeed, he supplemented his income in the early lean years by lecturing on art. But all the lectures, writings, and interviews help little to indicate what personal idea lay behind a particular work. For all his generous use of words, he distrusted them as interpreters of the visual arts. To a viewer of one of his "drawings in space" he once said: "you can reject it, like it, pretend to like it, or almost like it, but its understanding will never come with words, which had no part in its making, nor can they truly explain the wonders of the human sensorium."

Accordingly, when an interviewer tried to draw him out on the meaning of the *Cubis*, Smith's answer was not unexpectedly obscure. The interviewer said he saw a lot of the big stainless-steel figures as personages; were they at all this for Smith? "They don't start that way," Smith replied. "But how can a man live off of his planet? How on earth can he know anything that he hasn't seen or doesn't exist in his own world? Even his visions have to be made up of what he knows, of the forms and the world that he knows." As for myself, most of the *Cubis* have become personages: *Cubi VII*, of three distinct vertical forms, one much taller

than the others, is for me the sculptor and his two daughters [73]; *Cubi XII*, Smith's version of Rodin's *Balzac* [3, 1]; *Cubi XVII*, a woman combing her hair [74]; and *Cubi XXVI*, an archer [104]. Most of the series are frontal, meant to be seen from one point of view, like a painting. *Cubis VII* and *XVII* are unusual in that they have to be seen from several points of view.

For certain viewers the *Cubis'* appeal is as a link with architecture, involving balanced (sometimes ingeniously) steel girders and other shapes, on a massive scale. They suggest skyscrapers, and are among the growing family of monumental sculptures that demand a certain space around them. The *Cubi* in New York's Whitney Museum has been almost literally buried, beneath sidewalk level, in a cramped corner—presumably because of a lack of adequate space.

Smith has been acclaimed as one of the great sculptors of the century, and has inspired younger generations of artists to a multitude of variations on his themes and techniques. It will, apparently, take some time for his work equally to impress the average viewer. I recently spent half an hour near a Smith on a college campus while hundreds of well-dressed visiting ladies, apparently of a comfortable station in life, trooped by it to an auditorium where they were gathering for a convention. Not one looked at the Smith.

Welded iron and steel have been used for sculptural effects quite different from those of an airy Gonzalez figure, or the somewhat similar early David Smiths or his later massive constructions of stainless-steel boxes. Alexander Calder, born eight years earlier than Smith, in 1898, was one of the first to create sculptures of a novel kind—broad cutouts of flat or curving metal sheets, intersecting in complex ways. This family of figures, tending toward the massive and monumental, can be regarded as part of the progeny of Naum Gabo, springing from seeds planted in such early sculptures as his *Head* (1916) [49], in which flat plates are combined in ways that give the impression of mass, yet also expose the inner space. Sculpture of this kind

was a relatively late development with Calder, who first won critical and public notice through another invention—mobiles. These involve modernist sculptors' approaches to the use of movement. A brief digression into that will lead us to the later Calder constructions of welded plates of iron or steel.

FROM SUGGESTED TO REAL MOVEMENT

Perhaps for the very reason that sculpture has traditionally been static, stable, and earthbound, many who have created three-dimensional works have felt challenged to make their creations seem to move. In a century in which the very notion of fixedness and stability in material things has been shattered it has become more than an amusing game to give the impression of mobility in objects known to be immobile and the feeling of flux in solid things; it has become, for earnest pursuers of truth, a requisite of their calling. We will, in the course of this digression, encounter both the playful and the solemn.

An early attempt to suggest a figure in motion was Myron's "Discobolos" of the fifth century B. C. It is the first known free-standing figure of a man in violent action, his body twisted and doubled up as he begins to hurl a discus. Later Greeks often depicted the body in motion, and the use of fluttering drapery made the task easier. The "Victory of Samothrace" is a famous example, in which the swirling garments, pressed by the wind against her body in front and fluttering out behind, help to inform us that she is swooping down to alight on the prow of a ship. The Italian futurist Boccioni had learned that lesson when he sought to capture "the construction of the *action* of the body" in his *Unique Forms of Continuity in Space* [55]. Rodin found his own method, unassisted by garments or other draperies, for suggesting motion in his *Walking Man* [4] and *St. John the Baptist* [5]. The illusion of movement became common enough in twentieth-century works. Sometimes "kineticism" went a step further, turning the object on its base, as in Lipchitz's original

version of *La Joie de Vivre* [64] (shown here on a non-revolving base).

Sculpture that actually moved, rather than simply giving the illusion of movement, is a twentieth-century phenomenon. In their *Realist Manifesto* of 1920 Gabo and Pevsner had called for "kinetic rhythms as a new and essential part of our sculptural work, because they are the only possible real expressions of Time emotions." They rejected the "thousand-year-old Egyptian prejudice" that sculpture must be static. Gabo himself produced only one three-dimensional work that actually moved, "Kinetic Construction" (1920), which consisted of a long, narrow flat steel spring inserted vertically in a vibrating electric motor. When set in motion the thin rod whipped back and forth, giving the visual impression of a solid object shaped like a narrow vase. One problem puzzled Gabo: How can the mechanism (electric motor and gears, for example) needed to produce motion be used without distracting (by whirs and hums of extraneous moving parts) from the "pure sculptural content"? "The solution of this problem," he concluded in an essay in 1937, "becomes a task for future generations." Many later sculptors have accepted the challenge. Indeed, Alexander Calder was already making his "mobiles" when Gabo wrote. These were, in their early forms, so airy, graceful, and full of fun that the more solemn-minded in the world of art were not able to take them seriously as works of art.

Calder was born in 1898 in Philadelphia, the son and grandson of sculptors. While he was growing up, the family moved about, mostly between the East and West Coasts, for his father was executing commissions in various places. Young "Sandy" eventually took an engineering degree at the Stevens Institute of Technology in Hoboken, and then for several years he worked as an accountant, insurance investigator, and demonstrator of motorized garden cultivators. After taking drawing lessons in 1922, he again roved, as boilerman on a steamer and timekeeper in a logging camp.

By 1923, having decided to be a painter, Calder entered the Art Students League of New York. Within a few years he was making figures of birds and animals by bending wires. In 1926 he went to Paris, as deckhand on a freighter. For a living he made action toys, and, for himself and his friends, a famous miniature circus, which he delighted in presenting to small groups. Anyone who has read Calder's engaging autobiography knows that the man who shines through is direct, uncomplicated, kind, and witty, yet there is little in the book to illuminate Calder's attitudes toward art or his own work—he is not voluble about his own aims and purposes. There are no manifestoes here, no invocations of aesthetic ultimates or cosmic meanings.

One of the rare passages to give some insight into his development as an artist tells of a visit, in 1929, to the Paris apartment of Piet Mondrian, the Dutch pure-form painter known for his abstract pictures composed of rectangular forms and primary colors. In a large room Calder saw "experimental stunts with colored rectangles of cardboard tacked on." This visit, he wrote, "gave me a shock that started things." Before, he had not really known or felt the term "abstract." After the visit he wanted, at the age of thirty-two, to begin working with abstract forms.

In 1931 his first show in Paris included two articulated and delicately balanced objects that swayed when the air around them was agitated. In a later show Calder exhibited fifteen objects moved by motors, and about fifteen others that had moving elements. Marcel Duchamp christened them "mobiles," and Calder became famous for them. Whether small enough to fit on a desk, or large enough to fill a big room, they consisted of elements cut from metal sheets and fastened to rods or wires that were composed, with their pendent weights, into delicately balanced configurations that shifted with each passing breeze. "They're meant to be touched delicately," Calder once said of them. "I like the whang they make—noise is like another dimension."

Originally impelled to experiment with these novel con-

structions by the rectangular plaques he had seen in Mondrian's studio, Calder early turned to more organic forms. In the 1930s Calder also began making what Jean Arp called "stabiles"— immobile objects of cutout parts, usually of steel sheets, fitted together. More massive and three-dimensional than the flat and graceful mobiles, they grew to monumental proportions as Calder made more and more of them. One example, called *Black Widow* (1959), is now in the Sculpture Garden of New York's Museum of Modern Art [77]. Calder has said, incidentally, that he names an object only after he has designed it, and after the industrial foundries, upon whom he has had increasingly to rely as the sculptures have increased in size, have executed it. Mobile and stabile are combined in another piece, made in 1950, now in the Hirshhorn Sculpture Garden [75].

Calder has dated the trend toward massiveness from 1954, when he designed a "water ballet" in Detroit, with jets of water, up to five hundred feet high, rising and falling at different speeds and rotating in variable patterns. The bigness was transferred to metal constructions as he worked with architects, fitting sculptures into sites of buildings and memorials.

From modest and playful beginnings Calder's creations have grown into a major influence on younger generations of sculptors. Claes Oldenburg's *Geometric Mouse* [76] is an example of Calder's impact—and Walt Disney's. The combined influence of Calder and David Smith is in large part responsible for the monumental constructions, their own and their disciples', that now people urban plazas and the approaches to corporate headquarters. When Calder and Smith were at work, a borrower and adapter like Picasso could not be far behind.

PICASSO IN CHICAGO

Welded plates and rods of metal. Open spaces within solid frameworks, and "surfaces" insubstantial and untouchable because they are the unseen skin stretched between tangible mem-

bers. A tendency toward bigness and monumentality, with architectural echoes. These, with many variations, were common attributes of the new constructivist sculpture that began with Gabo and Pevsner. The line of development divided at one point, as we have seen. Some sculptors, like the Russian brothers themselves, abjured forms seen in nature and celebrated the forms of geometry. Others, however much they might simplify and reduce observed forms, did not abandon them entirely. Picasso and Gonzalez, inaugurators of the new iron age, were among those who always made figural sculpture.

In the late 1920s, when Picasso was designing the construction of rods meant to be a memorial to Apollinaire [66], he also dreamed of other monumental works, some of which he hoped to place along the seafront in Cannes. But these huge shapes did not get beyond the stage of drawings or paintings or small models. He told Daniel-Henry Kahnweiler, the art dealer, that "I have to paint them, because nobody's ready to commission one from me." Roland Penrose, friend and biographer of Picasso, has told of seeing a painting, done in 1929, of one of these imagined monuments. Its severe outlines suggested a skyscraper, its walls decorated with a huge woman's head, geometrically designed, with three long strands of hair and a long mouth placed vertically. Much later, when Picasso began using sheet iron for sculptures, his dream of big monumental works became more practicable. By then he was famous, and there were people eager to buy or commission such constructions.

In the spring of 1963 a group from Chicago asked Penrose to help put them in touch with Picasso. They wanted to commission a gigantic metal sculpture for the plaza of the new Civic Center building in the heart of the city's downtown Loop. According to Penrose, Picasso told the delegation he was honored that the two cities famous for their gangsters should be the first to ask him for such monuments: Marseilles also was then wooing him. After long negotiations, and some disappointments for the

Chicago suitors, one of their architects was finally shown a maquette of the proposed construction in April 1965. It was a model in iron, about four feet hight [79], which was to be enlarged by engineers and metalworkers in Chicago to a structure standing about fifty feet high.

When the *Chicago Picasso* was unveiled on August 15, 1967 [78], the citizenry did not receive it with unalloyed delight. Derisive critics included the *Chicago Tribune* (which seemed as disturbed by the sculptor's membership in the French Communist Party and his lifelong custom of living with ladies out of wedlock as by the appearance of the work itself), an alderman who suggested that a large effigy of a local baseball hero be substituted for Picasso's effort, and the *Inland Architect*. Admirers have remarked how ingeniously and comfortably the metal head adjusts to its place in front of the tall Civic Center building. It is big—as befits the site—but also airy and light, not crowding the open space of the plaza as a more solid and massive piece of such dimensions would have done. Constructed, like the skyscraper behind it, of cor-ten steel, it has gradually acquired the same soft dark-rust color, now somewhat streaked by weathering.

To the extent that the Chicago work depicts a natural figure at all, it is obviously the head of a woman with long hair falling behind—a favorite theme on which Picasso had made many variations in two and three dimensions through a long lifetime. Some of the heads seem influenced by African art, including Bakota reliquaries [80], which Picasso is known to have seen. The woman's face in the Chicago construction is most obvious when the monument is seen from one of the rear corners [79]. A photographer who was a close friend of Picasso is said to have commented that, from the front, it is a portrait of the sculptor's Afghan hound. Given Picasso's puckishness, and his fondness for unlikely conjunctions and metamorphoses, we should not be surprised if he had included the suggestion of a dog in his gift to Chicago, as well as a woman's head and many other things.

Detractors have found much else—a dead eagle, vulture, flying horse, baboon, and duck-billed platypus. Picasso must have relished the furore.

Whatever the *Chicago Picasso* may represent (if, indeed, it represents anything at all other than a woman's head), it combines within its shapes of cor-ten steel a useful summary of several modernist characteristics: use of new industrial materials; openness and shaped space beloved by constructivists; a symmetry approaching geometric regularity that marks one branch of modernism; simplification of a natural form, almost to the point of complete abstraction, but (characteristically with Picasso) without quite forsaking observed nature; ambiguity and metamorphosis.

Most of the sculptors we have met in the past two chapters shared in developing these same ideas in sculpture. Gabo and Pevsner were unswerving in their renunciation of natural forms and their devotion to pure geometric figures (with Gabo, in particular, reducing the use of solids to a minimum and emphasizing space). Picasso, Gonzalez, Calder, and Smith also tried, at different times in careers more varied and widely experimental than those of the Russian brothers, to bring out the spatial qualities of their works—"drawing in the air," using rods and wires to define a core or an outline, emphasizing the emptiness around and within the object, but usually keeping some links with observed nature. All probably owed a certain debt to Lipchitz and his "transparents," but were striking innovators on their own.

Preoccupation with space is one of the distinctive features of much modernist sculpture, involving the use of techniques and forms tried before only by a few African tribes. The resulting airiness and the absence of tangible surfaces have been disconcerting even to so friendly an observer and interpreter of modernism as Sir Herbert Read, for whom mass, solidity, and "touchability" (the "haptic" quality he so greatly admired) were the essence of sculpture.

One other aim, of some of the group we have been consider-
ing, was to give sculpture a kinetic quality—the appearance or
actuality of movement. Gabo and Pevsner preached its virtues,
without seriously attempting to achieve it themselves. Calder
and Moholy-Nagy went further, preparing the way for vigorous
experimentation with moving parts and flashing beams of light
by younger sculptors in the years after the Second World War.

For later generations the use of such industrial materials as
iron, steel, and the varied family of plastics seems entirely famil-
iar. To weld, to cut, to bend, to mold the new materials come to
them as naturally as carving in stone or wood or modeling in clay
came to those who worked in the centuries-long tradition.

CHAPTER

5

Conscious of the Unconscious

A FEW facts are known about the early life of Leonardo da Vinci. He was the illegitimate son of a notary and a girl named Caterina, probably a peasant. At the age of five he was registered as living in his father's family, presumably with his childless stepmother. Later in life he spoke of an early memory, of a dream that came to him while he was still in the cradle: "a vulture came down to me, he opened my mouth with his tail, and struck me a few times with his tail against my lips."

From these bits of information Sigmund Freud constructed a psycholanalytic interpretation of Leonardo's painting of St. Anne, the Virgin Mary, and the Christ child—a triple subject seldom treated in Italian painting. Freud surmised that the vulture story was not a childhood dream but a later fantasy, linked with legends of an androgynous Egyptian vulture-headed goddess, Mut, who could bear a child without need of a mate. The bird's fluttering was, in Freud's view, a fantasy of fellatio, a symbol of Leonardo's homosexual tendencies and of his attachment to his real mother, with whom he had lived as an infant. The St. Anne in the painting is not a doting grand-

mother, but Leonardo's real mother, to whom he apparently was devoted and gave a lavish burial. St. Anne's smile was Caterina's, and so, in the more famous painting, was Mona Lisa's. Thus Freud spun a dense web of meaning from what would have seemed, to the pre-Freudian layman, stray and insubstantial threads.

Freud's *The Interpretation of Dreams* was published in 1900, appropriately ushering in an era in which humankind's awareness of itself would be forever (if we may ever safely use that word) altered. The approach to art—of creator, critic, collector, or onlooker—would never be the same. Freud, Jung, Adler, their disciples, schismatics, heretics, apostates, exegetes—their voices would permeate twentieth-century post-Christian society. Freud's psychoanalyses of Leonardo and Michelangelo, without benefit of couch or conversation, were the first trickle in what would become a flood of psychological interpretation of works of art.

The privateness and obscurity of much modernist art not only invite these exercises; they insist upon them. What does an artist think he is doing in this or that sculpture? Behind his conscious intentions, what unconscious urgings are at work, guiding his thought and hand—urgings of which the artist is only dimly, if at all, aware? But his uninvited analyst, lay or professional, knowingly ferrets out the hidden forces. If the sculptor's theme is archetypal, expressing the collective unconscious, then we, the general observers—amateur depth psychologists, one and all—are expected to respond to the universal vibrations. If the artist's sources are more individual and private, formed by his personal experiences, then presumably we must look to him for clues and insights (for he will be something of an analyst too, and aware of our needs for enlightenment), or to critics who hold themselves out as being more knowing than we, through acquaintance with the artist or through a professionally developed sensibility. It is an endless, circuitous game—amusing, challenging, and often rewarding.

Everyone can play it. Indeed, anyone claiming to appreciate modernist sculpture must play it. Some artists and critics of the pure-form persuasion resist the search for associated meanings in a work of art, conscious or unconscious, insisting that only the formal qualities of the work interest them—mass, shape, relation of solids to voids, interrelation of volumes, lines of force, color, texture. But they cannot escape so easily from the depth psychologist's reach, long as a goblin's arm in a childhood nightmare. Roundness may be linked to femaleness, straightness to maleness, and any schoolchild knows what cylinders and tunnel-like cavities mean. Moreover, what meanings are hidden in the denial of meanings? In brief, the pervasive influence of depth psychology, on all the players in the game, is one of the distinguishing marks of modernist sculpture. It would be foolish to enter the arena unarmed, without at least a quiverful of Freudian or Jungian notions—fortunately, for the art lover, standard issue in the contemporary educational system.

Freud had little appreciation of art. He wanted to find out why artists did what they did rather than to enjoy their work. A passage in his *Introductory Lectures* could hardly fail to outrage sculptors and painters (although by "artists" he usually meant poets and other writers). The artist, said Freud, is an introvert verging on neurosis. To cope with his unsatisfied longings for the things other people seek, "he turns away from reality and transfers all his interest, and all his libido too, to the creation of his wishes in the life of fantasy. . . . " The artist elaborates on his daydreams, generalizing them to appeal to others, and modifying them "sufficiently so that their origin in prohibited sources is not easily detected." And by attaching to the reflection of his fantasy life a strong stream of pleasure, he overcomes his repressions—for a time at least. Through his work others find a way "to the comfort and consolation of their own unconscious sources of pleasure" and give him their thanks and admiration. Thus "he has won—through his fantasy—what before he could only win in fantasy: honor, power, and the love of women."

The reaction of the world of art to such theorizing may be imagined. Roger Fry, for one, leading English critic in the first half of the century, responded indignantly. Fry held the view that art should be purely formal, unadulterated by ideas and associations with experience or by emotions other than the purely aesthetic. Ernest Jones, Freud's disciple and biographer, has reported Fry's objections. First of all, a true artist creates for himself, not for others, and should be indifferent to the reactions of an audience. More important, Freud failed to distinguish between formal aesthetic features and personal psychological ones. The effort to isolate "aesthetic" values is so persistent and significant, especially in modernist art, that we should linger a moment over Fry's ideas of the elements of aesthetic pleasure. We enjoy, for example, the rhythm of line (pattern, contours, shape), the senses of mass and of space (the solidity of a thing, the way its parts are put together and relate to each other, feelings of weight and lightness), relationships of light and shade and color. The list could be enlarged or elaborated, but it gives a fair sense of what critics mean when they speak of "formal values."

Fry complained that the Freudians paid too little attention to the formal aesthetic qualities—*the* distinctive characteristics of a work of art—and too much to the "meaning" of the work, the story it tells, the moral it points, the emotions it tries to stir up. To Freud it seemed that the "aesthetic qualities" were a lure to the observer: superficial eye-catching elements that held his attention long enough for the artist's message (probably an unconscious one, not known even to the artist) to sink in. To Fry and his kin among critics (who have tended to dominate twentieth-century art theory) this was an arsy-versy version of truth. The work of art, ideally, should have no associated meanings or content, no story or message; to the extent that it did have any such content, that element could be defended only as a means of catching the viewer's interest and cajoling him into an attitude of contemplation, to enjoy the *true* aesthetic qualities

that an artist had created, the pure and formal ones that had nothing to do with stories and messages and passions. Jones replied that "even in the most recondite productions of Picasso or of Henry Moore it is usually possible to divine some unconscious imagery that is symbolized in the outlines." To that comment it might be rejoined that Picasso and Moore always insisted on some relationship of a sculptured object with an observed object, of creation with experience, whereas others, like Gabo, did not.

ROCKINGHORSE AND UNSEEN HAND

Consciousness of the unconscious did not come in a dazzling flash. Decades passed, and much sectarian strife, before the ideas of depth psychology came into common currency. Along the way one modernist movement—surrealism—claimed a special relationship with the new psychology. But its few avowed adherents, among sculptors at least, give only a hint of the pervasive influence of depth psychology among modernists generally—artists, critics, collectors, and the viewing public. Surrealism, coming into public notice in the late 1920s, had its roots in dadaism, a phenomenon of the First World War. The dadaists were a group of young, modestly affluent protestors against the smugness and materialism of the dawning century, and, as the dimensions of the slaughter began to be apparent, against the madness of war and the sickness of society in which such butchery was possible. Avoiding military service in their belligerent homelands, on both sides of the conflict, the dadaists gathered in neutral Zurich and to some extent in New York.

Dadaism was more a way of life than an artistic movement. Like a new lot of young rebels half a century later, dadaists were more eager to tear down the old order than to plan a new one. "Let each man cry out; there is a big job, destructive and negative to be accomplished. Sweep, sweep clean!" So spoke the Dada Manifesto of 1918. Where the name came from has been much

debated. "Dada" means "yes, yes" in Rumanian, the nationality of Tristan Tzara, one of the group's chief organizers. In French it refers to a rockinghorse, in German it means a doltish and naïve yokel, in English it is among a child's first words. Jean Arp, the only major sculptor to emerge from this boisterous group, "settled" the question with a characteristically dadaist statement: "I hereby declare that Tzara invented the word Dada on 6th February 1916, at 6 P.M. I was there with my twelve children [which, of course, he did not have] when Tzara first uttered the word. I was wearing a brioche in my left nostril."

Arp himself did not often take part in the roisterings in the Cabaret Voltaire, the dadaist headquarters for skits, dances, songs, and readings of verses and tracts ridiculing everything in a bourgeois order that was, in dadaist eyes, morally bankrupt. Carl Jung was then in Zurich, but the dadaists were paying little attention to psychoanalysis. Lenin too was in the city, living for a time in a house catercorner from the Cabaret Voltaire, plotting his own (and, as it turned out, a far more influential) form of revolution.

Arp contributed some of his flat assemblages to decorate the Cabaret's walls, and he heartily concurred in the attacks on old ways and old art. "Dada," he later wrote, "gave the Venus de Milo an enema and permitted Laocoön and his sons to relieve themselves after thousands of years of struggle with the great sausage Python." During those war years he developed his flat reliefs in wood, combining organic shapes in new ambiguous forms. He was also discovering what he came to call the "laws of chance" that can guide a creative artist. The idea, later linked more broadly to the workings of the unconscious, became a major factor in modernist art.

Hans Richter, chronicler of dadaism, has given an account of the event that led, by chance, to finding the law of chance. Working on a drawing that did not work out as he wished, Arp in frustration tore it up. The pieces fluttered to the floor, falling in a pattern that pleased him, more satisfying than the one he had

been trying to draw. Thereafter he made it a practice to "create" such patterns that formed themselves by chance. He was giving rein to the unseen hand of the unconscious, which worked, he said, through purposeful "accident." He recommended a dark room for the exercise, where the flow of the unconscious seemed to work best. "The forms come," he wrote, "pleasing or strange, hostile, inexplicable, dumb or drowsy. They are born of themselves. It seems to me that I have only to move my hands." The "chance" that guided his fingers, and the forms that took shape, "give us access to mysteries, reveal to us the profound sources of life."

Occultism is replete with obvious parallels: the patterns formed by the yarrow stalks or coins cast in consulting *I Ching*, for example, or the order of Tarot cards, or the movements of the pointer on a Ouija board. Carl Jung, and to a lesser extent Freud, took an interest in the occult and were impressed (more than Freud's biographer Ernest Jones thought scientifically respectable) by phenomena reported to them. Commenting on *I Ching*, Jung noted that while the Western mind is devoted to exploring causality—explaining the chain of events that lead to this or that result—the Chinese attach importance to "synchronicity," the coincidence of events that is more than mere chance and reveals a "peculiar interdependence of objective events among themselves as well as with the subjective (psychic) states of the observer or observers." Some of Jung's experiments with parapsychology led him to thoughts not far from Arp's about the role of apparent accident.

APOSTLE OF ANTI-ART

Marcel Duchamp (1887–1968) was a leading dadaist, and the movement's guiding spirit in New York. In 1915 he arrived in America (then neutral, like Switzerland). Duchamp had earlier set New York on its ear with his painting of "Nude Descending a Staircase"—the sensation of the Armory Show of

1913—but shortly thereafter he had renounced painting as a profession. At least such abstinence was part of the legend that grew up about him. After his death it appeared that he had continued to be active as a painter throughout his life, in a very private way, and he did exhibit a few major pieces. Cool, detached, intelligent, regarding life as absurd, he seemed to mock at art as even more absurd—and the avant garde loved him for it. Duchamp was the inventor of the "readymade," an ordinary manufactured object that he declared, by fiat, to be a work of art. If the avant garde was weary of painted replicas of things observed in nature, why should they not turn to the thing itself? And if "art" was not something separate from life, why not seek out the ordinary objects of ordinary life and elevate them to art? Picasso and Braque were doing something similar, but their constructions—of bits of burlap, tin, wood, caning, and the like—were at least their own creations. Duchamp adopted without change things he found about him, produced and used in commerce.

In 1913 he fastened a bicycle wheel upside down on a white kitchen stool, and called it a sculpture. In 1915 a snow shovel was dubbed "In Advance of a Broken Arm." Replicas of both, easily found in shops, are still exhibited; the "originals" were lost long ago—a nice dadaist touch. In 1917 Duchamp submitted for exhibition by the Society of Independent Artists in New York a urinal made by the Mott Works, a manufacturer of plumbing equipment. The object was turned on its side, so that the in-pipe pointed toward viewers. He labeled it "Fountain," and signed it "R. Mutt, 1917."

When the jury for the show rejected the piece, Duchamp wrote a strong objection in mock indignation. "Whether Mr. Mutt with his own hands made the fountain or not is of no importance," he wrote. "He CHOSE it. He took an ordinary article of life, placed it so that its useful significance disappeared under the title and point of view—created a new thought for that object." As for the objection that "Fountain" was simply a piece

of plumbing, he commented that "the only works of art America
has given are her plumbing and her bridges."

His choice of readymades, Duchamp insisted, was based,
not on aesthetic grounds, but "on a reaction of *visual indifference*
with a total absence of good or bad taste." If we regard the
pleasure of contemplation as one of the distinctive marks of an
aesthetic experience (whatever else it may be), we can readily
agree that the readymades are not "art." Like all jokes, the
readymades, once registered, do not bear repeating. The labels,
essential to the jokes, were not to be regarded as titles, he said;
they were "meant to carry the mind of the spectator toward
other regions, more verbal."

Duchamp delighted in puns, anagrams, and invented
words. In 1920, for a "change of identity," he first used the
signature "Rose Sélavy." Taking Rose to be an anagram, we can
read the name as "Eros, c'est la vie" (Love, that is the life). "I
believe in eroticism a lot," he once said, "because it's truly a
rather widespread thing throughout the world, a thing that
everyone understands." (Duchamp added a second initial R,
making the name "Rrose," when making another, more compli-
cated pun in French over which we need not linger.)

Duchamp became an arbiter of taste among the modernists,
while continuing to profess indifference toward art. It was he
who named Calder's delicately balanced constructions
"mobiles." They "carry within them their own pleasures,"
Duchamp said, "which are quite different from the pleasures of
scratching oneself." He appeared to take at least two things
seriously (in addition to art, which he pretended to take lightly):
chess, which he played often and well, and the "law of chance."
In the second he was close to Arp—and, as we shall see, the
surrealists—believing that chance is an expression of the
subconscious.

Dadaism in general made little direct contribution to mod-
ernist sculpture, except through Arp. It was a major force,
within the small specialized world of art in the 1910s and 1920s,

however, for shaking people out of solemn attitudes toward tradition and encouraging experiment in all arts. And it served as a precursor to surrealism and the attendant fascination of sculptors with depth psychology.

SUPER-REALITY

With more deliberate effort to find and state the workings of the unconscious, André Breton, founder and authoritarian leader of the surrealist movement, set out to form an alliance with Freudian psychoanalysis. A medical worker during the First World War, he admired some of the dadaists but grew impatient with their nihilism. Breton not only wanted to tear down the old order; he wanted to build a new one. And the new would be based on the insights of depth psychology, on greater understanding of the workings of the unconscious. The hidden forces in the psyche, the irrational side of man's nature, must be reconciled with the rational. Dreams and automatic writing, both manifestations of the unconscious, were to be the keys to understanding the new reality—the super-reality—that had earlier eluded man's investigations of himself and his world.

After some disputes in the early 1920s about the meaning of the new term surrealism, Breton announced, in his *Surrealist Manifesto* (1924), with characteristic intolerance for dissent, that "I shall now define it once and for all."

SURREALISM, noun, masculine. Pure psychic automatism by which one intends to express verbally, in writing or by other method, the real functioning of the mind. Dictation by thought, in the absence of any control exercised by reason, and beyond any aesthetic or moral preoccupation.
ENCYCL. *Philo.* Surrealism is based on the belief in the superior reality of certain forms of association heretofore neglected, in the omnipotence of dreams, in the undirected play of thought.

"I believe," Breton proclaimed, "in the future resolution of the states of dream and reality—in appearance so contradictory —in a sort of absolute reality, or *surreality*, if I may so call it."

The development of a literary movement more or less consistent with this creed, the baptism and confirmation of converts, and the excommunication of those who strayed from dogmas announced by the pope, need not concern us. Breton himself was primarily a poet and writer, but sought also to convert and guide workers in the visual arts. Some sculptors, like Giacometti and Arp, were formal adherents at one time or another. Others were strongly influenced: Brancusi, Calder, Lipchitz, Moore, and Picasso, for example. Scarcely anyone, except those like Gabo, who worked with nonrepresentative geometric forms, fully escaped. (There is "no need," Gabo wrote in 1957, "to undertake remote and distant navigations in the subconscious in order to reveal a world which lies in our immediate vicinity.")

In his surrealist days Arp had been preoccupied with the hidden inner meanings of his creations, with "ferreting out the dream, the idea," as he put it, behind a plastic work and giving it a name. "Often the interpretation was more important for me than the work itself." That was good surrealist doctrine. Calder, too, has seemed to give free rein to his unconscious imaginings and, as we have noted, named his pieces only after they existed. Many modernists have found "psychic automatism" at work in their own creativeness. Calder's brand seems closer to that of Joan Miró, whom he knew, giving expression to the lighter and more joyful aspects of the unconscious rather than to the darker mysteries of the Freudians. Calder was one of the artists personally close to Breton late in the surrealist leader's life. Breton found in Calder's mobiles reminiscences of "the evolution of celestial bodies and the tremors of leaves as well as the memory of kisses."

Freud, for his part, never seemed to understand what Breton and his disciples were up to. According to one account, the only meeting between the two was disappointing for both: the

father of psychoanalysis did not know what to make of the father
of surrealism, who, although medically trained, did not seem
really to understand the psychologists whose works he tried to
discuss. According to the Rumanian photographer Brassaï, close
friend of Picasso, Freud wrote a letter to a friend regarding a
visit from Salvador Dali: "Until this time I was inclined to con-
sider the surrealists—who seem to have adopted me as their
patron saint—as one hundred percent madmen (or let us say, as
we would for alcohol, ninety-five percent)."

Breton finally gave up hope of winning Picasso as a true
convert to surrealism. The Spaniard was too much of an indi-
vidualist to commit himself to the dogmas of any organized
movement, be it surrealism or communism. He had, Breton
concluded, too much of an "unswerving attachment to the ex-
terior world . . . and the blindness that this disposition entails on
the organic and imaginative plane" to be a true surrealist. Years
earlier Picasso had made his own position clear. "I attempt to
observe nature, always," he wrote. "I am intent on resemblance,
a resemblance more profound, more real than the real, attaining
the surreal"—which is how he thought of surrealism—"but the
word was used [by Breton and his disciples] in an entirely differ-
ent fashion."

DESIRE AND ISOLATION

Alberto Giacometti (1901–1966) is often identified as a sur-
realist. He was a formal adherent of the movement for several
years, until Breton banished him in 1935 for beginning to work
from living models—much too close to a limited, unimagined
"reality" instead of surreality. Born in the Italian-speaking part
of Switzerland, Giacometti was the son of a painter, and he first
studied and practiced as a painter himself. His father sent him,
at age nineteen, to study in Paris. He told Matisse, much later,
that he would have preferred to go to Vienna, where living was
cheaper: "at this period my desire for pleasure was stonger than

my interest in the academy." In his middle twenties he began to try his hand at sculpture, working from memory and imagination. From the outset his use of dream material and reliance on the subconscious, together with a strong interest in erotic symbolism, gave him much in common with the surrealists. (Breton, himself a man of many love affairs, preached sexual liberation, although he was in many ways rather prudish and never used "rough" language.)

Giacometti found the open constructions of Lipchitz, Gonzalez, and Picasso of the late 1920s a compatible form for his ideas. He made a number of "cages"—frames within which objects fraught with personal meaning were hung. Of these the most famous is *Palace at 4* A.M. (1932) [67], now in New York's Museum of Modern Art. Giacometti never fully explained—but he did give hints from time to time—what he meant by this curious framework of sticks, within which hang or stand several isolated objects—the skeleton of a bird, a hanging spinal column, a small statue of a woman in a long dress, and a red ball attached to a narrow concave board, like a pea pod, that stands vertically against the "wall" of one "room" of the "palace."

This composition, he once told an interviewer, had taken shape in his mind bit by bit, some time following the end of a half-year period when "hour after hour was passed in the company of a woman who, concentrating all life in herself, magically transformed my every moment." He spoke (perhaps factually, perhaps poetically, perhaps with tongue in cheek, perhaps simply because it was the way surrealists talked) of building with her day after day (or night after night—they seemed the same) "a very fragile palace of matchsticks" that might collapse at a false touch and have to be rebuilt. As for the bizarre furnishings of the palace, he spoke of "the spinal column this woman sold me one of the very first nights I met her on the street"; of skeleton birds she saw just before their life together collapsed; of the statue as

an image of his mother, early remembered in a long black dress that seemed part of her body; of the red object in front on the board as something he identified with himself.

Perhaps "Suspended Ball" (1930–31) helps to explain the red object. Over a crescent-shaped form, like a fat banana with its concave side sharpened to a distinct edge, a red ball is suspended by a string. A thin wedge is cut out of the lower part of the ball, and the resulting cleft fits loosely over the ridge of the inside curve of the crescent. The ball is so hung that for a few inches it will slide along the ridge. Then, in one direction, it will swing free, and, in the other, stick against the crescent. Some who have seen it report a strong but unpleasant erotic sensation. In such constructions—"Palace" and "Ball"—Herbert Read has suggested that we find the purpose and effect of surrealist sculpture—what Giacometti called "the construction in space of 'precise mechanisms' that are of no use but are nevertheless profoundly 'disturbing.'" Again, that is the way surrealists talked.

As with all such works by artists trying to communicate through intensely personal symbols, the viewer must determine whether he is sufficiently interested in the artist's private experience and individual visual signs to try to decipher the puzzles. Giacometti's *Woman with Her Throat Cut* (1932) [81] is only somewhat less obscure, but any viewer is certain to have fairly strong reactions. From friends and critics we hear that Giacometti was preoccupied with death—his own and others'. Some subjects of his painted portraits have reported that death was a favorite topic in the conversations during sittings: Giacometti said he thought of suicide every day, not because he was weary of life but because death must be a fascinating experience; he would weigh the merits of various ways of dying—hanging, slitting one's throat with a kitchen knife ("the most definitive, courageous way"), drowning oneself in the Seine, burning oneself alive (*"the thing, the* suicide that really fascinates me"). It has been said that

he had a streak of cruelty, was fascinated by the thought of sexual murder, and often imagined how he might kill chance acquaintances or sitters for portraits.

Perhaps such reports—from Giacometti and others, whether or not part of a self-conscious and half-playful building of a legend—help to explain *Woman with Her Throat Cut*. A thin rodlike female body, with a long neckbone and back tensely arched, appears to lie in a pool of blood. Or is it also an insect? Or a crustacean? I have no idea whether Giacometti knew anything of the life cycle of the North American lobster. About once a year after the mature female molts her shell, and only then, for a brief time, can she receive the mating attentions of a male. Obviously, in her shell-less condition, she is extremely vulnerable to predators.

Giacometti is better known (and he preferred, it seems, to be remembered) for the works he began creating in the 1940s, after he had parted with the surrealists—tall, attenuated, ethereal figures of men and women, with rough surfaces in which features are barely suggested, characteristically heavy and pedestal-like in the feet, tapering toward the head. "Tall" is a relative term here, for the first of these familiar figures were tiny. The whole of Giacometti's production that survives from the years 1942–45, it has been said, could be fitted into six matchboxes. Then he began to make the thin figures truly tall. *Man Pointing* (1947) [83] stands nearly six feet high. Giacometti told a friend that he made it in plaster (then almost his sole medium) between midnight and nine one morning. As so often happened, he had made a similar man earlier but, dissatisfied with it, he had destroyed it. He had quickly redone it that night so that the foundry could pick it up the next day.

City Square [84] gives even more strongly the sense of isolation, alienation, and impersonality that mark his extensive family of thin folk. Three walking male figures proceed more or less toward each other, but without apparent awareness of each other. A woman stands at one side. Giacometti insisted that in

these attenuated, roughly modeled human shapes he was really trying to capture visual appearances of figures seen at a precise distance. No longer a surrealist, he was intensely preoccupied with recording his experience of visual perception. He could not "see" someone sitting next to him in a restaurant, getting only a confused impression of disconnected details. But each member of a family sitting across the room was, in his words, "clearly visible, though diminutive, thin, and surrounded by enormous slices of space."

In a pose characteristic of a large number of Giacometti's female figures, the woman in *City Square* stands with her feet together and arms straight down at the sides, as does the larger lady known as *Venice IX* [85]. The artist told David Sylvester, the British critic who wrote the text of the catalogue for Giacometti's last show in London's Tate Gallery (1965), that some group compositions of women in this attitude were based on girls he had seen on view in Parisian brothels. He put one group of four on a high solid base, which in turn rested on a very tall bronze stool, so that the figurines look tiny atop a massive construction many times higher than they. It was an attempt, apparently, to capture his feeling of remoteness from several naked women he had seen at the Sphinx, a famous Parisian establishment, while he was seated at one end of the room. "The distance that separated us . . . which seemed insurmountable in spite of my desire to cross it, impressed me as much as the women."

Giacometti worked from models at various times, one of his favorites being his brother Diego. In working from life, he did not seek to make likenesses, and it is not Diego we see in *Monumental Head* [82], which suggests one of the mysterious Easter Island sculptures. One casting of this is in the Hirshhorn Sculpture Garden in Washington. Before 1974, when that collection was moved to Washington, the head stared out over the swimming pool on the Hirshhorn estate in Greenwich.

Of his earlier openwork constructions Giacometti said: "Figures were never for me a compact mass but like a transpar-

ent construction." When he went on to make figures solid, they were so tentative, so attenuated, that the effect of transparency remains. As viewers we are as much aware of the space about them as of the solid forms. Giacometti must be included among the many modernist sculptors who explored spatial relationships as one of the qualities of sculpture.

Depth psychology had an influence far beyond the small band of surrealists. It has affected all modernist artists, with the possible exception, noted earlier, of those espousing geometric nonrepresentational form as the proper concern of sculptors. David Smith, the youngest of the innovators with whom we have dealt in these pages, was also one of those most conscious of depth psychology. His earlier works, up to about 1950, tended at first (like Giacometti's early sculpture, which Smith much admired) to draw first on private symbols, and then on more generalized ones.

By the middle of the century conscious use of Freudian symbols had become commonplace, and it has persisted. We are told that some of the monumental, less private and less personal, constructions Smith began to make in the 1950s, with sawed-off cylinders projecting from flat plates (as in his "Zig" series), not only might appear to the perceptive observer, but were intended by the artist, to be reminders of the erect male member. By studying Smith's notebooks and drawings Rosalind Krauss shows that he was indeed much preoccupied with the cannon as a symbol of the violence of war and of the violation of women. Some of the drawings, dating as far back as the 1930s, are explicit in showing artillery pieces with unmistakable resemblances to the male genitals astride women. "Possibly steel is so beautiful," Smith once said, "because of all the movement associated with it, its strength and function. Yet it is also brutal; the rapist, the murderer, and death-dealing giants are all its offspring." He was, we are told, a big man with big appetites, willful, sometimes violent, difficult with those he most loved (he was twice divorced), and, according to his friend Hilton Kramer, art

critic for *The New York Times*, profoundly unhappy except in his creative work.

THE GREAT MOTHER

As one of the sculptural geniuses of the twentieth century, Henry Moore has had his full share of attention from the depth psychologists, much of the interpretation being in terms of Jungian archetypes. Earlier we noted Moore's statement about his preoccupation, even "obsession," with two recurring themes: the reclining female figure and mother-and-child. In the eyes of Jung's disciple Erich Neumann both are manifestations of a single primordial archetype—an image emerging from what Jung called the "collective unconscious," developed by mankind through the ages—"the ruling powers, the gods, images of dominant laws and principles, and of typical regularly occurring events in the soul's cycle of experience."

The Great Mother—fertile, loving, comforting, understanding, sustaining—appears in some form in every known human culture, from the earliest, some thirty millennia ago [18, 19], to the present. She has shown herself in some of the works referred to in these pages: Lachaise's *Standing Woman* [20], Lipchitz's *Mother and Child* [86], Maillol's *Pomona with Lowered Arms* [10], perhaps banteringly in Picasso's *Baboon and Young* [88], and repeatedly in Henry Moore's sculptures [e.g., 34, 40, 42]. She is a favorite theme in African art [87].

To Neumann, who analyzed at length the sculptures incorporating favorite Moore themes, the sculptor, wittingly or not, created "an archetypal and essentially sacral art in a secularized age whose canon of highest values contains no deity, and the true purpose of his art is the incarnation of this deity in the world of today." In other words, Moore's sculptures on this theme are a reaffirmation of the need of feminine qualities in a world that has been dominated, and has begun to be sickened, by the machine. Moore as prophet (in Neumann's eyes) has given the

pendulum a nudge to reverse its swing. Neumann thought his thesis was confirmed by the sculptural qualities Moore favors, the formal characteristics of his reclining figures and mother images. The roundness, lack of symmetry, flow of living parts into each other are, according to Moore himself, signs of vital organic elements that he favored over the geometric and angular.

We do not know what Moore himself thinks of Neumann's interpretations. He has, we are told, avoided reading the psychoanalyst's studies of his work, presumably because they might upset and distort whatever unconscious creative forces are at work in him by making him too self-conscious of them. One of Moore's artistic biographers (and also his friend), Sir Herbert Read, remarked that Neumann's thesis of a mother deity for the twentieth-century, responding to a deep current of resistance to the "male" mechanization of society, is "an elaboration that exceeds the aesthetic facts." The sculptor, he added, was "primarily motivated by the fascination of the form" of the Mayan Rain Spirit and other antecedents of the female reclining figures. To identify those figures with the Great Mother might have some relevance to the unconscious creative process "but none to the immediate intention of the artist." But that is just the point. The depth psychologist takes upon himself the task of telling us things we do not know about ourselves. And in the continuing modernist debate about the supremacy of form over content, or vice versa, Read was a dedicated "form man."

There is much additional psychoanalytic interpretation of Moore's work, from Neumann and others. To one observer, a subconscious theme in much of his work (most notably in the Northampton *Madonna and Child* [42]) is death, resurrection, and immortality expressed in the sculptural qualities that Moore admires—stability, permanence, repose. Another interpreter finds recurring suggestions of the genitals, in solid shapes and curved voids, often misplaced and magnified (as when the Lincoln Center *Reclining Figure* is seen from certain angles [41]).

We have already noted that Neumann found in *Upright Internal and External Forms* [34] a reminder of an Egyptian sarcophagus shaped like a mummy, showing the mother goddess as the womb that contains the dead man as it once did the child: "outside and inside, mother and child, body and soul, world and man—all have been made 'real' in a shape at once tangible and highly symbolic."

From the beginning, as he himself has said, Moore has been far more interested in drawing and sculpting the female form than the male. Speaking of two massive ladies he made in bronze in 1957 and 1958, he pointed out that "both have the big form I like my women to have." One of them, he added, "emphasizes fertility like the paleolithic Venuses in which roundness and fullness of form is exaggerated." [*See* 18, 19]. Roundness and fullness—these are characteristic of most of his female figures, along with the smallness of head which, he said of his bronze *Seated Woman* (1957–58) [45], is necessary to emphasize the massiveness of the body.

Moore has said he often recalls the boyhood experience of massaging his mother's rheumatic back with a strong liniment. It was a broad back, and the kneading of flesh over muscle and bone on that expanse stayed in his memory. "Tactile experience," he added of this recollection, "is very important as an aesthetic dimension in sculpture."

Two of his rare male figures date from the early 1950s, after his visit to Greece in 1951. The bronze "Warrior with Shield" (1953–54) was the first single male figure he ever made, and he reported that the "bony, edgy, tense forms were a great excitement to make"—forms that turn up in such pieces as *Knife Edge* [43]. His second male figure is the *Falling Warrior* [46], a more ambiguous form, almost female in its roundness. The basic pose recalls that of Giacometti's *Woman with Her Throat Cut* [81].

DOOM OF SODOM AND POMPEII

Marino Marini's sculpture well illustrates several points that
have concerned us in this chapter: Jungian archetypes of the
collective unconscious, finding expression through an artist's
creation; Freudian symbolism; adaptation of both by the artist to
express a theme of the times. Moreover, Marini introduces us to
a question that we will take up in Chapter 7: Is the creative
modernist inevitably drawn toward simplification and
abstraction?

Marini, a Tuscan born in Pistoia in 1901, has spent most of
his life in Milan. He began as a traditionalist sculptor, in the
sense that his work was representational and based on living
nature, especially the human form. Yet from the beginning he
showed an interest in simplification and in smooth major
volumes—virtually unmodeled units such as heads, chests,
legs—rather than in the detail of muscle and flesh and joints that
preoccupied academicians of his early years. The modernist
movements were already far along as he matured. During visits
to Paris in the decade before the Second World War he met
Maillol and Gonzalez, and in Switzerland, where he passed most
of the war years, he came to know Giacometti and other sculp-
tors. Again, we should recall that the world of sculptors in the
first half of the century was a small one. Marini met about the
same group as David Smith met, and at about the same
period—with very different results. What they undoubtedly
share is twentieth-century man's self-consciousness about his
unconscious, collective and personal.

Marini was drawn to the directness and simplicity of the
ancient Etruscans, whose art had been uncovered in the Tuscan
hills near his birthplace. Their work stood in contrast to the
refinement and elegance of their contemporaries, the ancient
Greeks, whose "artiness" D. H. Lawrence deplored after seeing
Etruscan objects. Along with the Etruscans, the Romans and

their down-to-earth sense of reality attracted Marini. Etruria and Rome alike had long been dismissed as inferior branches of the classical Western tradition.

Like most major sculptors, Marini early settled on certain themes or subjects. One of these, elaborated and developed through the years, was Pomona, the Roman goddess of fruit and trees (and one of the many possible forms of the Great Goddess). The other was the horse and rider, for which he is best known. Critics and art historians, with or without prompting from the artist, have found various "sources" for his preoccupation with the theme of horse and rider. To one it is Marini's admiration for the equestrian monument to Marcus Aurelius in Rome, for Donatello's larger-than-life memorial to Gattamelata in Padua (which revived equestrian statues as a major form of sculpture in the Renaissance), and for the paintings of cavalry scenes by Paolo Uccello. To another the theme resulted from the location of an early Marini studio at a riding academy, where he daily saw the mounts and mounted that were joined in this favored motif, and from visits to German cathedrals (especially that in Bamberg) with their notable equestrian figures. To still another it came from the frescos of Etruscan tombs, with horses in painted cavalcades of red and black (colors Marini has sometimes used on horse-and-man figures in terra cotta or wood). The motif may have developed from any or all of these. The sculptor once said that the theme took a strong hold on him when he saw Lombard peasants on frightened horses fleeing from wartime bombings.

Observers of the psychoanalytic (more specifically, Jungian) persuasion find in this recurring theme an expression of an archetype from the collective unconscious—the horse as a symbol of virility, strength, untamed nature, and man trying to control the unruly animal. Through the years the Marini rider fails in his struggle. More accurately, neither man nor beast survives intact.

Beginning with the "Horse and Rider" of 1936, the pair is

stolid, composed, at rest, and not particularly interesting: it could be a standard equestrian statue of the kind the Romans turned out. By 1947 tensions have begun to build up. In the Tate Gallery's *Horseman* of 1947 the animal, with four legs firmly planted, extends its head nervously and threateningly, and the rider seems helpless and forlorn, looking upward for whatever help lies there [89]. In the series that follows, man and beast alike become more anguished and helpless. In the Hirshhorn's 1951 version the horse's head is raised high as if in a scream, its feet are splayed out, and the rider, arms akimbo, has begun to topple backward [90]. In this period the figures become phallic; indeed, each pair becomes an aggregation of erect male genitals: in the mount's head and legs, and in the horseman's head, torso, and outflung arms [90]. As if to emphasize the point, the sculptor gave one version of the rider a prominent phallus.

From this time on the pairs begin to fall apart. The horse's forelegs collapse, its muzzle scrapes the ground, it is reared back in impossible postures. The rider is in the last stages of his fall. Versions of horse and rider acquire new names—"Miracle" or "Warrior," both existing in a series. In the later variations on the theme, the figures become more angular and abstracted, not recognizable for what they are meant to be unless we know what has come before. In the last the disintegration is complete: barely recognizable creatures have become fragments in a "Group of Elements" (1964–65).

Along with the growing desperation in the theme is a steady trend toward simplification of the forms and greater angutarity, so that the last few riders (in a series extending over nearly thirty years) are far removed in spirit and form from the original placid rounded rider casually holding the reins of a docile mount. Marini himself has said that the series expresses "the anguish provoked by the events of my age." The catastrophes that strike the horse and rider "are similar to those that destroyed Sodom and Pompeii. Thus I am trying to symbolize the last phase of the decomposition of a myth"—the humanists' man

of virtue, the good and rational man more or less in control of his destiny. "I believe," Marini has said, "in the most serious way that we are heading toward the end of the world."

There have been, in these pages, many occasions to speculate on the inner psychic processes that lie behind this or that particular organization of form in sculpture. Consciousness of the unconscious has become so widespread in the twentieth century that it is impossible to appreciate modernist sculpture without sharing in the awareness. Even the artist who is determined to impart to his work no meaning beyond the "aesthetic"—to invite response to formal qualities only—cannot escape the question of unconscious aims, arising from urges shared with humankind or shaped by personal experiences of which he may have no conscious memory. The insistent invitation to speculate on these matters sets off modernist sculpture from that of the past—the works of the ancient Greek masters, medieval craftsmen, Michelangelo, even a sculptor so late as Rodin, to mention only those working in the Western tradition. They too (we are assured by depth psychologists) were expressing themes drawn from the collective or individual unconscious, but were not aware of the fact. Their conscious use of conventional allegories and visual symbols that might mean little to the uninitiated is quite another matter.

CHAPTER
6
A Different Past

A<small>T THE</small> turn of the present century Western Christendom seemed beyond challenge as the dominant world civilization, however much it was divided by national rivalries. The last great surge of colonialism began in the 1870s when there were still some lands to be acquired. In 1875 less than one tenth of Africa had been turned into European colonies. By 1895 only one tenth had *not* been taken over. By the beginning of the twentieth century the islands of the South Pacific had been divided among the old colonial powers, joined by Germany and the United States. Further north Japan and Russia joined in the scramble, with Northeast Asia and China the main targets. As a by-product of colonial expansion the museums of Europe's capitals became well stocked with exotic artifacts from such strange places as the tropical belt of Africa and the South Sea islands.

During the nineteenth century, too, were the beginnings of the study of prehistory. First, crude implements of flint and bone were discovered; later, paintings on cave walls and small sculptured figures of remarkable sophistication, dating from roughly 30,000 B.C. In the first two years of the twentieth

century scholars decided that the cave paintings, earlier thought to be hoaxes, were in fact genuinely ancient. In 1908 the so-called *Venus of Willendorf* [18] was discovered in Moravia. Quite possibly the first piece of sculpture, or even first work of art, ever created, the figure is tiny—four and a half inches long.

The fetishes, idols, and masks from the contemporary tropics and figurines from the Old Stone Age were of interest mainly to specialists in the budding sciences of Man—ethnologists, archaeologists, anthropologists, and paleontologists. Others looked upon the articles from the Ivory Coast and Polynesia, for example, jumbled together in museums of ethnology, as crude artifacts of barbaric societies—interesting curiosities, but hardly Art. Early in the twentieth century, however, avant-garde artists began looking at them with renewed interest. The painter Maurice Vlaminck, one of the first, had often visited the anthropological museum in the Trocadéro in Paris, and regarded the African objects as "barbaric fetishes." Two statues he saw in a bistro produced a profounder impression, and he began collecting African artifacts about 1903. Matisse soon followed, somewhere between 1904 and 1906. At about the same time Picasso became interested, and he too began a collection of African masks (we will return to him later). Epstein, Brancusi, Giacometti, Lipchitz, and Modigliani were among other collectors of Africana.

What was it about primitive art that struck responsive chords in modernist artists and others in the twentieth century? The very term "primitive art" is misleading, lumping together traditions as diverse as those of tropical Africa (in themselves immensely varied), Oceania, the pre-Columbian Americas, ancient Cycladic societies in the eastern Mediterranean, and bands of Ice Age hunters. One common denominator, it is sometimes said, is simplicity, or at least the assumption that in cultures remote in time or place there was a simplicity truer to man's real nature than the complications and corruptions of contemporary civilization. In their reactions against the dehumanized drabness

of the industrial and militarized modern world, some of the avant garde found comfort in the thought of societies supposed to have been moved more by natural instinct than by calculating reason—happy communities of Jean-Jacques Rousseau's "noble savages." And simplicity in art appeared to accompany the lack of social complexity.

"The eye exists in a savage state." With these works André Breton began his first *Surrealist Manifesto* in 1924. *Sauvage*, we should remember, does not necessarily mean barbaric; it can indicate the wild or untamed, primitive, and natural. Modernists must clear their eyes, excise the cataracts suffered by aged and tired civilizations. Primitive man's perceptions were more "real," more directly concerned with what was necessary and useful to a good life. So thought Breton and many others. A decade before surrealism was launched Henri Gaudier-Brzeska, a young avant-garde sculptor killed in the First World War at the age of twenty-four, drew a distinction between the works of people to whom reason is secondary—the primitive races—and the "pretty works of the great Hellenes," the productions of a "civilized" people in whom instinct and feeling were smothered by reason. The modern sculptor should be a man whose inspiring force is instinct. "That this sculpture has no relation to classic Greek," he wrote, "but that it is continuing the tradition of the barbaric peoples of the earth (for whom we have sympathy and admiration) I hope to have made clear."

Others were drawn to the primitives in their search for basics, for essential reality uncluttered by the superficial and accidental distinguishing marks of different cultures or of individual people within the same culture. If the surface appearances are stripped away, the essential core is uncovered. Brancusi was a notable exemplar of the strippers-away. And as you get closer to essences (so runs this train of thought) you begin to comprehend the universality of humankind and to understand the enduring archetypes—the dominant powers and principles that manifest themselves in visible images at all times and places

and hence become sculptors' particular concerns. The Great Mother or Female Principle (we can choose among various names) appeared in the first sculptures ever made long before recorded history. The *Venus of Willendorf* [18] is one of many exaggeratedly female figures found in the geologic strata of the Old Stone Age (fifty-five, according to one recent count, as compared with five male), from the Pyrenees to Siberia.

Many millennia later, in the general range of 3000–1500 B.C., other embodiments were produced, small in total size but enormous in significant places, with huge breasts, or exaggeratedly wide pelvises, or fat thighs and buttocks. Or, as in some Cycladic figures, the genital triangle may be clearly marked. Such exceedingly female figures, dating from that general period, have been found from Egypt and the Aegean through the Middle East as far as India. Psychoanalytical critics have detected twentieth-century counterparts of those early figurines in Henry Moore's reclining women-mountains and mother-and-child carvings [e.g., 39, 40], and in Jacques Lipchitz's *Mother and Child* [86]. When he was creating his own earth-mothers, Gaston Lachaise well knew some of the bulbous ladies of the Old Stone Age [18, 19]. Was Picasso (as was earlier suggested), in a characteristically puckish and irreverent mood, varying the ages-old theme in his *Baboon and Young* [88]?

ANYTHING BUT GREEKS

Gaudier-Brzeska's slap at the classical Greeks was not a lonely act. For many an innovator it is not enough to be confident of his own purposes: he must disparage the other fellow's. Embracing a different past, he must put a certain distance between himself and the familiar past, the one whose traditions have shaped prevailing tastes. To clear the ground for his new creations, he feels obliged to raze the old and accepted structures. His rhetoric varies from a raucous derision to a more thoughtful development of a reasonable thesis: in form and theme tradi-

tional sculpture might be superb for the times when it was made, and still immensely enjoyable in those terms, but it is not expressive of our own times. What is the point, he asks, of repeating the same old formulas, out of habit or out of resistance to inevitable change?

As we noted earlier, a virtue of dadaism, Arp said, was to have given the Venus de Milo an enema and enabled Laocoön and sons to relieve themselves after millennia of struggles with the snake. "I would rather make them and be wrong," said Brancusi of his simple ovoid heads, "than to make the Venus de Milo and be right, for she has been done. And she is unendurably old." "A roaring automobile . . . is more beautiful than the Victory of Samothrace," wrote the Italian futurist poet Marinetti. For a long and impassioned attack on the Greeks the reader can turn to the English critic R. H. Wilenski's *The Meaning of Modern Sculpture* (1935). The futurist sculptor Boccioni wrote that sculptors must convince themselves of this "absolute truth: to continue to construct and want to create with Egyptian, Greek, or Michelangelesque elements is like wanting to draw water from a dry well with a bottomless bucket."

The modernist objection to the Greeks and their followers was especially aimed at their preoccupation with the human figure, carved or molded naturalistically, and representing noble beings—gods, saints, heroes—or symbolizing ideas and doctrines deemed to be sublime. For most men and women in the West, statues of this kind *were* sculpture. For the avant garde, naturalism, representation, and propaganda for the establishment were what the new art must escape. Modernists found encouragement in the varied traditions of a past different from their own which could be invoked to demonstrate that the conventional Western idea of sculpture was far from being the only one. Indeed, it was hardly representative of man's many cultures. True, the human figure had a way of looming importantly in human artistic concern in all times and places, but almost no one else in the history of the world had attached such impor-

tance to representing it naturalistically as had the classical Greeks and their followers.

In an article on primitive art written in 1941 Henry Moore commented that "a hundred years of Greece [the classical fifth century B.C.] no longer blot out eyes to the sculptural achievements of the rest of mankind." He listed other civilizations that have created different and impressive traditions, including the Old and New Stone Ages, pre-Columbian societies in the Americas, early (pre-classical) Greece, and Africa. As he saw the splendors of their art, "a new ideal of 'vitality and power' replaced 'beauty' " as the proper criterion for sculptural excellence. It came to him that "the realistic [naturalistic] ideal of physical beauty in art which sprang from fifth-century Greece was only a digression from the main world tradition of sculpture."

We, as viewers, can perhaps learn something from Moore's own development as an eminent innovator, determined, like other modernists of his own and an earlier generation, to break out of the past, yet not derisive of that past and influenced by it strongly at various points in his long career. As we have already noted, the Mayan Rain Spirit, *Chac Mool* [35], was the acknowledged inspiration for some of Moore's early reclining figures. He saw it first in a photograph in a German publication, and late in 1929, after he had made the famous *Reclining Figure* [36], he saw a plaster cast of the Mexican carving in Paris.

Like other avant-garde sculptors trying to escape from the past, he tended to pay little attention to the Elgin Marbles and the British Museum's other treasures of classical Greece. As a student he saw them, of course, but he turned more eagerly toward the sculpture of earlier Greece and of other civilizations relegated to the ethnological sections of the museum. But we can hardly doubt that the classical Greeks left deep traces on his mind. They and the Renaissance masters could not be ignored, even if one resisted the tendency of the times to imitate them. In later years Moore told an interviewer that he had never been

more miserable than he was for about half a year after his return from a six-month visit to Italy on a scholarship in 1925. His exposure to the masterpieces of European art had stirred up a "violent conflict" with his previous ideals of sculpture freed from tradition. "I couldn't seem to shake off the new impressions, or make use of them without denying all I had devoutly believed in before." After a time of doubt and inability to work, he gradually began to find his way out of his "quandary," veering back toward his earlier interests in a more universal sculpture.

In Moore's wartime series of "Shelter Drawings" (of people taking refuge from bombs in London's Underground) he turned toward a greater naturalism and became interested in the flow of drapery, as it defines the human figure and follows its own laws. After that he felt more free "to mix the Mediterranean approach" with his "interest in the more elementary concept of archaic and primitive peoples." He felt that the conflict still existed in him right after the war, and he asked himself if this conflict was what "makes things happen" or "will a synthesis eventually derive?" The answer seems to be that both alternatives were realized. After Moore's first visit to Greece, in 1951, a "synthesis" could be found in a renewed interest in the uses of drapery, a much more extensive use of bronze, and the naturalism of some figures. But he was far from settling into a "synthetic" style; some of his boldest and most original innovations lay ahead, and in these classical and Renaissance influences had no evident part.

Some critics have suggested that the synthesis was accomplished long before Moore himself consciously realized it, that even when he was most strongly drawn to the different tradition and sculptural qualities of early Mexican and other "primitive" stonecarving, he also had the Greeks in the back of his mind. We have already noted that the male rain god from Mexico that inspired his *Reclining Figure* of 1929 [35, 36] became in Moore's carving a female, that the rigid and symmetrical body had become more natural and rounded. There is a suggestion of the

river gods from the pediment of the Parthenon, Ilissos and Dionysos, both of which Moore has written that he likes and admires enormously. "I think you will be quite right," he wrote to a correspondent in 1973, "in finding in my work influences" of the two Parthenon figures.

SOME MATTERS OF FORM

A reaching-out to other times and places for something close to geographical and cultural universality, a search for essences, a belief in simplicity of form and of instinctual human nature—all these, rather than a desire to imitate, drew modernist sculptors and other artists to primitive art. But sculptors create three-dimensional form, and primitive art also had an impact on the formal aspects of the innovative works of avant-garde artists.

Henry Moore, dedicated to "truth to materials" in his early days, found this virtue strikingly evident in primitive sculpture. Africans, he pointed out, understood the open forms made possible by the fibrous consistency of wood. He exploited these possibilities himself, without at all imitating African models. In pre-Columbian Mexico he found truth in the stoniness of the material its carvers worked. Masks of certain African tribes, like those of the Dan or Baule people from the Ivory Coast [91], had concavities where in naturalistic faces we see convex cheeks. But African carvers did not use this device in depicting other parts of the body. The substitution of negative for positive, as we have seen, became a favorite formal device for modernists like Archipenko [37] and Moore [39].

A long cylindrical torso is characteristic of much African work [94]. Matisse, one of the first admirers of African art, used such a cylinder in his *Serpentine* [95], but curved it in an un-African way. His later verisons of *Jeannette* resemble some masks from Cameroon. A statue of the war god Ogoun from Dahomey played a role in the development of welded-iron sculptures by Gonzalez (*see* pp. 57–58). The angularities and extreme simplifi-

cation of some of the Cycladic goddesses of the third millennium B.C. [96], remarkably like a Chontal female figure from Mexico of about the third century B.C. [97], strongly appealed to the modernist eye. Giacometti's *Femme Qui Marche* [98] bears a family resemblance to some of the Cycladic goddesses. A Cycladic seated idol, playing a lyre that seems almost to be part of its body, recalls the joining of a human body and stringed musical instrument that appear in works by Lipchitz, Moore, and Picasso.

Lipchitz's *Figure* [65], a bronze sculpture developed in the years 1926–30, shows strong African influences, in the protruding eyes of a simplified concave "face," in the modified cylinder of the body, its legs short beneath a long torso, and in the symmetrical frontality. Lipchitz said, however, that its origins were to be found mainly in rock formations he had seen on the coast of Brittany in the summer of 1926. In particular, he saw a massive stone balanced precariously on another; the lower rock had been carved into an archlike form by the erosion of the sea. He made several small sketches of such a formation, much simplified and made symmetrical. And he added, on the top stone, a relief of a reclining human figure, because there had been people on the beach nearby. Then he stretched out the sketch into four sections, beginning to see in it a primitive totem. The relief figure in the "head" was transformed into staring eyes. *Figure* had acquired a personality—a rather forbidding one. He enlarged the little terra-cotta sketch into a large bronze, over seven feet high, as a commission for a Mme. Tachard.

There has been a long controversy as to whether there was a direct African influence in an important early work by Picasso—not a sculpture, but the painting "Les Demoiselles d'Avignon." Of the five nude and pink *filles de joie* in this painting, two have faces with features that could have been borrowed from certain African masks. There are, in one, the sunken concave cheeks we have earlier noted. Both faces are elongated, and have tiny mouths and long noses, with striations or striped shadowings that might also be the scarifications of the skin made

by many tribes. Because "Demoiselles" is regarded as a landmark painting, as a decisive stage in the development of cubism, art historians attach importance to finding out whether Picasso first saw the Dan or Baule masks [91] and Bakota reliquary figures [80] before, during, or after the period when he was painting the famous bordello ladies. Without rehearsing all the evidence that has been brought forward by friends, colleagues, critics, and historians, we might note a couple of pieces in the puzzle contributed by Picasso shortly before his death in 1973.

His friend and biographer Roland Penrose seems to be convinced that Picasso had seen African masks that suggested the painting's two bizarre faces—so startling were they at the time (1907) that Matisse, on first seeing the painting that was to launch cubism, angrily concluded that Picasso was poking fun at the modernist movement. Others, finding different nlues in remarks Picasso made, decided that his interest in African sculpture came after "Demoiselles" was completed. One friend worked with the Spanish artist in his last years on a catalogue of his early works. Picasso, he has written, was always visibly irritated when asked about the relationship between "Demoiselles d'Avignon" and African art. On one occasion Picasso brought out drawings and paintings he had made before he began looking at African art. They showed the same oblique shadings, slice-of-Brie noses, tiny mouths, and concave cheeks that later turned up in two of the Demoiselles.

"Everyone looks for African masks that resemble what I have done," he complained on that occasion. He pointed out some early Iberian statuettes, which (along with Cezanne's paintings) he, for one, regarded as the chief source of ideas for his "Demoiselles." You see, he said, where the idea of the women's faces had come from, "and what it became. [Historians have always accepted that three of the faces were inspired by early Iberian sculpture; the controversy has centered round the other two.] Well, it was the same with the Negro masks. I did something else with them."

And what did he do with them? In sculpture, at least, it seems he was fascinated by the same phenomenon that Archipenko and Lipchitz, and later Moore and many others, had used to good effect: the interchangeability of solids and voids, positives and negatives, projections and depressions. Among the masks in Picasso's collection, according to Penrose, was one from the Ivory Coast with protruding cylinders for eyes. In 1946, looking at photographs of graffiti, Picasso saw some in which two or three hollows in a wall were used as features for human faces. He called a friend Brassaï's attention to the eyes—they were holes cut into a wall, "but some of them seem to be protuberant, as if they were done in relief. What causes that? It's not an optical effect. We can see very clearly that they are holes. Our knowledge affects our vision." In the *Guitar* [51], a construction made in 1911 or 1912, the cavity in the instrument becomes a projecting cylinder. Many other sculptures and paintings contain similar reversals or transformations. The wires of the *Chicago Picasso* [78] suggest striations, as in an African mask, and expose empty space where we expect the solid mass of a face.

A LIFE SHORT BUT INTENSE

Out of the first generation of "true" modernists—those who had broken more or less completely with the old tradition and whose innovative work began to burgeon in the first two decades of this century—two men, Brancusi and Modigliani, are commonly considered to have been most directly indebted to the sculpture of a different past, and especially to African art.

Amedeo Modigliani (1884–1920) was born in Livorno (Leghorn), the son of an unsuccessful Sephardic Jewish merchant and his educated, rather literary wife, who gave Amedeo a conventional middle-class upbringing against which he later rebelled. According to one of his biographers, Alfred Werner, young Modigliani early committed to memory large parts of Dante and Petrarch. At the age of fourteen, after a bout of

typhoid in which he raved about Italian masterpieces of painting he had never seen, his mother took him to see some of those treasures. Thereafter, she recorded, "Dédo has completely given up his studies and does nothing but paint . . . all day and every day with an unflagging ardor that amazes and enchants me."

In 1905 or 1906 Modigliani went to Paris, where he lived in Montmartre, near several avant-garde artists. At first he lived simply, diligently went to art classes, and drank only a little wine. Within a few months he was addicted to hashish and absinthe, sexually promiscuous (notably handsome, he was constantly besieged by women), and a modernist painter.

He was drawn to sculpture after meeting Brancusi, who helped him start carving, and after an exposure to African art. In 1909 he gave up painting, and for some five years turned more or less exclusively to sculpture. He shared, as we have earlier noted, a belief then common among the avant garde, that "sculpture was sick, that it had become very sick with Rodin and his influence." Like Brancusi, Modigliani insisted on carving directly in stone, not working first in clay or plaster, for, in his view, only this way could sculpture be saved. With Rodin and academic sculptors, he thought, there was "too much modeling in clay, too much 'mud.'"

His surviving production is small (only some twenty-five pieces have been identified as his), for he made a practice of throwing away or destroying anything that he considered below his standards. By 1915 he had abandoned sculpture, although he preferred it to painting. Throughout his life he had little success with critics or buyers, his only one-man show was a failure, and he could not afford the materials needed by a sculptor. Moreover, a friendly dealer was willing to grubstake him modestly in painting. Modigliani told Lipchitz that he wanted a life that was "short but intense." His wish was granted: he died at the age of thirty-five, a bit more than a year after the birth of a daughter to one of the two women with whom, among

the many casual couplings, he had had a serious and relatively long relationship.

Jacob Epstein, himself a collector of African art, saw Modigliani's studio in 1912, about six years after the Italian had come to Paris. It was a "miserable hole" filled with sculptures, including nine or ten long heads carved in stone that had been suggested by African masks. "At night," Epstein wrote, "he would place candles at the top of each one and the effect was that of a primitive temple. A legend of the quarter said that Modigliani, when under the influence of hashish, embraced these sculptures."

Two stone heads by Modigliani [92, 93] show a strong resemblance to certain African masks [91] in the long nose, the short tube of pursed lips, the elongated faces, and, in one, the concavity of the cheeks. Others have seen in them influences from the simple sculpture of archaic Greece. African art is immensely varied, despite certain characteristics that seem to be almost universal, and I make no attempt here to describe it generally or to attribute a particular feature appearing in a modernist sculpture to a particular African antecedent. Indeed, it is risky to suggest that any modernist sculptor in Europe copied or imitated an African model. For those wanting to attempt a more rigorous identification, or to obtain a knowledge of what the avant garde was collecting from the Dark Continent, a catalogue was issued in 1967 by the Musée de l'Homme in Paris, noting the works that European artists collected: *Arts Primitifs dans les Ateliers d'Artistes*.

Brancusi was certainly aware of African art by 1909, when he became Modigliani's friend. Art historians sometimes speak of him as one of the modernists directly and strongly influenced by African works. Others disagree. In Brancusi's carvings in wood, the material almost always used in tropical Africa, influence of one kind seems apparent. A characteristic of much African sculpture is the division of full-length figures into well-defined volumes (units)—heads, necks, torsoes (with arms

appended), and nether limbs—all separated from each other by distinct horizontal breaks or bands, in symmetrical frontal poses [87, 94]. African idols and ancestor figures seldom depart much from strict frontality; human bodies look straight forward, with both sides, from an imaginary central axis, almost identical (except, perhaps, for asymmetrical positions of the arms and objects they are holding). Twisting of the body on that axis is rare.

Something close to horizontal divisions and frontality of the same sort are found in Brancusi's wood carvings, such as *Socrates* [28] and *Adam and Eve* [27]. In the latter, the rugged lower part of the work is the male figure; the upper section, of rounded shapes, is the female (although, with the ambiguity in Brancusi's work that we have already noted, the female parts also suggest the male).

THE CANDY STORE AND THE LUMBER YARD

At first glance—or, for that matter, at fourth—Louise Nevelson's assemblages of wood seem a far cry from primitive art. But the Russian-American sculptor, born in Kiev in 1899, has said that when she saw an exhibition of American Indian masks and figures in Paris in 1931: "I took only one look and saw their power." Similarly, she "immediately identified the power" of African art. Back in New York she recognized similar qualities in the black supporting columns in subways: "it was as if they were feeding me energy like the primitive sculpture did." Another sharp impression in New York came from what one interpreter called the "surreal tableaux of isolation" found in window displays. Still later, on archaeological trips to Central and South American in 1948 and 1949, Nevelson was much impressed by the sculptural reliefs of pre-Columbian ruins, framed by the encroaching jungles. "This was a world of forms that at once I felt I could identify with," she said, ". . . a world of geometry and magic."

Nevelson's father brought the family to America when she

was four. A sight in Liverpool, en route, stuck in her memory: rows of shelves in a sweets shop filled with glass candy jars. When the family moved to Maine in 1905, her father ran a lumber yard. By the age of six Nevelson was carving and assembling scraps of wood. She has, it seems, never ceased. From small collages and individual columns (of all her work the most likely to have been influenced by African carvings) she moved to more elaborate reliefs and assemblages of open-sided boxes and crates filled with pieces of machined wood (such as newel posts, chair legs, umbrella handles, T-squares, and spools) along with a miscellany of wooden pieces, sometimes broken and charred, found on the junk heap. About 1942 she began to make "landscapes," of which *American Dawn* [100] is a late and elaborate example. In the process of stacking object-filled boxes for storage she developed, about 1957, the first wall-reliefs for which she has become famous, among which is *Black Wall* [99].

African fetishes, American Indian totems, reliefs on Mayan temples, New York subway girders, advertising displays in Fifth Avenue shop windows, shelves full of candy jars in Liverpool, childhood play in daddy's lumber yard—perhaps these glimpses of Nevelson's life (which we owe mainly to her dealer and artistic biographer, Arnold Glimcher) help us to understand her enigmatic reliefs and landscapes, usually in somber black or joyful white. Other sights of New York have evidently impressed themselves upon her—skyscrapers, advertising signs, a rising sun or full moon over the city. For amateur psychonalysts an additional bit of her biography should be noted: when her father went to Maine ahead of the family, to set up his business as builder and lumber dealer, she says she stopped talking for six months because of the paternal "desertion." She is a strong believer in the special creative powers of women, quite apart from motherhood, which she found constricting. The critic Barbara Rose has reported that women artists associated with the feminist movement regard the dark mysterious interiors of Nevelson's sculptures as early examples of a specifically feminine imagery, with

erotic overtones, appealing to a distinctively feminine sensibility.

Nevelson's links with what we have been calling primitive art remain obscure and indirect, especially since she has never recognizably represented the human or animal figures that have always been the concern of Africans and other "primitives." The "power" she admired could have come from many sources. And so could symmetry and frontality. But the influence of primitive art on other modernists was similarly indirect. Few have wanted to imitate it. Some selected what they liked from the primitive repertory of forms. What they all got was an excitement of discovery of forms very different from those in their own fading tradition, an encouragement to experiment, and a sense that humankind was much broader and richer, across time and space, than the society in which they happened to be born.

CHAPTER

7

The Sculptural Thing

ONE epithet flung at Rodin's *Balzac* [1] was "menhir," as if it was somehow ridiculous to evoke in sculpture the ancient and mysterious monoliths that have been found in many parts of Europe and other continents. Within a few decades similar ambiguous figures, usually less tied to human forms, were part of many modernists' repertories. Henry Moore created several monumental upright figures, of varied composition. The so-called *Glenkiln Cross* [47] is a striking example. Barbara Hepworth—his compatriot, fellow student, and friend—adopted a similar idea as one favored form, again with many variations. She has spoken of being impressed, on early drives in Yorkshire with her father, by the contrast between the countryside and the squalor of industrial towns. She imagined stone images rising out of the ground that would express the dignity of man and his capacity for survival despite the horrors of the machine age. She considered the "fundamental and ideal unity of man with nature . . . to be one of the basic impulses of sculpture."

Hepworth's *Figure for Landscape* (1960) [2] is a work in bronze, a convoluted shell full of space, definitely human in contour, suggesting a mummy case but also a tree trunk blasted by lightning. (When first I saw it not far from a casting of Rodin's famous statue, I also had the irreverent thought that it was the box that *Balzac* came in; by coincidence, they are of exactly the same height.) Most of Hepworth's work is more "abstract." Her *Sea Form (Atlantic)* [106] is an example of a theme often varied —monolithic (although of bronze), vaguely humanoid, deeply indented by circular or oval depressions that are, finally, perforated. She has been drawn to highly simplified and geometric (but not symmetrical) forms. But in her work there is often some reminiscence of human experience—a "meaning."

David Smith's late works, the monumental *Cubis*, made of stainless-steel boxes and cylinders, can have much the same impact as the other "menhirs." We can feel free to read them as giant personages of the industrial age if we are so inclined. They too may have "content," however abstract they seem.

"Abstract": I have used the word sparingly in these pages. It appears, in specialized writing on art, in many senses and can be misleading outside a specific context. Often "abstraction" is used as the opposite of "representation." A naturalistic, representational late-Greek statue, in which the sculptor has tried faithfully to reproduce the appearance of a human being, is taken to be at the opposite pole from a greatly simplified, abstract body in a Cycladic idol [96] or Mexican carving of the fourth century B.C. [97]. But both unmistakably have a human connection; they are simply at different points in a spectrum of representation.

Some would reserve "abstract" for those figures in which the human connection, or relationship to anything observed in the visible world, is wholly severed—in Gabo's constructions, for example [56], or Hepworth's *Pelagos* [105]. *Woman Combing Her Hair* by Gonzalez [71] is abstract in the first sense only, and so possibly are Smith's *Cubis* [3, 73, 74, 104]. In one meaning all sculpture of human and other observed figures is abstract, be-

cause the sculptor cannot copy precisely from nature; hence he chooses (abstracts, draws out) those features he wants to emphasize and necessarily modifies what he has seen.

Whatever meaning we may give to "abstraction" in relation to sculpture, it is evident that one persistent tendency of modernism is simplification of observed forms, radical distortion, reduction to essentials, often until the connection with surface appearances is barely recognizable. The one thing that was not permitted to the early modernist was to imitate nature closely. Naturalistic, mimetic, realistic, pictorial, representational: these were pejoratives in his lexicon. There is no lack of explanations for this attitude. Seeking new modes of expression, modernists had to reject the old. Natural figures had been represented in sculpture for millennia, and superbly so; there was little, if anything, to add. Naturalism seemed the ally of waning causes. It had too long served gods and kings forgotten or rejected, and decorated a social order many thought sick. Because naturalism dealt with surface appearances, the modernist must search for essences, for general truths that had been confused by incidentals. Naturalism was the particular hallmark of Western Christendom, from Greece through Rome, the Renaissance, and later. No other civilization had pursued it so assiduously. In a shrinking world forms from other cultures must be part of the artist's repertory.

It has been suggested that historically (or, more accurately, prehistorically) there was a progression from naturalistic art in the Old Stone Age to highly stylized and geometric forms in the New Stone Age and Bronze Age. The line of development, according to this theory, was from a high degree of naturalism in the oldest known art (in the times of cave-dwelling bands of hunters and their presumed use of art for magical purposes) to more highly stylized and geometric forms in the times of settled agricultural communities with a more strictly ordered social life and the beginnings of organized religious worship. Another example often cited is the movement from naturalism in pre-

dynastic Egypt (before the middle of the fourth millennium B.C.)
to the formalism of the dynasties, when Egypt was under tight
kingly and priestly rule, persisting with little interruption for
more than three thousand years.

More recently, with more extensive finds of prehistoric art
in various parts of the world, the theory of a natural progression
from naturalism to formalism has been questioned. There are
too many "aberrant" oscillations. The very earliest humans
known to create art did so with astonishing versatility and vari-
ety. And the flowering of naturalism in classical Greece, along
with Western man's first serious intellectual inquiry into himself
and his universe, can scarcely be dismissed as a side current in
the main stream of history. That Western man in the twentieth
century is less self-confident than ancient Greek or Renaissance
humanists, and has turned to art of a different form, is a more
persuasive thesis than that there is an inevitable development
from naturalism to formalism. And in the major surviving civili-
zations that embraced figurative art—the Western world, China,
and India—the line of development has been from archaic for-
malism to a vigorous naturalism to an uninspired repetitiveness.
In short, the historical argument for abstraction is full of holes.
But in the first half of this century, when most of our group of
innovators were at work, the authority of prehistory was fre-
quently invoked as a justification for rejecting naturalism and
turning toward formalism.

A more persuasive theory about the reasons for the turnab-
out concerns the new role of the creative artistic mind, as seen by
artists and their interpreters. Intimate, don't imitate, said
Picasso—the inveterate experimenter who never wholly aban-
doned observed figures. Exactitude is not truth, Matisse com-
mented. To produce, not reproduce, was Arp's stated purpose.
In a variety of ways modernist sculptors (as well as painters)
asserted powers of creation. In the artist's mind a wholly new
image could be summoned up, only vaguely connected with
what registered on the retina of eye or camera. Moreover, things

seen and imagined could be combined into wholly new forms. With freedom to create, a sculptor projected onto the clay or marble or steel what he imagined and thought, only incidentally, if at all, recording what he saw.

Jose Ortega y Gasset, one of the most perceptive early interpreters of the new art, wrote his *Dehumanization of Art* in 1925 and it remains a good guide to the motives and intentions of the innovators. It should be remembered that he wrote when dadaism was giving way to surrealism, after the experiments of Brancusi, Gabo, and "cubists," but before most of the innovators we have met in these pages had entered their major periods of production. Ortega traced the line of development in painting as he saw it: first, *things* were painted, then sensations (as in impressionist painting), and finally ideas. "This means that in the beginning the artist's attention was fixed on external reality; then, on the subjective; finally, on the intrasubjective."

When an artist tries to include, in his projection of a private world, the flow of unconscious ideas, the created image may be all the more complex. There are opportunities for unexpected conjunctions, ironic comparisons, and visual metaphors and puns.

APOTHEOSIS OF FORM

Allied to representation and naturalism, qualities many early modernists rejected, was "content": gods, saints, and heroes portrayed, legends recounted, historical triumphs celebrated, virtues allegorized, and nymphs titillatingly disrobed. Like words connoting imitation of nature, such terms as "content," "meaning" and "literary association" were, for an influential group, deprecatory. Ortega wrote in 1925 that "all great periods of art have been careful not to let the work revolve around human contents. . . . " The "new inspiration, extravagant though it seems, is merely returning, at least in one point, to the royal road to art. For this road is called 'will to style.' But to

stylize means to deform reality, to derealize; style involves dehumanization."

Roger Fry, the English critic whose views had a great influence in the first half of the century, leaned heavily on the rudder to steer the modernist course from content to form. Having tried, like many before and since, to isolate from all others *the* aesthetic quality, the constant and fundamental emotion felt by anyone looking at a work of art, he identified it with form. "I found that this 'constant,' " he wrote to the poet Robert Bridges, "had always to do with the contemplation of form. . . . It also seemed to me that the emotions resulting from the contemplation of form were more universal . . . more profound and more significant spiritually than any of the emotions which had to do with life. . . "—that is, with "content."

We have already seen that content becomes more obscure as form becomes more simplified, stylized, and geometric— "abstract." Even in sculpture full of meaning, such as Moore's or Lipchitz's, the creators were preoccupied with formal qualities: relationship of solids and voids; organization of volumes (constituent units) into compositions with the symmetry, or degree of asymmetry, the sculptor thought expressive; choice of texture; massiveness or lightness; choice of angular or curved shapes.

One major branch of modernist sculpture renounced, as we have seen, all ties with visible figures. In pure-form sculpture is any "meaning" desirable, or possible? Moholy-Nagy, among many of its advocates, thought so. He traced representational art through several stages. First came objects of a *type*, with generalized features, such as the figurines of the Old Stone Age [18, 19] and later [96, 97]. Then individual characteristics were perceived. The Greeks explored the representation of individuals in great detail, and when there was nothing more to find along that road, there was a reaction: a return to stylization. This view of history can be questioned, as we have noted, but the main point is what follows. In the twentieth century, according

to Moholy-Nagy and others, there was a new discovery: the formal qualities of a work had expressiveness and emotional impact in themselves, quite apart from any direct pictorial allusions to human experience.

Once this was accepted, there was no longer a need to "represent" an observed or imagined figure, even in highly simplified form, with which a viewer would invest meanings drawn from experience. At first—in the guitars of cubists like Picasso, for example [51], or in that artist's little sculpture of an absinthe glass—simple homey objects were still depicted. They gave the sculptor a chance to experiment with formal qualities without depicting something highly charged with emotional meaning as an object. The next step was to abandon known objects altogether, even emotionally neutral ones. The formal qualities of a non-object, in this view, could be as expressive as the abandoned "content." Let us consider one example—that of the straight line, in painting or in sculpture.

ACUTE ANGLES AND THE FINGER OF GOD

"The impact of the acute triangle on a circle produces an effect no less powerful than the finger of God touching the finger of Adam in Michelangelo," wrote Wassily Kandinsky, painter and leading theoretician of post-impressionist art. The Italian futurist Boccioni adapted the thought to sculpture when he found "more truth" in planes, angles, and lines "than in all the tangles of muscles, in all the breasts and thighs of the heroes and Venuses. . . . " There is an extensive literature on the expressiveness of lines, a quality of particular importance to sculptors, who usually do not rely on reinforcement of expressiveness through color.

The artists just quoted extolled the virtues of straight lines and angles and, in three-dimensional figures, of polyhedrons. (Others are wedded to arcs and spheres and the whole family of curved shapes.) Diagonals and uprights were used long ago in

compositions representing natural figures to help express feel-
ing. An upright suggests—well, uprightness. And among other
attributes it summons up thoughts and feelings of dominance,
strength, growth, austerity. A diagonal may suggest attack or
defense, threat or compliance, a falling or rising. Traditional
sculptors were well acquainted with these possibilities. In the
frieze of the Mausoleum at Halicarnassus, carved in the fourth
century B.C., a classical Greek sculptor (possibly Scopas) depicted
the legendary battle between Greeks and Amazons. In one panel
[101] the bodies of the attacking (and apparently triumphing)
Greeks are built around strong diagonal axes, and those of the
faltering Amazons around more wavering, broken slanted lines.
In some panels it is the Amazons who enjoy the advantage of
strong, slanted, victoriously attacking lines.

A relief carving from southern India of the seventh century
A.D. shows the Great Goddess, Durga, attacking a buffalo-
headed demon who has won control of the universe [102]. The
erect goddess, astride her lion, is confident in her onslaught,
assisted by a spirit army equally erect—equally "upright." A
strong diagonal runs through the body of the defensive
buffalo-demon, from his toes to the tip of his headdress, as he
draws back warily, war club poised for a mighty counter-blow.
The impending defeat is announced by the slanting bodies of his
demon army.

The big difference is that the modernists have, to varying
degrees, greatly simplified figures known from nature, or
abolished them altogether, while seeking to evoke similar feel-
ings in the viewer through the use of lines (or other formal
qualities). In Archipenko's *Boxing* [103], an attacker seems to
lean over his opponent in a slightly curved diagonal. The defen-
der in this exchange falls back, also diagonally. The carving
might equally well, except for the suggestion of harshness in the
pointed and angular shapes, be a man embracing a woman; the
title helps. In any event, modernists would say that the intended
meaning, the "content" of the piece, is of secondary, if any,

importance, that the viewer is free to read into it any meaning he chooses, but that the arrangement of lines will evoke a feeling of tension and encounter, of conflict or meeting.

The diagonal bodies of Marini's horses and riders (which become progressively angular and simplified) convey increasing tension and disintegration in the long series on this theme, which the sculptor has said symbolizes the impending collapse of civilization [89,90]. David Smith kept only the most tenuous references to human figures in his late *Cubis*. But those constructions of burnished-steel boxes and cylinders do (if they communicate as he apparently intended) waken in the viewer a sense of human attitudes and feelings. *Cubi XXVI*, as I have already noted, is to me an archer, tensed and drawing his bow (or, more likely, in view of Smith's fascination with more modern weaponry, a machine-gunner or rifleman) [104]. It may mean something quite different to another viewer and nothing more to another than an arrangement of diagonals that may or may not evoke the feelings such patterns are supposed to evoke.

The severest test of the expressiveness of form comes in the works of those who have renounced all references to natural or other observed figures, in "non-objective" or "non-figurative" sculpture. Lines and other formal elements, Gabo insisted, "possess their own forces of expression independent of any association with the external aspects of the world" and "their life and their action are self-conditioned psychological phenomena rooted in human nature." Mathematics and engineering technics became, starting with Gabo, modes for creating purely formal sculpture (or, with others, painting). That "pure" forms please many twentieth-century eyes is evident in the extent to which they have been borrowed (or originated) by the decorative arts, in geometric patterns for everything from floor tiles to draperies, from household furnishings to automobile design. There has been a lively traffic in ideas between the industrial designer's drawing board and the sculptor's or painter's sketch-

book and finished creations—a traffic that innovators like Moholy-Nagy participated in and encouraged.

As we have already noted, not all psychologists accept that meaning connected with broader human experience can really be dismissed in a pursuit of "pure" form. Is the sculptor, in effect, allying himself with science and technology, and, to the extent he is concerned with the human predicament, asserting a faith that the best hope lies in them? Is he trying to suggest in visual form newly discovered laws of physics? It is not easy to rid form of content.

IMAGINARY EXHIBIT

Henry Moore used to muse about the possibility of bringing together, in one grand show, sculptural treasures of the British Museum selected not just from the familiar Elgin Marbles and rooms of classical Greek statues, but also from the African, pre-Columbian, Cycladic, Oceanic, and other "primitive" collections. Such an exhibit would demonstrate, he thought, that there is "a fundamental sculptural *thing*," a common language of three-dimensional form that does not depend on associations with any particular culture.

Moore's imagined exhibit would serve as a good introduction to one major trend in modernist sculpture—a sculpture based on observed forms, often biomorphic, drawing on the sculptural ideas of many cultures. Some sculptors have consciously elaborated those ideas, with some distinctively new notions about formal qualities and about the role of the artist's imagination in creating new forms. A strong link with life is maintained. Indeed, it is of central importance (in this line of modernist development) that created works have "content": meaning may be obscure and ambiguous, but it is there.

Of the innovators we have looked at in these pages, several belong to this line of development, although with highly indi-

vidual variations: Arp, Brancusi, Hepworth, Lipchitz, Marini, Moore, and sometimes Picasso. The list does not include those who were making tentative gestures toward modernism, like Degas, Lachaise, Maillol, Matisse, and Rodin.

For another major trend the organizer of the exhibit would find it hard to uncover antecedents from the ethnological departments of museums. We have noted that Gonzalez saw, in Paris, the war god Ogoun from Dahomey, bristling with iron debris from Europe. And some ancient iron sculpture could be found—for example, from Syria, about 1000 B.C. But welded-iron figures as we know them are a distinctive invention of twentieth-century modernists, beginning with Picasso and Gonzalez late in the 1920s, with some suggestions from earlier "transparents" by Lipchitz. They developed in two main directions: the "drawings in space" and other open, airy figures of Picasso, Gonzalez, early Calder, early Smith, and Giacometti; and the more monumental constructions of later Calder and Smith and, sometimes, Picasso. Sculpture of both types kept some ties with observed nature, including, often, the human figure. Like Henry Moore, all of this group were interested in the newly discovered sculptural material—space. Unlike Moore, they often abandoned what had always been regarded as major characteristics of sculpture—its touchability and mass.

For the roots of yet a third major trend in modernism, the organizer of an exhibit of antecedents would have to reach beyond the art and ethnological museums to those of science and technology—to the Science Museum in South Kensington, for example, where Moore saw models illustrating mathematical formulas, or to the Institut Henri Poincaré in Paris, with its similar constructions. But the real originators of three-dimensional geometric arrangements, wholly divorced from forms to be seen in nature did not start their work in London or Paris; they were the Russian brothers Gabo and Pevsner and the Hungarian Moholy-Nagy. Their images were not drawn from nature, but consisted of the cube, pyramid, and other polyhed-

rons, as well as spheres, ovoids, and the orbits of planets and atomic particles. Their creations were, as Gabo once put it, "a synthesis of art, learning, and technical knowledge." Since Gabo experimented with expressing the idea of a universe folded in upon itself [58], emphasizing the pervasiveness of space by using transparent materials, new theories of the physical universe and origins of life have become common knowledge.

"The crumbling of the atom was to my soul like the crumbling of the whole world," the painter Kandinsky wrote in 1913. What would he have said half a century later of the shattering of old certainties? After Darwin, Freud, and Einstein mankind in general and artists in particular could still find some comfort in the mystery of life as an ultimate and appropriately human concern. By the 1960s even the line between organic and inorganic matter was indistinct. Life, it appeared, might be a cosmic accident, resulting from a chance conjunction of certain extraterrestrial rays with a certain mixture of primal soup.

Many younger sculptors have found the proper path for their art in Gabo's efforts to join art and science. The constructivist branch of modernism, abjuring all references to visible natural forms, concentrating on technics, is to some extent in rebellion against Moore (as the early modernists reacted to and rebelled against Rodin). "Old" notions of vital forms must, in their view, yield to ideas based on an ever changing body of science and technology that may soon blur, even more than in the recent past, the line between man and computer, organic and inorganic. The Jungian analyst Erich Neumann, we have seen, reached the precisely opposite conclusion—that Moore, one of the "vitalists," was expressing feminine archetypes deeply yearned for by a world sick of a mechanized life reflected in masculine geometric angularities.

New generations of sculptors, younger than the innovators with whom we have been concerned, have experimented vigorously with newer forms of sculpture. A few have turned to a naturalism far more lifelike than Greek and Renaissance mas-

ters could aspire to—for example, in flesh-tinted fiberglass casts of living men and women. Some have explored the use of light rays in place of solids. Others have followed Marcel Duchamp's lead to make works of "art" out of ordinary objects of daily life. There are experiments in bewildering variety, having little in common but a conviction that anyone who thinks a marble nymph *à la Grecque* is an adequate expression of the twentieth-century spirit has not been reading the news. We cannot now know whether organic, or technological, or some other form of sculpture will turn out to be most expressive of that spirit. Perhaps by the year 2000 the dominant form will be that of a bulbous fertility goddess, carved in the salt mines of Kansas or some other refuge from radiation.

Note on Sculpture in the Customs Shed

BUT IS IT A BIRD?

THE object in the courtroom was tall, slim, gently curved, rising from a narrow base, slightly bulging, then tapering to a point at the top. It was made of gleaming highly burnished bronze. When it had been imported into New York in 1926, the collector of customs classified the object as a manufacture of metal, subject to duty of 40 per cent. Its creator, Constantin Brancusi, protested that the shiny bronze tube was an original work of art, admissible without any duty at all, and took the matter to court.

By that time well-known as a modernist sculptor, Brancusi had made this one in a series of sculptures using the motif of a bird [25, 26]. He had first carved it in marble, then made a plaster cast, given that to a foundry along with a certain formula for bronze alloy, and, when the rough bronze casting had been delivered, had filed and chiseled away the excrescences and polished it with emery. *Bird in Space* was the title bestowed on the

object then under scrutiny in the Customs Court in New York City.

There was considerable questioning of witnesses during the trial about the degree of resemblance, if any, it had to a bird. The photographer Edward Steichen, who had seen the *Bird* at various stages of its creation in Brancusi's studio in Paris and finally bought it for $600, was one of the witnesses for Brancusi. Presiding Judge Byron Waite asked him: "If you saw it on the street you never would think of calling it a bird, would you?" Another judge interceded: "If you saw it in the forest you would not take a shot at it?" Steichen had to admit that in either case he would not. When Jacob Epstein took the witness stand Assistant Attorney General Marcus Higginbotham, appearing for the government, pointed to the bronze object and asked: "Does that represent a bird to you?" Epstein replied that it was a matter of indifference to him what it represented; if an artist he respected wanted to call it a bird, that was good enough for him. There were, he added, elements of a bird; the profile, for example, "is like the breast of a bird." Judge Waite asked him if it did not look like the keel of a boat too, or "a little like the crescent of a new moon." Asked by Higginbotham if it would look like a fish to him, Epstein said he could accept that designation if Brancusi had so dubbed it, but not another suggested by the Assistant Attorney General—a tiger.

The presiding judge shifted to another line of questioning that he thought more rewarding. Apart from the title was there "some underlying aesthetic principle that makes it a work of art?" "I don't think it makes any difference whether it is called a bird or an elephant," he commented at one point; "The question is whether it is artistic in fact, in form, or in shape and lines." Witnesses for Brancusi (two art critics and the Director of the Brooklyn Museum of Art, in addition to Steichen and Epstein) found aesthetic virtues of various kinds in the *Bird*—harmonious proportions, distinctive form, balance, symmetry, and suggestiveness of the ideas of flight, grace, and strength. Two

traditionalist sculptors, testifying for the government, found no aesthetic value in the object. "It is too abstract and a misuse of the form of sculpture," said one, who had carved an allegory of "Agriculture" for the Memorial Bridge in Washington; "I don't think it has the sense of beauty."

Higginbotham pressed the point that, even if the object was found to be beautiful, it might as readily have been made by a mechanic as by a sculptor. He asked Epstein: "If we had a brass rail, highly polished, curved in more or less symmetrical circles, it would be a work of art?" Epstein replied that it might become one. "Whether it is made by a sculptor or by a mechanic?" asked the lawyer. "No," said Epstein, "a mechanic might polish the object, but would not be able to "conceive those particular lines which give it its individual beauty."

The Customs Court was not entirely free to exercise its own judgment and apply its own aesthetic standards in deciding whether or not Brancusi's *Bird in Space* was a work of art. A long history of judicial interpretations narrowed its choices. Since 1846 tariff preference had been given works of art imported to our culture-hungry shores, through levying duties lower than those charged against most other imported goods. The degree of favorable treatment varied with fluctuations in tariff policy, sometimes highly protectionist, sometimes more open-armed. From 1897 to 1913, a high-tariff period, only works of art that could be proved to be at least twenty years old were admitted duty-free (although there were then, as earlier, other exemptions, such as those for temporary exhibitions or for use by certain cultural organizations and municipalities).

In 1913 there were two important events. On February 17 the International Exhibition of Modern Art opened in the 69th Regiment Armory in New York City. Later that year the new President, Woodrow Wilson, who was pledged to reduce tariffs, called Congress into special session to revise the tariff laws. The same venturesome people who had organized the Armory Show persuaded the new Congress to admit, free of duty, all "original"

sculptures (along with paintings), "including not more than two replicas and reproductions," if they had been "made as the professional productions of sculptors." John Quinn—New York lawyer, eager collector of modernist art, and admirer of Brancusi's work—was among the chief movers of the Armory Show and the new tariff provisions. For the first time, it seemed, a modernist work by a live Picasso or Brancusi would enjoy the same advantage long enjoyed by the works of long-dead traditionalist old masters.

As it turned out, the struggle for critical, popular, and official acceptance of the new art was far from over. Teddy Roosevelt had visited the Armory Show on the day of Woodrow Wilson's inauguration. On the whole Roosevelt's attitude toward the new art was not unfriendly. "It is vitally necessary to move forward to shake off the dead hand of reactionaries," he wrote in a current periodical; "and yet we have to face the fact that there is apt to be a lunatic fringe among votaries of any forward movement." There was relatively little sculpture in an exhibition dominated by paintings. One three-dimensional work, an elongated "Kneeling Woman" by Lehmbruck, hardly seems to us today to be a daring departure from the old tradition. But it drew a growl from the ex-President: "though obviously mammalian it is not especially human. . . . One might as well speak of the 'lyric grace' of a praying mantis, which adopts much the same attitude."

The remark was a portent of troubles to come for artists and collectors who departed from tradition far more radically than Lehmbruck. For one thing, there remained in the new tariff law the requirement that to qualify for exemption from duty, an original work must be the "professional production of a sculptor"—a phrase carried over from earlier acts, encrusted with earlier judicial interpretations, and susceptible to some surprising new ones.

The Supreme Court had to consider the meaning of the phrase in a case decided in 1883. A firm of dealers in statuary for

cemeteries—the Viti Brothers—had imported seven marble statues from Carrara, the seat of a thriving business in producing such monuments for tombs. The seven involved in this case were two angels, two boys copied from antique models, and someone's impression of three seasons—Summer, Autumn, and Winter. Other popular items that could be turned out to order in Carrara's workshops included Faith, Hope, Memory, Sorrow, Gratitude, and Sailor Boy.

Customs collectors decided that the seven statues were "manufactures of marble," subject to duty of 50 per cent of assessed value. The Viti Brothers protested, insisting that the carvings were "statuary," dutiable under the law then in effect at only 10 per cent—if they were "professional productions . . . of a sculptor." The trial court found that "all these statues were executed in the studio of a professional sculptor, and under his direction, by two other professional sculptors."

On the government's appeal, Justice Gray, speaking for the Supreme Court, observed that

> The evident intent of Congress . . . is to encourage the importation of works of art, by distinguishing between the productions of an artist, and those of an artisan or mechanic; between what is done by workmen in a sculptor's studio, by his own hand or under his eye; and what is done by workmen in a marble shop.

Justice Gray indicated that he might not have found the cemetery statues from Carrara to be "professional productions of a sculptor" if he had been free to decide the question for himself. But he felt bound to accept the jury's findings of fact (that being its responsibility) in the trial court.

A few years later, in 1889, the Supreme Court was again called on to consider the question. Here the importer was Charles Tiffany's emporium of things conspicuously valuable which had brought from France and England some bronze

statues and statuettes. Were these "manufactures of copper"? If
so, duty would be 45 per cent of their assessed value. Or were
they "statuary" and "professional productions of a sculptor"? If
so, under the law then in effect, the duty would be only 10 per
cent. Were the Tiffany bronzes the works of manufacturers and
mechanics, made by mass-production methods, or the creations
of those nobler and rarer beings—artists—of whom the nation
was less confident it had an ample and illustrious supply.

Tiffany's buyer testified on the method of making such
bronzes. A sculptor makes a clay model and from that a plaster
one that he sells to a founder or reproducer. The buyer may be
the "editor," who undertakes all the subsequent processes of
casting, chasing, and finishing off the bronze statuette. (The
sculptor, of course, may be his own editor, at least in finishing off
the casting that comes from the foundry, and usually is if he is a
serious sculptor making an important work.) Some of the Tif-
fany bronzes had been "edited" by Barbédienne, a leading and
enterprising caster of statues and statuettes in Paris, with whom
Rodin, for example, made a contract for reproducing small
versions of some of his more popular items—"The Kiss" and
"Eternal Springtime." One witness for the government (which
was, of course, trying to prove that these were manufactures)
said that he had been making bronze statuettes in New York City
for eleven years. The company he worked for was turning them
out at the rate of forty thousand a year.

At the trial the jury found that the Tiffany imports were
"professional productions of sculptors," but the Supreme Court
held that the judge had instructed them wrongly on the law, and
sent the case back for another trial. In so deciding, the court
declined to attempt an all-embracing definition of "professional
productions of a sculptor." For this particular case, said Justice
Field,

> it is sufficiently accurate. . . . to say that the definition em-
> braces such works of art as are the result of the artist's own

creation, or are copies of them, made under his direction and supervision, or copies of works of other artists, made under the like direction and supervision, as distinguished from the production of the manufacturer or mechanic.

Tiffany's was the importer in another case that got as high as the Circuit Court of Appeals in 1908. This involved a work by the French painter and sculptor Jean Léon Gérôme, of "La Bellona," or Goddess of War. Her face, arms, and feet were of ivory; the rest of her of metal, mainly cast bronze. The collector of customs decided it was a manufacture of metal and ivory, and assessed duty at 35 per cent of value, that being the rate then in effect on ivory, which was judged to be the component of chief value. Tiffany's protested and claimed that the duty should be only 15 per cent, then the rate for statuary that qualified as a "professional production of a sculptor."

The judge outlined what he perceived to be the underlying policy of the tariff act as it concerned works of art:

That Congress, realizing the importance of works of art to a comparatively new country, has in all later tariff acts discriminated in favor of paintings and statuary cannot be denied. It was the evident intention of the lawmakers to welcome the works of meritorious artists and sculptors on the one side, and on the other to prevent the productions of mere artisans and empirics from taking advantage of the lower duty.

The judge emphasized the importance of the artist's handiwork in finishing off a casting, referring to the "mass of metal which comes from the mold" and is then taken in hand by the sculptor "who does the work which characterizes it and impresses the marble [or bronze] with his idea." As to Gérôme's Goddess of War, the court decided that she was the professional production of a sculptor: after the parts had been cast, "the important work, that which gives it its distinctive personal

character, was done by hand, the sculptor carefully going over the figure and making the alterations and changes necessary to embody his ideas."

"IMITATIONS OF NATURAL OBJECTS"

After these decisions came the Armory Show and the Tariff Act of 1913. It seemed, as we have noted, a bright year for the modernists. But three years after the Armory Show the Court of Customs Appeals gave a jolting pronouncement in the *Olivotti* case.

A church had imported a marble font, with associated objects including marble seats, their arms terminating in lions' heads and their legs in lions' paws. Were these dutiable as marble, at 45 per cent, as the customs collector ruled? Or as works of art but not original professional productions of sculptors, dutiable at 15 per cent, as the Board of General Appraisers (precursors of the Customs Court) held? Or as original sculptures, duty-free, as the importers claimed?

The Court of Customs Appeals allowed that these objects were the work of a sculptor, and were "artistic and beautiful." But no one gazing on them, said the court, can forget that they are seats or chairs—the expression of "a conception brought to material form primarily and principally to serve a useful purpose, and not to please." The distinction between objects intended to give aesthetic pleasure and utilitarian objects that are incidentally pleasing to the eye would have been basis enough for the court's holding that the font and chairs were not only not "original sculptures" but not even "works of art." But the court went far beyond this to attempt a general definition of sculpture:

Sculpture as an art is that branch of the free fine arts which chisels or carves out of stone or other solid material or models in clay or other plastic substance for subsequent reproduction

by carving or casting, imitations of natural objects, chiefly the human form, and represents such objects in their true proportions of length, breadth, and thickness, or of length and breadth only.

Imitations of natural objects, chiefly of the human form! True proportions! What fighting words for the modernists. For a dozen years the court's decision held unchallenged sway, tying "sculpture," for Customs purposes, to imitations of nature. Then, in 1928, came the celebrated case of Brancusi's *Bird in Space*.

We return to the courtroom in Manhattan. Giving the Customs Court's decision at the end of the trial, Judge Waite had no difficulty in finding that Brancusi was a professional sculptor and that this bronze object was an original production by him. But did it conform to the legal definition of sculpture as a work of art, laid down by a higher court (the Court of Customs Appeals)? Could it pass the *Olivotti* test as an imitation of a natural object?

Judge Waite noted that the piece was characterized as a bird, and went on to say:

Without the exercise of rather a vivid imagination it bears no resemblance to a bird except, perchance with such imagination it may be likened to the shape of the body of a bird. It has neither head nor feet nor feathers. . . . it is entirely smooth on its exterior, which is a polished and burnished surface.

Arriving at the moment of truth, the judge noted that "under earlier decisions this importation would have been rejected as a work of art. . . ." He referred to *Olivotti*—the case of the marble font and chairs with lions' extremities—and the Court of Customs Appeals' decision that sculpture must be representational and naturalistic. Since then, he continued,

there has been developing a so-called new school of art, whose exponents attempt to portray abstract ideas rather than to imitate natural objects. Whether or not we are in sympathy with these newer ideas and the schools which represent them, we think the fact of their existence and their influence upon the art world as recognized by the courts must be considered.

In the end the court held that Brancusi's bird was a sculpture within the meaning of the tariff act. Modernists should erect a statue to Judge Waite (of whom they have probably never heard)—suitably non-representational. But his decision could not override that of the higher court in *Olivotti*. In 1934 one of the judges of the Court of Customs and Patents Appeals did suggest that the Waite opinion had become law. The U.S. Tariff Commission, he pointed out, had called the attention of Congress to the *Brancusi* decision and had also quoted the *Olivotti* judgment. Because Congress had made no change, after this notification, to clarify the matter in the Tariff Act of 1930, it could be assumed, according to one canon of statutory interpretation, that the legislature had accepted Judge Waite's opinion. But this was a minority view, one that did not prevail.

Museums, private collectors, and dealers complained that customs officials continued to insist that a carving or casting or other three-dimensional work, if it was to qualify as a "sculpture" under tariff legislation, must bear a recognizable resemblance to a natural object. And what of collages and other assemblies in which bits of paper, burlap, wood, metal, or anything else, may be glued, pinned, nailed, or otherwise attached to a background or to each other—neither paintings nor sculpture, as defined by the tariff laws, but new forms of artistic production that began, with Picasso and Braque, about 1912. In several instances collectors of customs classified these as manufactures, not works of art, assessable at the rate fixed for the component material of chief

value. But then they would turn around and appraise the value according to what the collage might fetch on the market. Thus an assembly of scraps whose material value might be about twelve cents could be charged duty at the rate of 20 per cent (the rate for vegetable fiber, for example) on the appraised value of $12,000 as a work of art—which, in view of customs collectors, it was not.

These and other problems led in 1959 to a major revision of the tariff code as it applied to works of art. A committee formed by the American Association of Museums had been urging reform for some ten years, and Senator Jacob Javits of New York was one of the vigorous sponsors of change. "The existing laws," he told the Senate Finance Committee in 1959, "impede the cultural development of our Nation and tend to expose us to ridicule in other advanced countries." To avoid living in a "cultural desert," the United States must recognize as art non-representational sculptures, collages, lithographs, and primitive carvings. The Tariff Commission and Treasury supported most of the museum committee's proposals.

The law that emerged from this review admitted duty-free works in all the categories mentioned by Senator Javits. "Collages" were specifically listed in the new free list, and original sculptures "made in any form from any material" so long as they were "the professional production of sculptors." Primitive sculptures—"ethnographic or artistic objects" made in "traditional aboriginal styles"—were admitted duty-free only if they were at least fifty years old.

"I am very glad the Treasury Department wants to get out of the business of deciding what is art," Senator Paul Douglas commented during the hearings on the new bill. And since its enactment, customs officials and courts have had fewer quarrels with importers of art objects, the principal remaining problem, so far as sculpture is concerned, being to draw a line between objects that are sculptors' own creations and made-to-order carv-

ings and castings that are to be treated as objects of trade. It had taken the modernists forty-six years since the revolutionary Armory Show to win their major legal battles.

"ORIGINALS"

In the tariff law that emerged from the review of 1959 one new provision is of particular interest. Since 1913 an original sculpture and two replicas had been admitted free of duty. Since 1959 the original model plus ten castings (of articles cast in metal) have had the duty-free exemption.

It is not always easy to determine whether a particular piece of sculpture is one of the first two, or ten, castings. One case that reached the Customs Court under the 1930 law (original and two replicas) illustrates the problems that arose. The dispute involved "Hercules the Archer" by Antoine Bourdelle, a student and assistant of Rodin before he achieved recognition as an artist in his own right. The Isaac Delgado Museum of Art in New Orleans imported a "Hercules" marked as the tenth casting, made after Bourdelle's death under the supervision of his widow, Cleopatra, who was also a sculptor. Another of this edition was in New York's Metropolitan Museum.

The New Orleans "Hercules" was only the second to be imported into the United States. Warren Burger, now Chief Justice of the United States, argued the Government's case as an Assistant Attorney General. He persuaded the court that unless it was shown that this was the second casting made (not just the second casting to be imported), then it could not be admitted free of duty. "It is to be kept in mind," said the court, agreeing with him, that the limit to two reproductions "was intended primarily to cover original works of fine art and not commercial objects produced in great numbers. . . . Where 10 or 100 reproductions are made, the sculptures become articles of trade, which, while still works of art, do not belong to that class of fine

art of a rare or special genius" covered by the tariff schedule relating to "originals."

Assistant Attorney General Burger similarly succeeded the next year, when it was a question whether a casting of the French sculptor Barye's "Roger and Angelique" was an original. The importer testified that the sculptor himself had finished off the casting, adding fine details. Castings of the sculpture were to be found in several American museums and collections—New York's Metropolitan, Washington's Corcoran Gallery, and Mr. Walters's collection in Baltimore. The importer testified that every time a mold is used it is somewhat damaged and must be cleaned or worked over. Barye had done this refurbishing for the bronze in question. Therefore it was an original, even if it could not be proved that it was one of the first two castings made. The court, at Mr. Burger's urging, held otherwise. "It has long been recognized," said the judge, "that there comes a time when replicas, reproductions and copies cease to be art by reason of their numbers and become objects of trade." In the absence of proof that this was one of the first two castings, the court declined to hold that it was a duty-free original.

Problems like these led spokesmen for the world of art to ask for the change made in 1959, admitting duty-free the original and first ten castings. In raising the number, Congress followed the recommendations of the Tariff Commission, which in turn were prompted by the museum committee. Miss Dorothy Dudley of New York's Museum of Modern Art, testifying on behalf of the museum committee before the Senate Finance Committee in 1959, said that "sculpture is customarily cast from molds in strictly limited editions of usually no more than ten replicas. Each unit is finished by hand, and the first is not more valuable or more original than the last." Such editions, she added, "are a normal feature of professional production in sculpture and do not constitute mass-produced commercial reproductions." The change, increasing the number of duty-free

originals from three to eleven, should be made to meet the wants
of "the large number of American museums and private collec-
tors interested in casts of the same work." The Tariff Commis-
sion supported that recommendation: "When a sculptor creates
an acceptable piece of statuary, about ten castings or replicas are
generally cast which measure up to the dignity of a work of art.
This number of replicas is said to be needed to meet the demand
of art museums and is approximately the number which may be
made by casting before the mold deteriorates."

Even with the more generous number of duty-free origi-
nals, problems remained. Not all sculptors (or their heirs) have
numbered the copies of their works. Indeed, it seems to be a
relatively recent practice to do so. Rodin, for example, usually
did not. There are, according to the handbook of the Rodin
Museum of the Philadelphia Museum of Art, more than forty
casts of the life-size "Age of Bronze," one of Rodin's first major
works. In a survey made for the California Palace of the Legion
of Honor in San Francisco, which has one of the major American
collections of Rodin's work, it was found that, in public collec-
tions alone, there are at least nineteen bronze casts of "The
Thinker" in its large version (seventy-eight inches high), and
twenty-five in its original smaller form (twenty-seven inches
high).

The Musée Rodin in Paris, which fell heir to all Rodin's
property—his plaster models, molds, records, drawings, and the
like—has continued to make castings of many of his works,
presumably exercising some control over the number. The an-
nounced policy has been to limit editions to twelve. But there are
few publicly available records of the total numbers made of
many Rodin sculptures during and after his lifetime.

"In exceptional cases," Miss Dudley had informed the Sen-
ate Finance Committee in 1959, "an edition is completed by
associates after the death or incapacity of the sculptor." The
current law specifically provides that the ten "original" castings
may include ones made after the sculptor's death. And yet, in

both legal and aesthetic judgment, considerable importance has been attached to the artist's role in giving the finishing touches to a work, as an essential part of the sculptor's act of creation.

Recall, for example, the judicial discussion of the bronze Goddess of War, with her ivory face and limbs. The court spoke of the crude mass of metal that emerges from the founder's mold. "After the various parts had been cast," it said of that statue, "the important work, that which gives it its distinctive personal character, was done by hand, the sculptor carefully going over the figure and making the alterations and changes necessary to embody his ideas." There have been similar pronouncements, from both judges and sculptors. But a distinction should be made between the rough work of chipping off the excrescences and incrustations left by the lost-wax process of casting (foundryman's work) and the final polishing, definition of detail, and development of the patina (tasks most artists would insist on performing themselves, or at least closely supervising if performed by others).

Obviously, when a cast is made after the artist's death, he can have had no hand in finishing it off. Consider Degas's *Little Fourteen-Year-Old Dancer*, of which at least eighteen castings are in various collections around the world. In London she is in the Tate Gallery, where, from the condition of her hair ribbon —tattered, faded, and slipping from the ponytail of bronze —you might suppose that the rag of satin was being carefully preserved because that is the way Degas made it. But Degas himself never laid eyes on any of these little bronze girls. The castings (as we noted in Chapter 1) were made after his death, from a wax model now in the Collection of Mr. and Mrs. Paul Mellon [7]. To question (as some have done) whether the casts are truly the works of Degas may seem niggling. The models were apparently prepared for casting by a friend and fellow-sculptor Bartholomé, the founder was the expert and careful Hébrard, the number was limited, and the object cast was one that the artist himself had prepared for public exhibition.

What tests should be applied in determining whether a sculpture, duplicated in castings, ceases to be the artist's work, when his own role in creating the final work has been in some way limited, and especially when it exists in such numbers that it might be labeled a "manufacture"? Courts decide such matters on the basis of expert advice, which may vary from time to time and which is often conflicting in any given case. There are no simple or final answers. As we have seen, attitudes of the courts and Congress, and of those from the art world who advise judges and legislators, have varied.

Legal authorities have been preoccupied, when dealing with traditional sculpture, with attempts to draw a line between the work of an "artist" and that of a "mere" mechanic or artisan. Such a distinction is meaningless, or must be substantially modified, in considering the works of many modernists who want to combine art and technics. For some, like Gabo, the impersonality (the "objectivity") of his constructions, the very lack of an individual touch, is among the highest values of sculpture. The expression of universals, not personal feelings, is their concern.

For some the creative idea, not its execution, is what counts. "In comparison with the inventive *mental* process of the genesis of the work," said Moholy-Nagy, "the manner—whether personal or by assignment of labor, whether manual or mechanical—is irrelevant."* In this view, it might not have mattered if Brancusi had produced the famous bronze *Bird* himself or if a metalworker had turned it out according to his specifications. The *Chicago Picasso*—like most of the monumental iron sculptures that now adorn civic plazas and corporate headquarters—was the product of engineers and ironworkers, copying the artist's maquette or design.

With regard to most sculpture, however, artist and viewer

*In 1922 Moholy-Nagy ordered five paintings, in different sizes, from a factory supervisor by telephone. Each had before him graph paper and color charts of the same kind; from these "catalogues" the paintings were "ordered."

alike look upon the personal touch in execution as an integral part of the creative act. There may be valid questions about "originality" when the sculptor whose name is attached to an object has left important parts of the physical work to others. Inquiries as to who finished off a particular sculpture, however, and how many copies have been made, are of more concern to art historians, museum administrators, prospective purchasers, and customs officials than to those of us who go to museums to enjoy a sculptor's work. The average museumgoer could well take the view that the more castings made of an eminent sculptor's work, to be seen in the more museums or private collections, the better—unless deteriorated molds, poor casting, duller definition of detail resulting from making copies of copies, and displeasing patination result in a marked loss of quality. The Musée Rodin in Paris, for example, has exhibited a casting of the "Prodigal Son"—the familiar kneeling man with body and head bent back and arms raised skyward. There are big blisters of bronze, one between his shoulder blades and another on the left buttock, and a conspicuous right-angled scar on the right buttock caused by a badly aligned mold.

A very similar casting (stamped "Copyright Musée Rodin 1969" and presumably made in that year), with the two blisters but not the right-angled indentation, was sold at Sotheby's in London, in March 1973, for $22,500. It had a sickly patination of mottled shades of green and brown. A few miles away in London another casting of the "Prodigal" could be seen—one of several sculptures Rodin himself presented to the Victoria and Albert Museum in 1914 on one of his visits to England. This is quite a different statue from the others. The blisters (which presumably are to be found on Rodin's own original plaster mold, at least in its present form) have been all but obliterated; the remnants would be noticeable only to someone looking for them. There is scarcely a trace of a mold-seam anywhere, and no right-angled scar. The patina is a rich deep brown.

Most major sculptors of cast-metal pieces sign their works and indicate in the metal the total number of casts made in the edition, and that a particular casting is the first, second, or other appropriate number in the series. In addition, certificates giving the pedigree of a piece as it passes from sellers to buyers (or from donors to donees) may reassure wary collectors. The Bureau of Customs relies largely on a declaration by the owner, artist, or ultimate consignee of an imported object in determining whether it is eligible for free entry as an original. If the imported article is a piece of sculpture, the declaration must state whether it is the original model or one of the first ten castings, replicas, or reproductions. There are severe penalties for false declarations.

Apart from the definition of "originals" in the tariff laws, there is no legal or usage-of-the-trade test in the United States for the quality of "originality." Six or seven castings, for large works, is a rule widely followed by reputable artists; somewhat larger editions are acceptable for small statuettes and figurines. There is, as we have seen, some point, reached by various possible routes, at which a work cannot in good conscience or artistic taste be considered an original made by the sculptor whose name is attached. But let us leave such problems to the directors and acquisition committees of museums and to other collectors, and enjoy what they offer for our viewing—hoping they will be candid if there is some question about the claim to originality.

Illustrations

THE captions for the following illustrations include the names of the artists, titles or brief descriptions of works and their dates, and, in italics, the sources of the photographs. The numbers following each caption refer to the pages of the text on which the object is mentioned.

More complete descriptions of the sculptures shown, their present locations, and full credit lines for the photographs, will be found in the list of illustrations.

The following short forms are used in the captions:

Eliot Elisofon Archives: Eliot Elisofon Archives, Museum of African Art, Washington, D.C.

Hirshhorn Museum, Washington: The Hirshhorn Museum and Sculpture Garden, Smithsonian Institution, Washington, D.C.

Meadows Museum, Dallas: Meadows Museum, Southern Methodist University, Dallas, Texas.

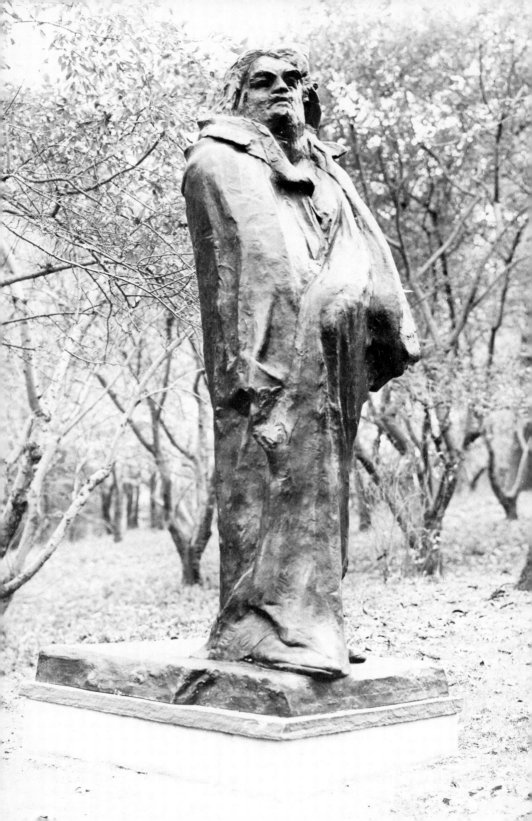

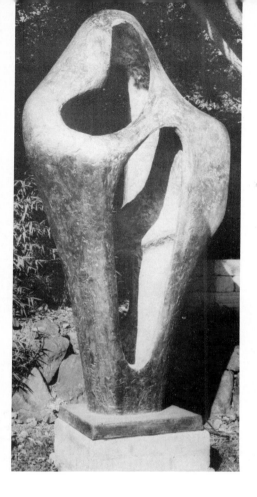

2. HEPWORTH. Figure for Landscape. 1960. *Hirshhorn Museum, Washington.* **113**

3. Right: SMITH. Cubi XII. 1963. *Hirshhorn Museum, Washington.* **61–63, 113**

1. Opposite: RODIN. Monument to Balzac. 1898. *Hirshhorn Museum, Washington.* **7–8, 63, 112**

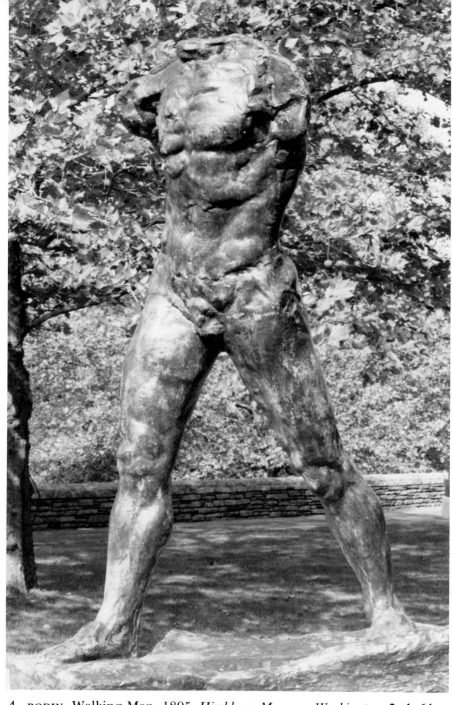

4. RODIN. Walking Man. 1895. *Hirshhorn Museum, Washington.* **2–4, 64**

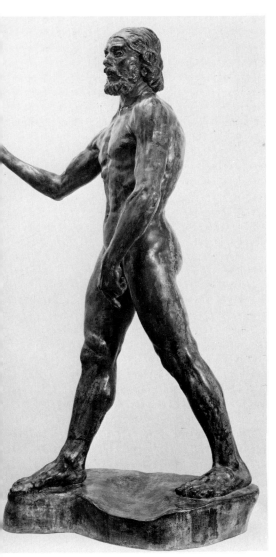

6. MATISSE. Le Serf. 1900–
03. *Hirshhorn Museum,
Washington.* **14**

5. RODIN. St. John the Baptist Preaching.
1878. *Museum of Modern Art, New York.*
2–4, 7, 14, 64

7. DEGAS. Little Fourteen-Year-Old Dancer. 1880–81. *Collection of Mr. and Mrs. Paul Mellon.* **10–11, 139**

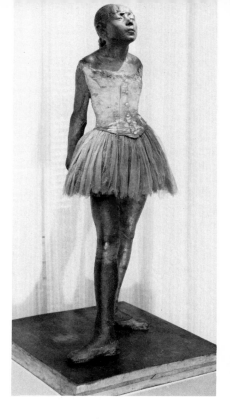

8. DEGAS. Dancer Holding Her Right Foot. c. 1896–1911. *Collection of Mr. and Mrs. Paul Mellon.* **10**

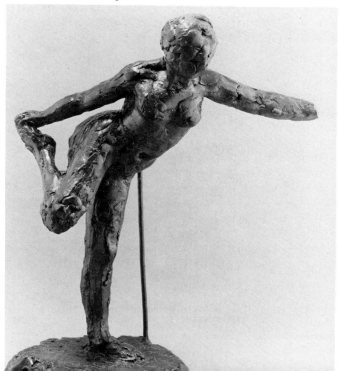

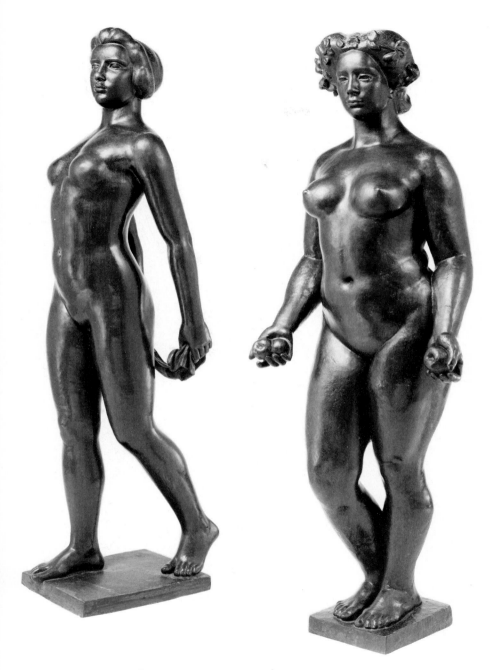

9. Left: MAILLOL. Île-de-France. 1925. *Philadelphia Museum of Art.* **13**
10. Right: MAILLOL. Pomona with Lowered Arms. 1937. *Philadelphia Museum of Art.* **13, 89**

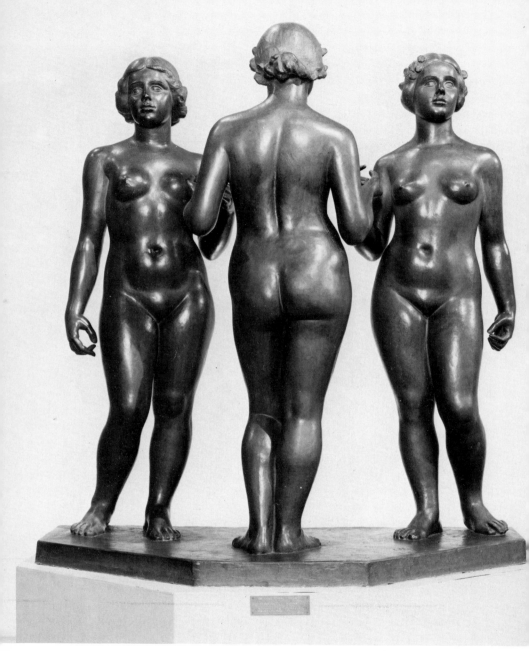

11. MAILLOL. Three Nymphs. 1930–38. *Tate Gallery, London.* **13**

12. Opposite: PICASSO. Man with Lamb. 1944. *Philadelphia Museum of Art.* **20**

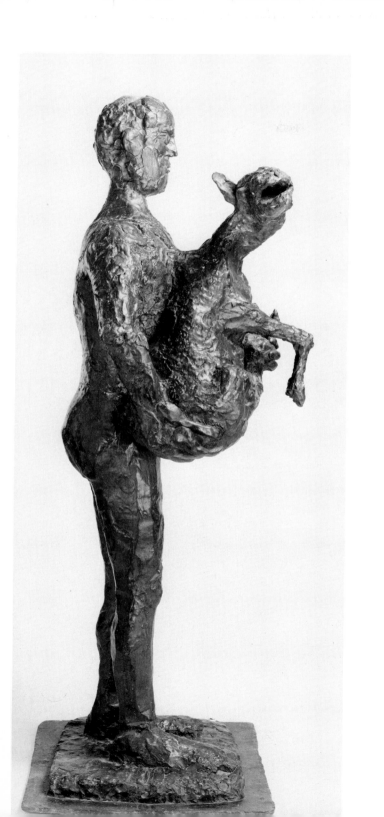

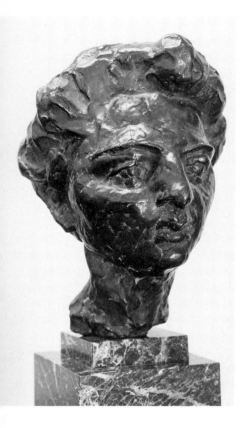

13. MATISSE. Jeannette I. 1910–13. *Museum of Modern Art, New York.* **15**

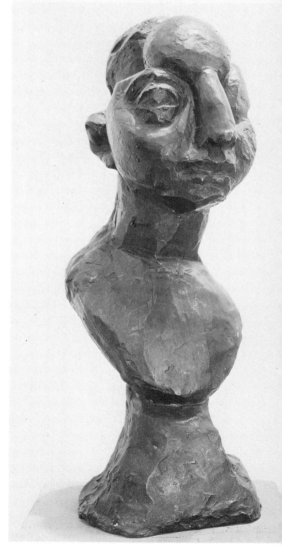

14. MATISSE. Jeannette V. 1910–13. *Museum of Modern Art, New York.* **15**

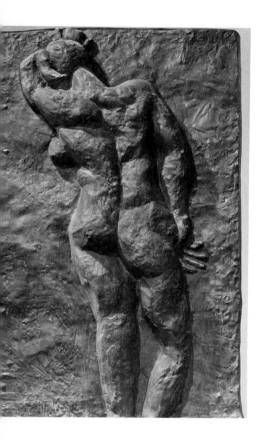

15. MATISSE. The Back I. c. 1909.
Tate Gallery, London. **16**

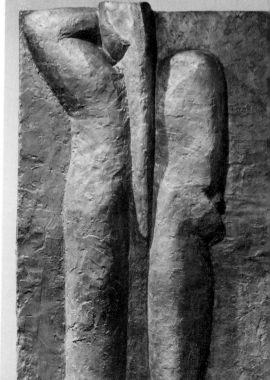

16. MATISSE. The Back IV. c. 1929.
Tate Gallery, London. **16**

17. LACHAISE. Floating
Figure. 1927. *Museum
of Modern Art, New
York.* **18**

18. Left: "Venus of Willendorf." 30,000–25,000 B.C. *Natur-
historisches Museum, Vienna.* **89, 91, 97, 99, 117** 19. Right:
"Venus of Lespugue." 30,000–25,000 B.C. *American Museum of
Natural History, New York.* **89, 91, 99, 117**

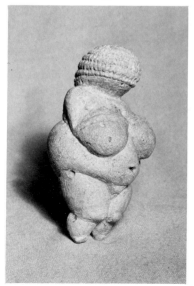
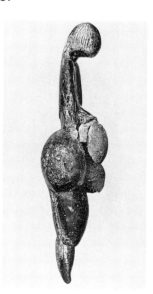

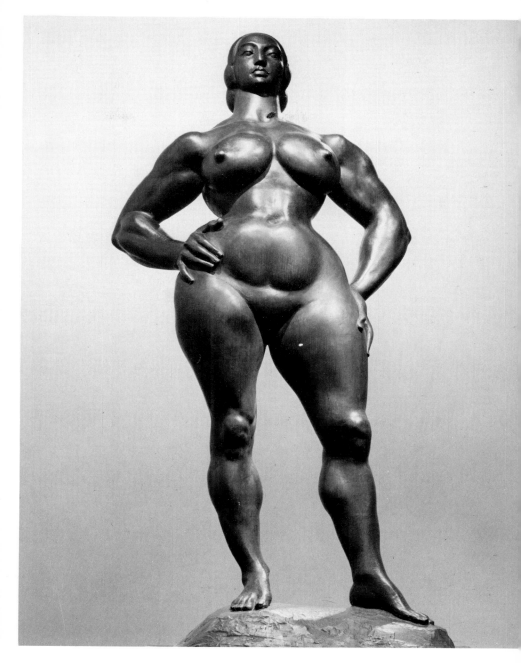

20. LACHAISE. Standing Woman. 1932. *Museum of Modern Art, New York.*
18, 89

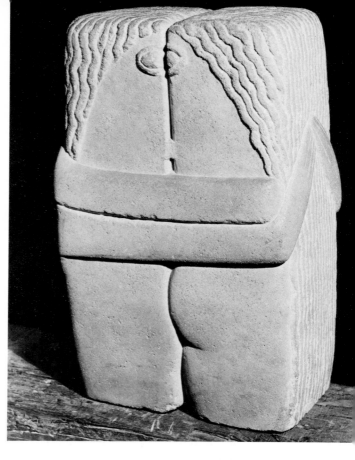

21. Above: BRANCUSI. The Kiss. 1911.
Philadelphia Museum of Art. **24, 28, 44**

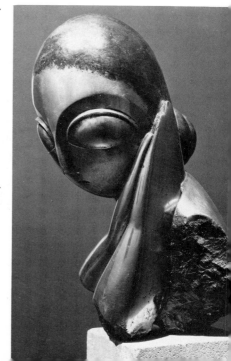

22. Right: BRANCUSI. Mlle. Pogany. 1913.
Museum of Modern Art, New York.
24–25, 48 fn.

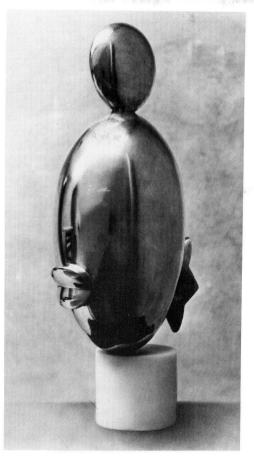

23. BRANCUSI. Blond Negress. 1933. *Museum of Modern Art, New York.* **25, 48 fn.**

24. Below: BRANCUSI. Leda. 1920. *Art Institute of Chicago.* **28–29**

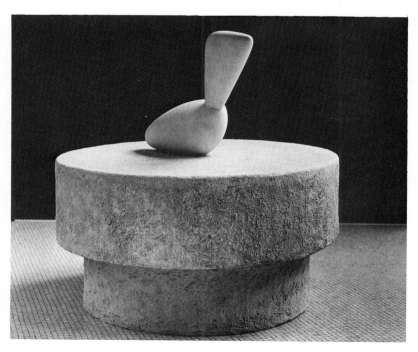

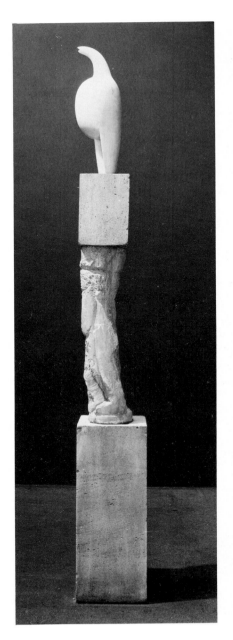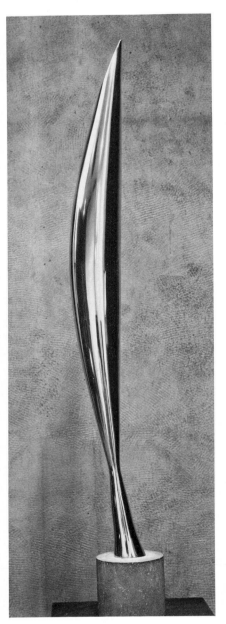

25. Left: BRANCUSI. Magic Bird. 1910. *Museum of Modern Art, New York.* **26, 125** 26. Right: BRANCUSI. Bird in Space. 1928? *Museum of Modern Art, New York.* **26–27, 125**

27. Left: BRANCUSI. Adam and Eve. 1916–19. *Solomon R. Guggenheim Museum, New York.* **25, 29, 109** 28. Right: BRANCUSI. Socrates. 1923. *Museum of Modern Art, New York.* **29, 109**

29. ARP. Growth. 1938–40. *Art Institute of Chicago.* **31–32**

30. ARP. Human Lunar Spectral. 1957. *Hirshhorn Museum, Washington.* **32**

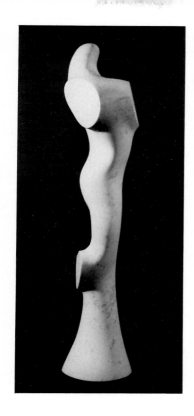

31. Left: ARP. Floral Nude.
1957. *Museum of Modern Art,
New York.* **32** 32. Below:
ARP. Sculpture Classique.
1960. *Dallas Museum of Fine
Arts.* **32**

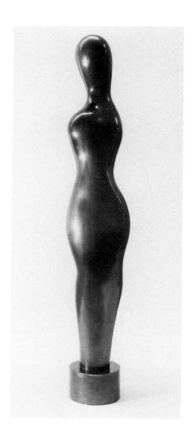

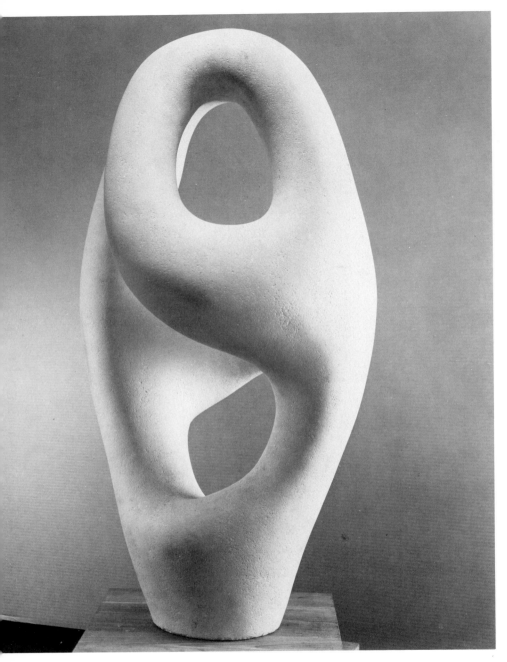

33. ARP. Ptolemy I. 1953. *Mr. and Mrs. William A. M. Burden.* **32**

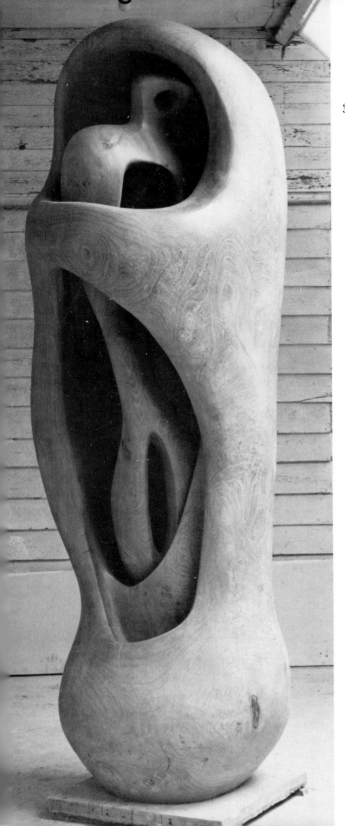

34. MOORE. Upright Internal and External Forms. 1953–54. **39, 89, 91**

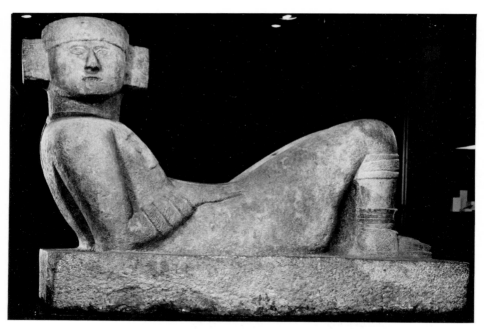

35. Above: Chac Mool, Mayan Rain Spirit. A.D. 948–1697. *Museo Nacional de Antropología, Mexico, D.F.* **34, 90, 101, 102** 36. Below: MOORE. Reclining Figure. 1929. **34–35, 101, 102**

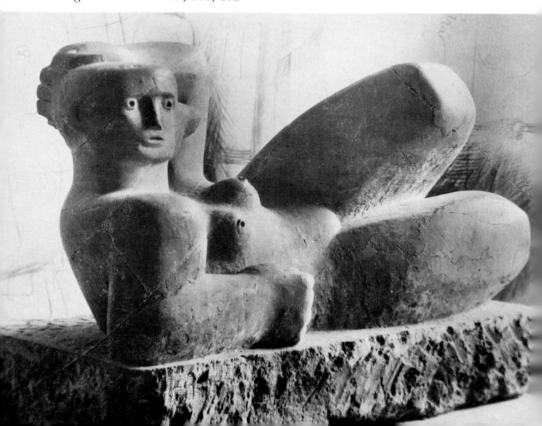

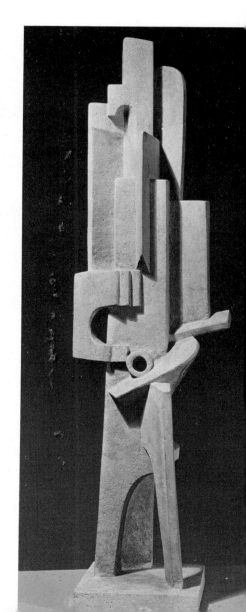

37. ARCHIPENKO. Woman Combing Her Hair. 1915. *National Gallery of Art, Washington.* **36, 57, 103**

38. LIPCHITZ. Man with a Guitar. 1915. *Museum of Modern Art, New York.* **36, 44**

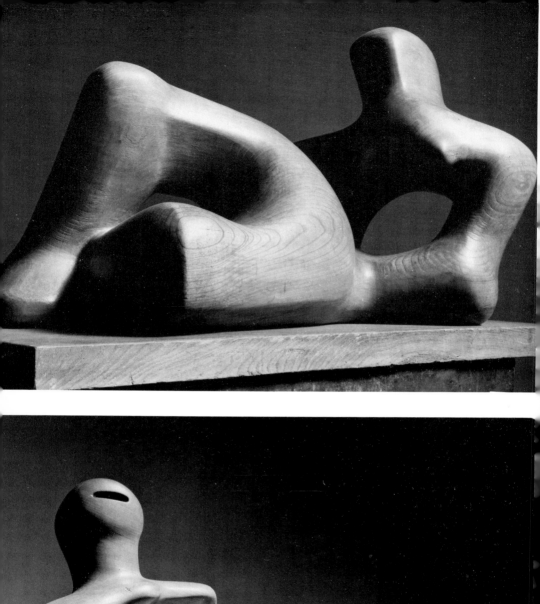

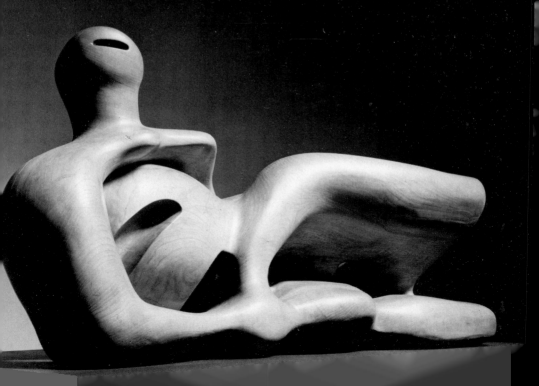

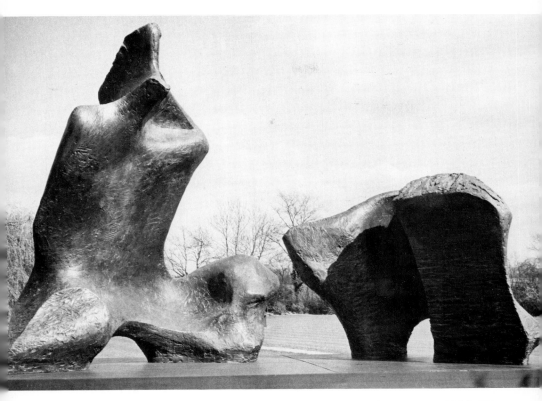

41. MOORE. Working Model for Reclining Figure (Lincoln Center). 1965. **37, 40, 90**

39. Opposite top: MOORE. Reclining Figure. 1936. **37, 99, 103**

40. Opposite bottom: MOORE. Reclining Figure. 1945–46. **ix, 37, 89, 99**

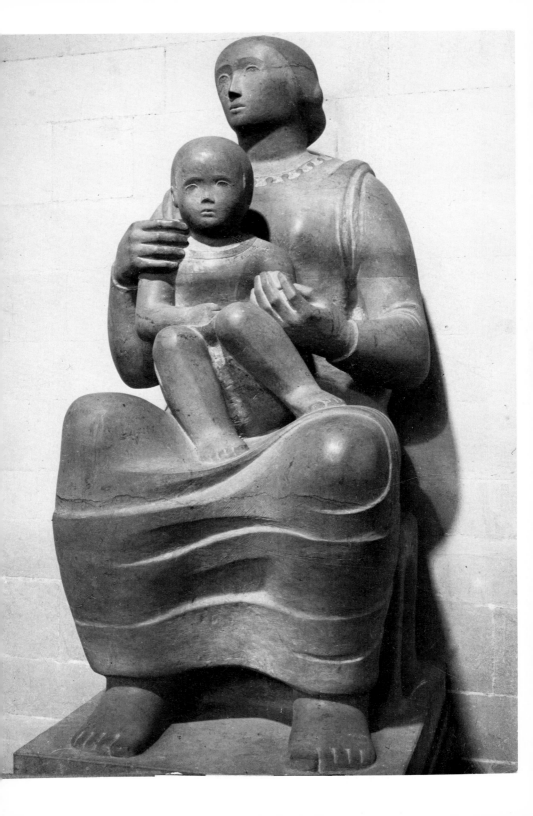

43. MOORE. Working Model for Standing Figure: Knife Edge. 1961. *Hirshhorn Museum, Washington.* **40, 91**

42. Opposite page: MOORE. Madonna and Child. 1943–44. **19, 34, 38, 89, 90**

44. MOORE. King and Queen. 1952–53. **38**

45. MOORE. Seated Woman. 1956–57. *Hirshhorn Museum, Washington.* **40, 91**

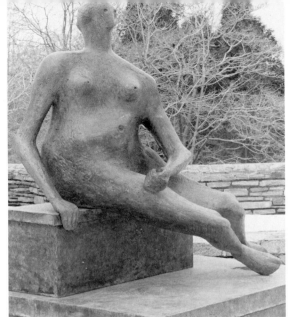

46. MOORE. Falling Warrior. 1956–57. *Hirshhorn Museum, Washington.* **91**

47. Opposite: MOORE. Upright Motive No. 1 (Glenkiln Cross). 1955–56. **40, 112**

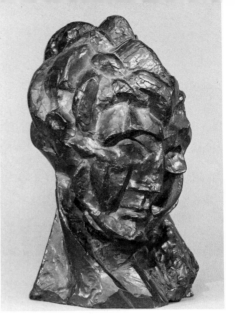

48. PICASSO. Head of a Woman. 1909. *Hirshhorn Museum, Washington.* **15, 43**

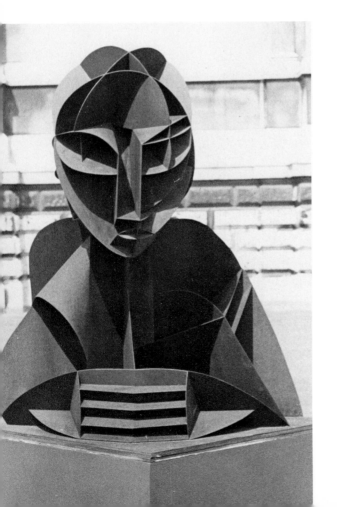

49. GABO. Constructed Head No. 2. 1916. (enlarged 1964). *Tate Gallery, London.* **43–44, 48 fn., 63**

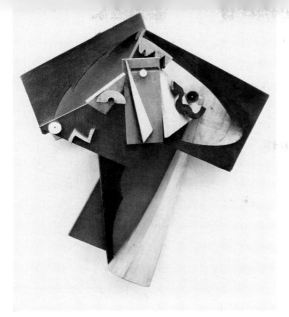

50. LAURENS. Head. 1918.
*Museum of Modern Art,
New York.* **44**

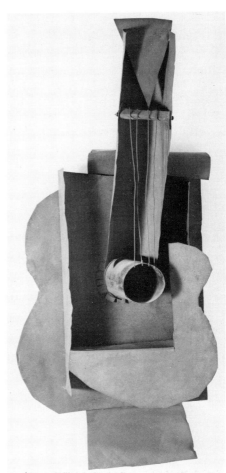

51. PICASSO. Guitar. 1911–12.
*Museum of Modern Art, New
York.* **106, 118**

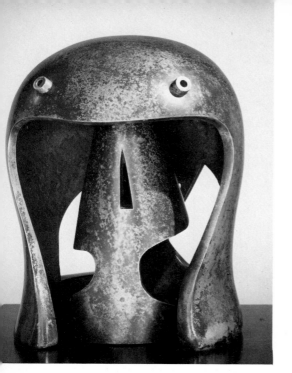 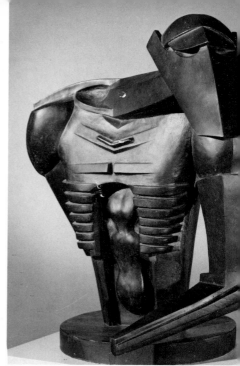

52. Left: MOORE. Helmet Head No. 1. 1950. *Tate Gallery, London.* **39,
47** 53. Right: EPSTEIN. Rock Drill. 1913–14. *Tate Gallery, London.* **39,
46–47**

54. Opposite top: DUCHAMP-VILLON. Horse. 1914. *Hirshhorn Museum, Wash-
ington.* **46**

55. Opposite bottom: BOCCIONI. Unique Forms of Continuity in Space. 1913.
Museum of Modern Art, New York. **46, 64**

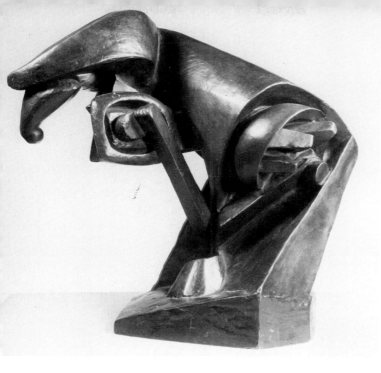

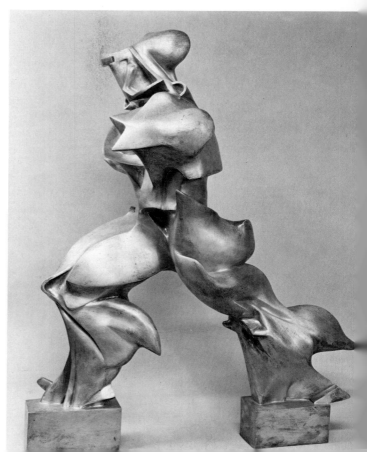

56. GABO. Linear Construction No. 2. 1949. *Art Institute of Chicago.* **48, 50, 113**

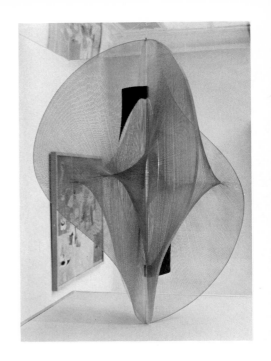

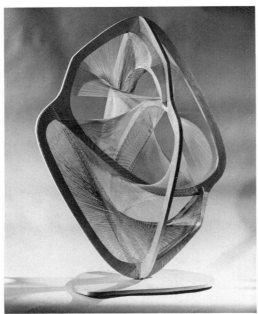

57. GABO. Linear Construction No. 4. 1959–61. *Hirshhorn Museum, Washington.* **50**

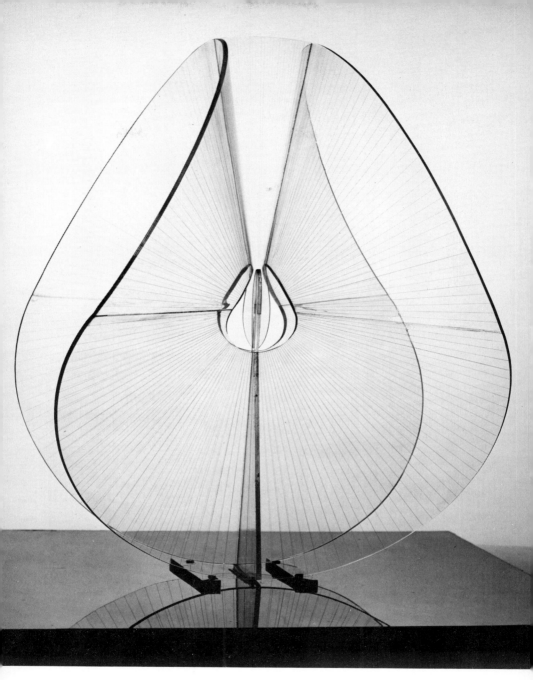

58. GABO. Translucent Variation on a Spheric Theme. 1937. *Solomon R. Guggenheim Museum, New York.* **48, 50, 123**

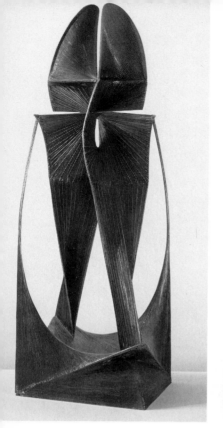

59. PEVSNER. Twinned Column. 1947. *Solomon R. Guggenheim Museum, New York.* **50**

60. PEVSNER. Column of Peace. 1954. *Hirsh horn Museum, Washington.* **50**

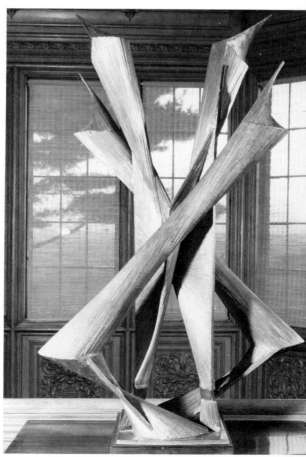

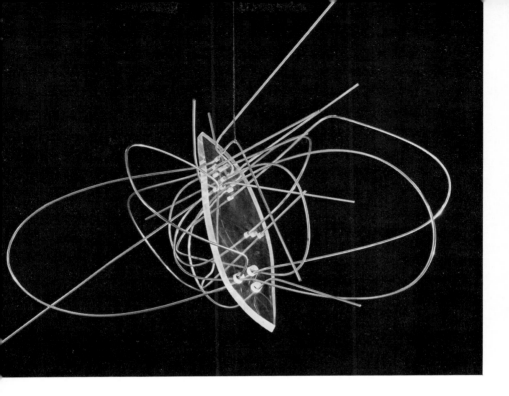

61. Above: MOHOLY-NAGY.
Dual Form with Chro-
mium Rods. 1946. *Sol-
omon R. Guggenheim
Museum, New York.* **51**

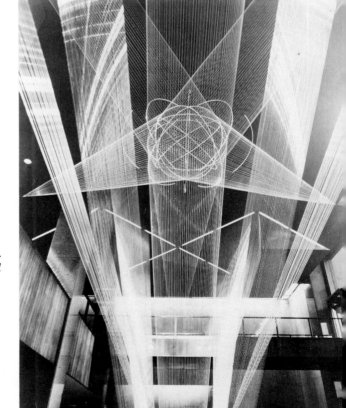

62. LIPPOLD. Flight. 1964.
*Pan American World
Airways.* **50**

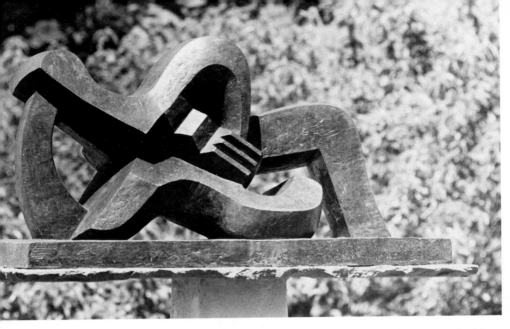

63. LIPCHITZ. Reclining Nude with Guitar. 1928. *Hirshhorn Museum, Washington.* **52**

64. LIPCHITZ. La Joie de Vivre. 1927. *Meadows Museum, Dallas.* **52, 65**

65. LIPCHITZ. Figure. 1926–30. *Hirshhorn Museum, Washington.* **104**

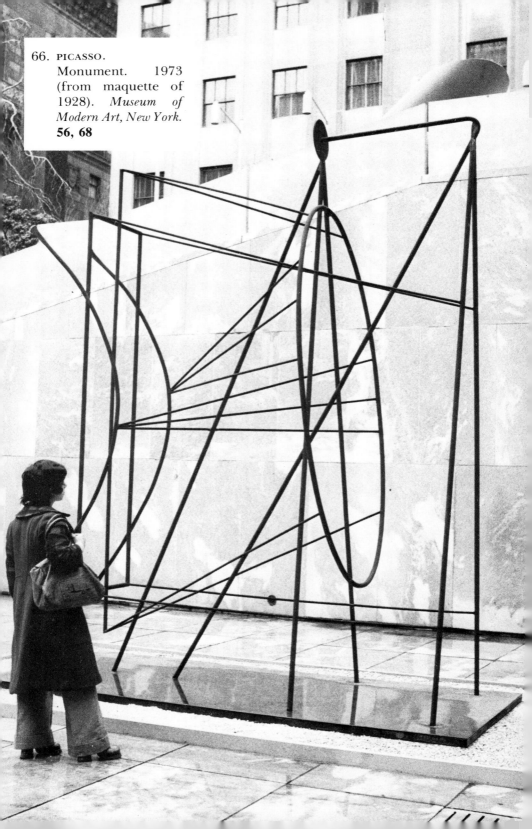

66. PICASSO.
Monument. 1973
(from maquette of
1928). *Museum of
Modern Art, New York.*
56, 68

67. GIACOMETTI. Palace at 4 A.M. 1932–33. *Museum of Modern Art, New York.* **84–85**

68. SMITH. Australia. 1951. *Museum of Modern Art, New York.* **60**

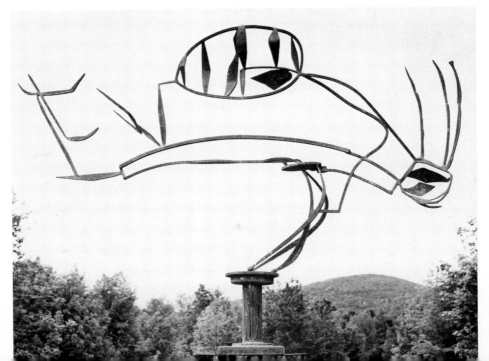

70. GONZALEZ. Head. 1935? *Museum of Modern Art, New York.* **57**

69. Left: Fon people. Ogoun, God of War. *Eliot Elisofon Archives.* **57–58, 103**

71. Opposite: GONZALEZ. Woman Combing Her Hair. 1936. *Museum of Modern Art, New York.* **57, 113**

72. ARP. Seuil Configuration. 1960.
Hirshhorn Museum, Washington.
61–62

73. SMITH. Cubi VII. 1962. *Meadows
Museum, Dallas.* **62–63, 113**

74. SMITH. Cubi XVII. 1963. *Dallas Museum of Fine Arts.* **63, 113**

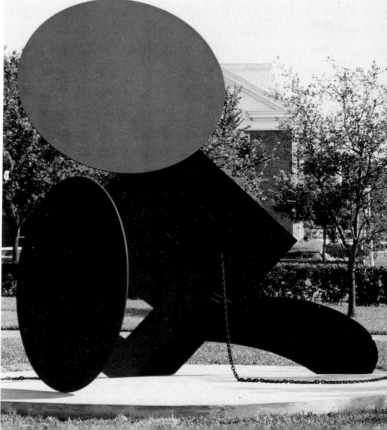

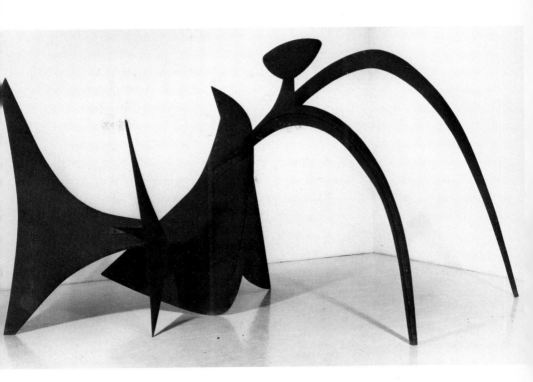

77. CALDER. Black Widow. 1959. *Museum of Modern Art, New York.* **67**

75. Opposite top: CALDER. Mobile-Stabile. 1950. *Hirshhorn Museum, Washington.* **67**

76. Opposite bottom: OLDENBURG. Geometric Mouse. 1969–70. *Meadows Museum, Dallas.* **67**

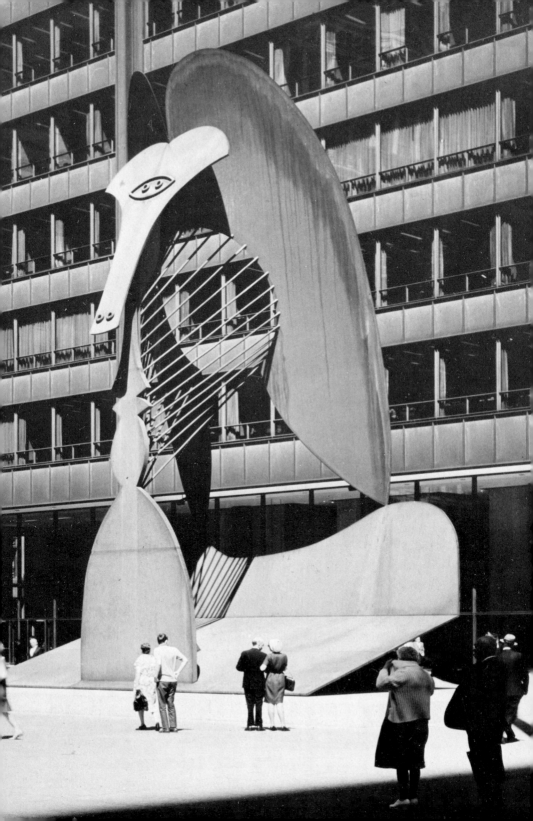

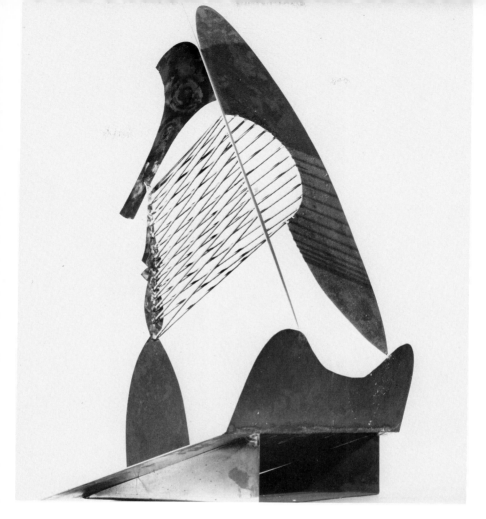

79. PICASSO. Maquette of Monument for Chicago Civic Center. 1965. *Art Institute of Chicago.* **69**

80. Right: Bakota people. Reliquary Figure. *Eliot Elisofon Archives.* **69, 105**

78. Opposite: PICASSO. Monument for Chicago Civic Center. 1967. *Art Institute of Chicago.* **69, 106**

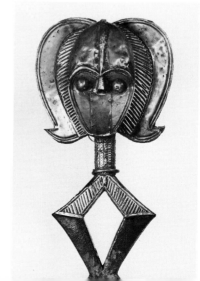

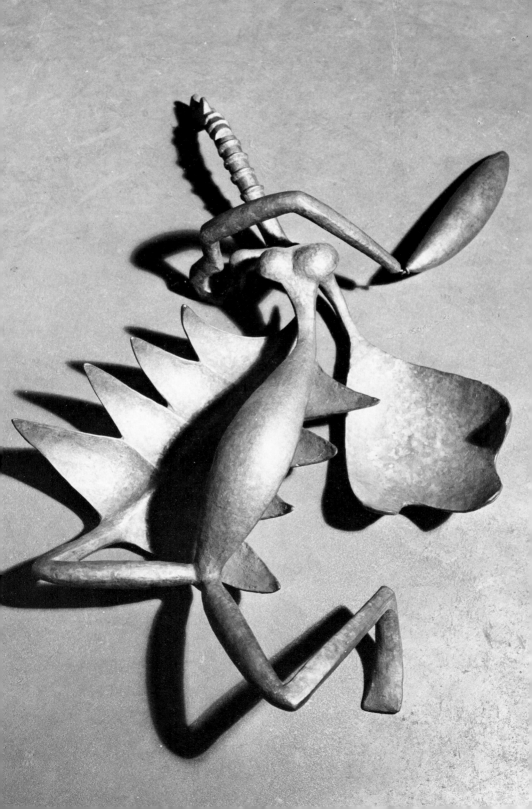

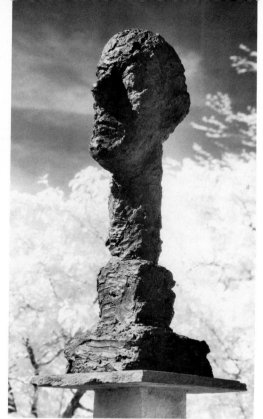

82. GIACOMETTI. Monumental Head. 1960. *Hirshhorn Museum, Washington.* **87**

83. GIACOMETTI. Man Pointing. 1947. *Museum of Modern Art, New York.* **86**

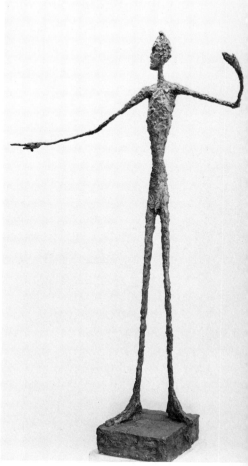

81. Opposite: GIACOMETTI. Woman with Her Throat Cut. 1932. *Museum of Modern Art, New York.* **ix, 85–86, 91**

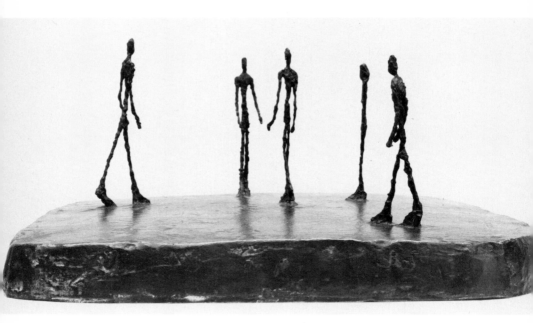

84. GIACOMETTI. City Square. 1948. *Museum of Modern Art, New York.* **86–87**

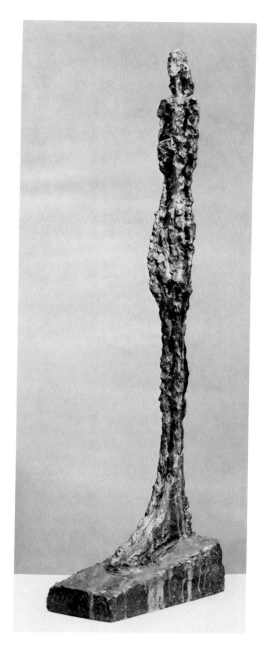

85. GIACOMETTI. Woman (Venice IX). 1949. *Tate Gallery, London.* **87**

86. LIPCHITZ. Mother and Child II. 1941–45. *Museum of Modern Art, New York.* **89, 99**

87. Dogon people. Woman and Child. *Eliot Eliso-fon Archives.* **89, 109**

88. PICASSO. Baboon and Young. 1951. *Museum of Modern Art, New York.* **58, 89, 99**

89. MARINI. Horseman. 1947. *Tate Gallery, London.* **94, 120**

90. Below: MARINI. Horse and Rider. 1951. *Hirshhorn Museum, Washington.* **94, 120**

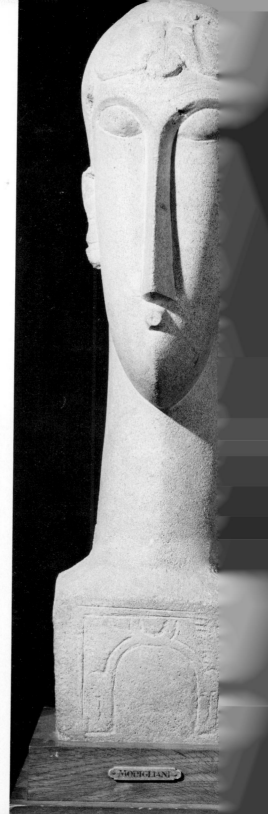

92. MODIGLIANI. *Head.* c. 1915. *Phila-delphia Museum of Art.* **108**

91. Baule people. Mask. *Museum of African Art, Washington.* **103, 105, 108**

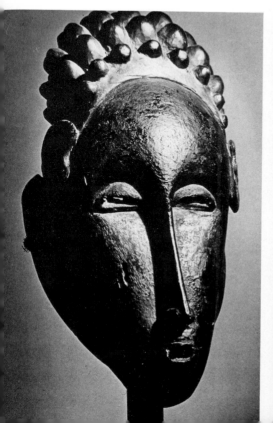

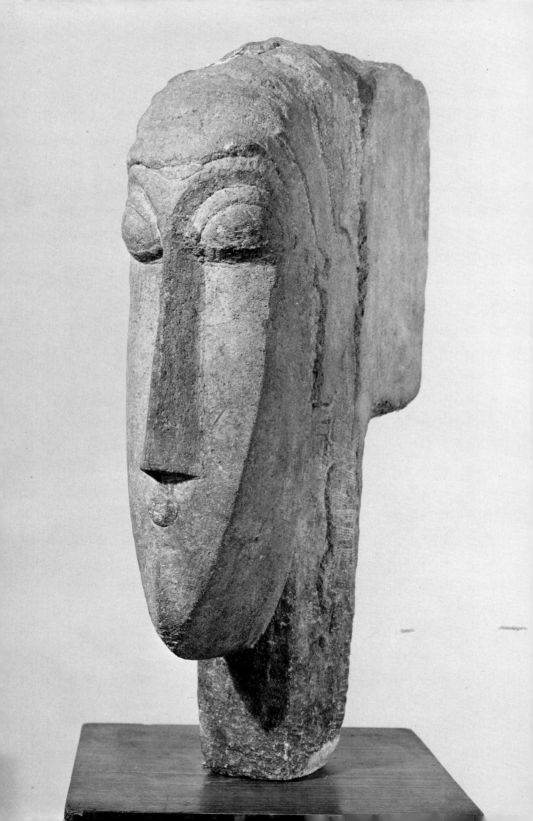

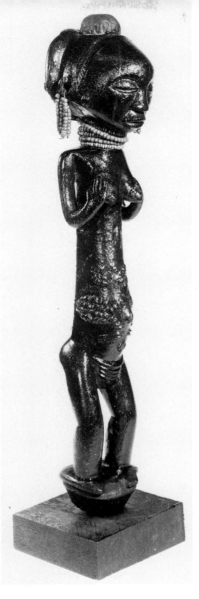

94. Luba people. Standing Female Figure. *Dallas Museum of Fine Arts.* **103, 109**

95. MATISSE. La Serpentine. 1909. *Hirshhorn Museum, Washington.* **16, 103**

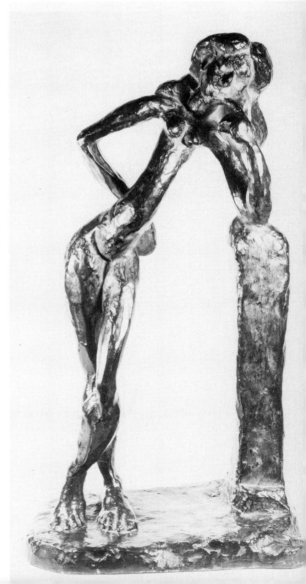

93. Opposite: MODIGLIANI. *Head.* c. 1915. *Museum of Modern Art, New York.* **108**

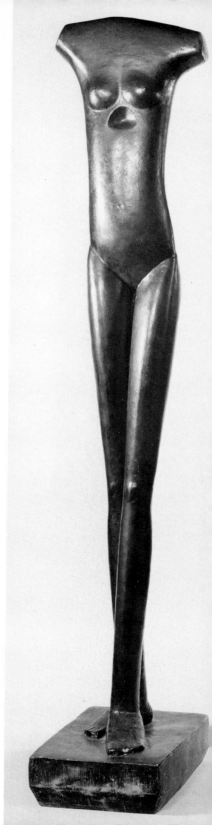

96. Left: Cycladic Idol. Third millennium
B.C. *Museum of Fine Arts, Boston.* **104,
113, 117** 97. Right: Chontal. Stand-
ing Female Figure. 300 B.C. or earlier.
Dallas Museum of Fine Arts. **104, 113, 117**

98. GIACOMETTI. Femme Qui Marche.
1933–34. *Museum of Fine Arts, Boston.*
104

99. NEVELSON. Black Wall. 1959. *Tate Gallery, London*. **110**

100. Below: NEVELSON. American Dawn. 1962–67. *Art Institute of Chicago*. **110**

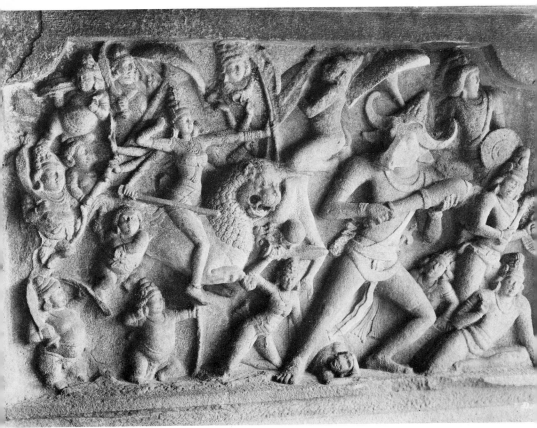

101. Top: Battle of Greeks and Amazons. Fourth century B.C. *British Museum, London.* **119** 102. Bottom: Durga Slaying the Buffalo Demon. Seventh century A.D. *Archaeological Survey of India.* **119**

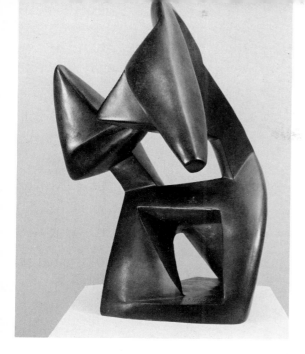

103. ARCHIPENKO. Boxing. 1914. *Museum of Modern Art, New York.* **52, 119**

104. Below: SMITH. Cubi XXVI. 1965. *Baltimore Museum of Art.* **61–63, 113, 120**

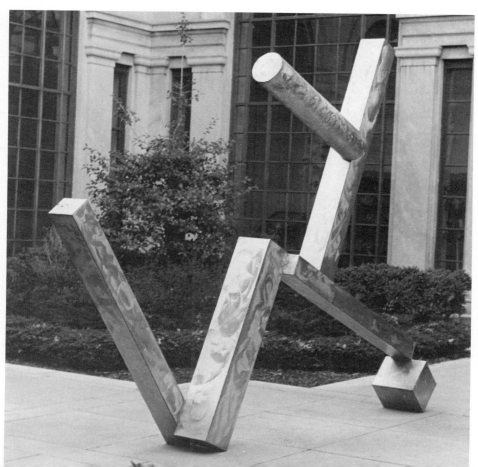

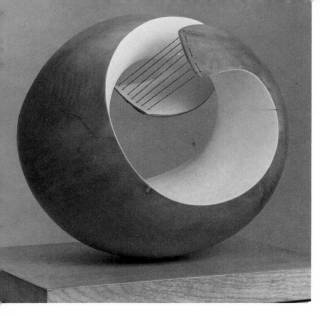

105. HEPWORTH.Pelagos. 1946.
 Tate Gallery, London. **54,
 113**

106. Below: HEPWORTH. Sea
 Form (Atlantic). 1964.
 Dallas Museum of Fine Arts.
 113

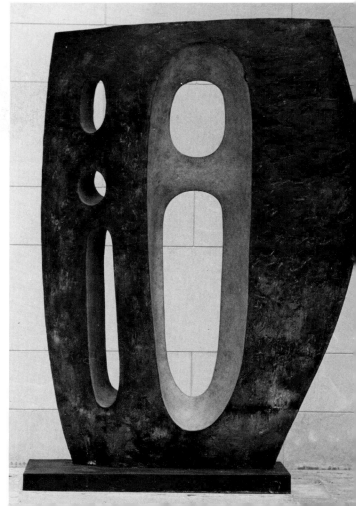

List of Illustrations

EACH entry gives (if the information is known) the name of the artist, title or brief description of the work, the date when it was made, the material of which the object is made, dimensions, present location (although there may be other locations if there has been an edition of several replicas), and the source of the photograph.

1. RODIN, Auguste
 Monument to Balzac. 1898. Bronze, 106″ × 42½″ × 50″
 The Hirshhorn Museum and Sculpture Garden, Smithsonian Institution, Washington; photo, courtesy of the Museum
2. HEPWORTH, Barbara
 Figure for Landscape. 1960. Bronze, 106″ × 50″ × 26½″
 The Hirshhorn Museum and Sculpture Garden, Smithsonian Institution, Washington; photo, courtesy of the Museum
3. SMITH, David
 Cubi XII. 1963. Stainless steel, 109″ × 49″ × 26″
 The Hirshhorn Museum and Sculpture Garden, Smithsonian Institution; photo, courtesy of the Museum
4. RODIN, Auguste
 Walking Man. 1895 (cast 1962). Bronze, 83″ × 61″ × 28″
 The Hirshhorn Museum and Sculpture Garden, Smithsonian Institution; photo, courtesy of the Museum

15. MATISSE, Henri
 The Back I. c. 1909. Bronze, 74″ h.
 The Tate Gallery, London; photo, courtesy of the Gallery

16. MATISSE, Henri
 The Back IV. c. 1929. Bronze, 74″ h.
 The Tate Gallery, London; photo, courtesy of the Gallery

17. LACHAISE, Gaston
 Floating Figure. 1927 (cast 1935). Bronze, 51¾″ h., 96″ 1.
 Collection, The Museum of Modern Art, New York, given anonymously
 in memory of the artist; photo, courtesy of the Museum

18. *"Venus of Willendorf".* Paleolithic, 30,000–25,000 B.C.
 Found near Willendorf, Austria, 1908. Stone, 4½″ h.
 Naturhistorisches Museum, Wien; photo, courtesy of the Museum

19. *"Venus of Lespugue".* Paleolithic, 30,000–25,000 B.C.
 Found near Lespugue, Haut-Garonne, France, 1922. Mammoth tusk,
 5¾″ h.
 Musée de L'Homme, Paris; photo, courtesy of the American Museum of
 Natural History, New York

20. LACHAISE, Gaston
 Standing Woman. 1932. Bronze, 88″ × 41⅛″ × 19⅛″
 Collection, The Museum of Modern Art, New York, Mrs. Simon Gug-
 genheim Fund; photo, courtesy of the Museum

21. BRANCUSI, Constantin
 The Kiss. 1911. Limestone, 23″ × 13″ × 10″
 Philadelphia Museum of Art, the Louise and Walter Arensberg Collec-
 tion; photo, courtesy of the Museum

22. BRANCUSI, Constantin
 Mlle. Pogany. Version I, 1913, after a marble of 1912. Bronze, 17½″ h.
 Collection, The Museum of Modern Art, New York, acquired through
 the Lillie P. Bliss Bequest; photo, courtesy of the Museum

23. BRANCUSI, Constantin
 Blond Negress. Version II, 1933, after a marble of 1928. Bronze, 15¾″ h.,
 four-part pedestal of marble, limestone, and wood, totaling 55½″ h.
 Collection, The Museum of Modern Art, New York, the Philip L. Good-
 win Collection; photo, courtesy of the Museum

24. BRANCUSI, Constantin
 Leda. 1920. Marble, 21″ h., on plaster base
 The Art Institute of Chicago, Bequest of Katherine S. Dreier; photo,
 courtesy of the Institute

Chronology

LIVES OF SCULPTORS

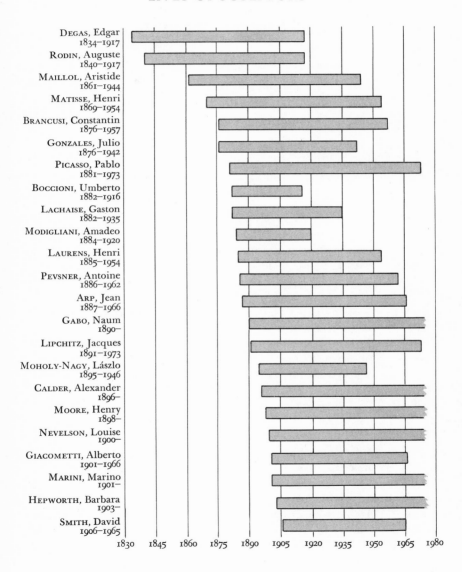

DEGAS, Edgar
1834–1917

RODIN, Auguste
1840–1917

MAILLOL, Aristide
1861–1944

MATISSE, Henri
1869–1954

BRANCUSI, Constantin
1876–1957

GONZALES, Julio
1876–1942

PICASSO, Pablo
1881–1973

BOCCIONI, Umberto
1882–1916

LACHAISE, Gaston
1882–1935

MODIGLIANI, Amadeo
1884–1920

LAURENS, Henri
1885–1954

PEVSNER, Antoine
1886–1962

ARP, Jean
1887–1966

GABO, Naum
1890–

LIPCHITZ, Jacques
1891–1973

MOHOLY-NAGY, László
1895–1946

CALDER, Alexander
1896–

MOORE, Henry
1898–

NEVELSON, Louise
1900–

GIACOMETTI, Alberto
1901–1966

MARINI, Marino
1901–

HEPWORTH, Barbara
1903–

SMITH, David
1906–1965

1830 1845 1860 1875 1890 1905 1920 1935 1950 1965 1980

Chronology

1914–17 Gabo and Pevsner in Norway; Gabo makes *Constructed Head No. 2* of sheet iron, 1916; the brothers return to Moscow, 1917

1917 Death of Rodin and Degas

1918 Lachaise exhibits *Standing Woman* in New York

1919 First commercial exhibition of primitive art in Paris

1920 Gabo and Pevsner issue *Realist Manifesto* in Moscow

1922 Exhibition of modern Russian art in Berlin

1923–28 Moholy-Nagy teaches at Bauhaus in Weimar

1924 André Breton issues *First Surrealist Manifesto*

1924–25 Hepworth studies in France and Italy; Moore in Italy

1925 Lipchitz begins developing "transparents"
First surrealist exhibition in Paris

c. 1928–32 Picasso and Gonzalez collaborate on welded sculpture

1929 Moore makes *Reclining Figure* based on *Chac Mool* (Mayan Rain Spirit)

1929 Calder begins making "mobiles"

1930 André Breton issues *Second Surrealist Manifesto*

c. 1930–35 Giacometti's surrealist period

1931 Calder's first show in Paris

1932 Moore's "Year of the Hole"

1935–36 David Smith visits Europe

1936 Marini makes first of horse-and-rider series

1937 Gabo's *The Constructive Idea in Art* published
Moholy-Nagy moves to the United States

1939–45 Second World War
Arp, Giacometti, and Marini in Switzerland during most of the war
Gabo, in England during the war, moves to the United States in 1946
1941 Lipchitz moves to the United States
Picasso continues to live in Paris
David Smith works as a welder in a tank factory during part of the war
Moore does "Shelter Drawings" and turns briefly to naturalistic sculpture
1941 Nevelson's first one-man exhibition of sculpture

1951 Henry Moore's first visit to Greece

c. 1952 David Smith turns to making monumental public sculpture in *Tank Totem* series

1961–65 David Smith's *Cubi* series

Biographical Notes

DATES of certain events in an artist's life, including some of the dates of particular works, may be variously reported in different sources. It is suggested that readers who want to be as accurate as possible about significant dates for a particular sculptor consult several sources, especially the most recently available scholarly monograph or biographical article on that artist.

ARCHIPENKO, Alexander. Born in Kiev, 1887; died in New York, 1964. Studied painting and sculpture in Kiev and Moscow, 1902–6. Settled in Paris, 1908, and opened an art school there, 1910. In Berlin 1921–23. Migrated to the United States, 1923; lived in Washington State, Chicago, New York City, and Woodstock.

ARP, Jean (Hans). Born in Strasbourg, 1887; died in Basle, 1966. Studied in Strasbourg and Weimar. In Paris, 1907, and Switzerland, 1908–14. In Paris during first year of First World War; Moved to Zurich, 1915. Active with dadaists. Met Sophie Taeuber, 1915; married, 1922. To Paris after war, and settled in Meudon. Began to do sculpture in the round, 1930. During Second World War fled to southern France and then to Zurich. First visit to United States, 1949.

BOCCIONI, Umberto. Born in Reggio, Calabria, 1882; died in Verona, 1916, after fall from a horse while in military service. Studied in Rome, 1898–1902. Traveled to France and Russia, 1902–3. Settled in Milan, 1908. Met poet Marinetti in 1909 and with him launched futurist movement. Met cubists in Paris, 1911. Enrolled as volunteer, 1915.

BRANCUSI, Constantin. Born in Pestisani Gorji, Rumania, 1876, died in Paris, 1957. Left home at eleven. Studied in Craiova and Bucharest. Made way to Paris, 1908, and enrolled in Académie des Beaux-Arts. Abandoned naturalism in sculpture, 1908. First one-man exhibition in New York, 1914, and first visit there, 1926. Visited India, 1937. Became French citizen shortly before death, in order to leave studio to France.

CALDER, Alexander. Born in Philadelphia, 1896. Graduated from Stevens Institute of Technology. First took drawing lessons, 1922. Entered Art Students League, 1923. Went to Paris, 1926, and there made his miniature circus of wire objects. Began making mobiles, 1929, after visits to Piet Mondrian's apartment. Established home in Roxbury, Connecticut, 1933.

DEGAS, Edgar. Born in Paris, 1834; died in Paris, 1917. Made first wax models, 1866. *Little Fourteen-Year-Old Dancer*, only sculpture to be shown publicly, exhibited in 1881. After 1892 worked mainly in sculpture instead of painting or drawing because of failing eyesight.

GABO, Naum. Born Naum Pevsner in Briansk, Russia, 1890. Studied medicine and science in Munich. Spent war years 1914–17 in Copenhagen and Oslo. In Russia 1917–21 where he and brother, Antoine Pevsner, launched the constructivist movement. To Berlin in 1922, Paris in 1932, London in 1936, and Cornwall during the war years 1939–45. In Middlebury, Connecticut, since 1946. Became American citizen, 1952.

GONZALEZ, Julio. Born in Barcelona, 1876; died in Arceuil (near Paris), 1942. Came of family of metalworkers. Studied painting in Barcelona. Went to Paris with brother about 1900. Became friend of Brancusi and Picasso. Turned to sculpture about 1926. Collaborated with Picasso about 1928–32.

HEPWORTH, Barbara. Born in Wakefield, Yorkshire, 1903. Studied at Leeds School of Art and Royal College of Art, where she was a classmate of Henry Moore. Traveled and studied in Italy, 1924–25. Married sculptor John Skeaping, 1925. Married second husband, painter Ben Nicholson, 1930. Since 1939 has lived in St. Ives, Cornwall.

LACHAISE, Gaston. Born in Paris, 1882; died in New York, 1935. Began artistic training at thirteen. While a student at the Académie des Beaux-Arts, 1900–05, met and fell in love with Mrs. (Isabel Duhaut) Nagle of Boston. Went to Boston, 1906. Assisted established sculptors, and did own creations in free time, in Boston and New York, 1906–20. First one-man show, 1918.

LAURENS, Henri. Born in Paris, 1885; died in Paris, 1954. Introduced to cubist painting by George Braque, 1912. Practiced "cubism" in sculpture until about 1925, then turned to making sculpture based on natural figures.

LIPCHITZ, Jacques. Born in Druskieniki, Lithuania, 1891; died in Capri, while on vacation, and buried in Jerusalem, 1973. Went to Paris, 1909. Began "cubist" sculptures in 1914, and "transparents" in 1925. Later sometimes

turned to more naturalistic figures. First major exhibition in New York, 1935. Moved to New York, 1941. Lived in Hastings-on-Hudson beginning in 1947.

MAILLOL, Aristide. Born in Banyuls, France, 1961; died in Banyuls, 1944. First worked mainly in painting and tapestries. Turned to making statuettes in wood and terra cotta in 1896. Bronze casts first exhibited 1902. Toured Greece, 1905. Met Dina Vierney when she visited his family outside Paris in 1934. Returned to Banyuls during Second World War.

MARINI, Marino. Born in Pistoia, Tuscany, 1901. Became professor of sculpture at School of Fine Arts of Villa Reale in Milan, 1927. Visited Paris, 1930, 1931, and 1936. First of horse-and-rider series, 1936. In Switzerland during most of Second World War, 1942–46. Lives in Milan.

MATISSE, Henri. Born in Le Cateau, 1869; died in Nice, 1954. Famous mainly as a painter; regarded as rival of Picasso. First seriously attempted sculpture in 1900. Gave up sculpture after 1933.

MODIGLIANI, Amedeo. Born in Leghorn, 1884; died in Paris, 1920. Began painting at fourteen. After being sick with tuberculosis at sixteen, traveled to Rome, Florence, and Venice. Went to Paris, 1906. Became friend of Brancusi, and worked in sculpture from 1909 to 1915. Returned to painting with help of his dealer in 1916.

MOHOLY–NAGY, László. Born in Bacsbarsod, Hungary, 1895; died in Chicago, 1946. Served in Austro-Hungarian army. Took law degree, 1918. Meanwhile had begun drawing and painting. Taught at Bauhaus in Weimar from 1923 to 1928—metalwork, stage design, mural painting, and photography —and experimented with light and color. To Berlin, Paris, and London, 1928–37. Started a school in Chicago in 1937.

MOORE, Henry. Born in Castleford, Yorkshire, 1898. After military service, 1917–18, studied at Leeds Art School and Royal College of Art where he was a classmate of Barbara Hepworth. Visited France and Italy in 1925. First one-man exhibition, 1928. Married Irina Radetzky in 1929. Moved to Perry Green, Hertfordshire, in 1940. First one-man show abroad, in New York, 1943. Daughter Mary born, 1946. First trip to Greece, 1951.

NEVELSON, Louise. Born in Kiev, Russia (née Berliawsky), 1900. Moved to United States in 1905, and grew up in Rockland, Maine. Married Charles Nevelson, 1920; divorced, 1941. Studied at Art Students League of New York, 1929. Studied in Germany, 1931. First one-man exhibition of sculpture, 1941. Took archaeological trips to Central and South America, 1948–49. Lives in New York City.

PEVSNER, Antoine. Born in Orel, Russia, 1886; died in Paris, 1962. Brother of Naum Gabo. Studied in Kiev and St. Petersburg, 1902–10. In Paris, 1911–14, and Oslo, 1914–17. Returned to Moscow, 1917; left for Berlin,

1922, when Communist regime closed studio. Turned from painting to sculpture, 1922. Settled in Paris, 1923, and became French citizen, 1930.

PICASSO, Pablo. Born in Malagá, Spain, 1881; died in Mougins, southern France, 1973. Studied with his father and at art schools in Barcelona and Madrid. Settled in Paris, after three earlier visits, 1903. After Second World War settled in south of France. Lived with seven women, more or less seriatim; married two. Major periods as sculptor: 1905–6, 1909, 1928–35 (including period of collaboration with Gonzalez), Second World War, and occasionally in later years.

RODIN, Auguste. Born in Paris, 1840; died in Meudon (suburb of Paris), 1917. Trained at "Petite École" (Free School of Design). Met Rose Beuret in 1864; married her fifty-two years later, in the year when both died. Employed by Carrier-Belleuse beginning in 1864, in Paris and Brussels, and later by Van Rasbourg, in Brussels. First work accepted by Salon in 1875.

SMITH, David. Born in Decatur, Indiana, 1906; died in car accident near Bennington, Vermont, 1965. Studied briefly at Ohio University, 1924, and Notre Dame University, 1925. Worked in Studebaker plant in South Bend, Indiana, summer of 1925. Enrolled in Art Students League of New York, 1926. Moved to Bolton Landing, New York. Worked as welder in Schenectady during Second World War. Visited Paris, Athens, and Russia in 1935. Twice married (1927 and 1953) and twice divorced.

Further Reading

FROM the voluminous literature on modern sculpture I have selected a few books that can be helpful to readers who would like to pursue the subject further. Some deal generally with the topic. Some concern particular movements in modernism, or influences (such as primitive art) that have made themselves felt. The third list includes books on individual sculptors. The references do not include any articles from periodical literature.

GENERAL

Elsen, Albert. *Origins of Modern Sculpture.* New York, 1974.

Goldwater, Robert. *Space and Dream.* New York, 1968.

———. *What Is Modern Sculpture?* New York, 1969.

Hamilton, George Heard. *Painting and Sculpture in Europe,* 1880–1940. Baltimore, 1967.

Newmeyer, Alfred. *The Search for Meaning in Modern Art.* Englewood Cliffs, N.J., 1964.

Ortega y Gasset, José. *The Dehumanization of Art* (written in 1921). Translated by Helene Weyel. Princeton, 1968.

Read, Herbert. *A Concise History of Modern Sculpture.* New York and Washington, 1964.

———. *The Art of Sculpture.* 2d. ed. New York, 1961.

Ritchie, Andrew C. *Sculpture of the Twentieth Century.* New York, 1952.

MOVEMENTS AND INFLUENCES

Burnham, Jack. *Beyond Modern Sculpture: the Effects of Science and Technology on the Sculpture of This Century.* New York, 1968.
Cooper, Douglas. *The Cubist Epoch.* New York, 1971.
Elisofon, Eliot, and W. B. Fagg. *The Sculpture of Africa.* New York, 1958.
Giedion, Sigfried. *The Eternal Present: The Beginnings of Art* (vol. 1 of 2 vols.). New York, 1964.
Golding, John. *Cubism: a History and an Analysis, 1907–1914.* New York, 1959; 2d ed., London, 1968.
Goldwater, Robert. *Primitivism in Modern Art.* Paperback edition, New York, 1967.
Neumann, Erich. *The Great Mother.* New York, 1955.
Powell, T. G. E. *Prehistoric Art.* New York, 1966.
Richter, Hans. *Dada: Art and Anti-Art.* New York, 1966.
Rickey, George. *Constructivism.* New York, 1967.
Rubin, William S. *Dada and Surrealist Art.* New York, 1968.
Sandars, Nancy K. *Prehistoric Art in Europe.* Baltimore, 1968.
Willett, Frank. *African Art.* New York, 1971.

INDIVIDUAL SCULPTORS

Karshan, Donald, H., ed. *Alexander Archipenko.* Washington, 1969.
Soby, James Thrall, ed. *Jean Arp.* Exhibition catalogue. Museum of Modern Art, New York, 1958.
Read, Herbert. *The Art of Jean Arp.* New York, 1968.
Geist, Sidney. *Brancusi: a Study of the Sculpture.* New York, 1968.
Giedion-Welcker, Carola. *Constantin Brancusi.* New York, 1959.
Lewis, David. *Brancusi.* New York, 1957.
Calder, Alexander. *Calder, an Autobiography.* New York, 1966.
Sweeney, James Johnson. *Alexander Calder.* New York, 1943.
von Matt, Leonard, and John Rewald. *Degas: Sculpture—The Complete Works.* New York, 1957.
Gabo: Constructions, Sculpture, Paintings, Drawings, Engravings. Introductory essays by Herbert Read and Leslie Martin. Selected writings of Naum Gabo. Cambridge, Mass., 1957.
Dupin, Jacques. *Alberto Giacometti.* Translated by John Ashberry. Paris, 1963.
Hohl, Reinhold, ed. *Alberto Giacometti.* New York, 1972.

Museum of Modern Art. *Giacometti.* Exhibition catalogue, with introduction by Peter Selz and autobiographical portrait by artist. New York, 1965.

Museum of Modern Art. *Gonzalez.* Exhibition catalogue, with introduction by Andrew C. Ritchie. New York, 1956.

Hammacher, A. M. *Barbara Hepworth.* London, 1968.

Ally, Robert. *Barbara Hepworth.* Exhibition catalogue. Tate gallery, London, 1968.

Katz, Leslie, and Robert J. Schoelkopf, Jr., eds. *The Sculpture of Gaston Lachaise.* New York, 1967.

Museum of Modern Art. *Lachaise.* Exhibition catalogue, with note by Lincoln Kirstein. New York, 1935.

Los Angeles County Museum of Art. *Lachaise.* Exhibition catalogue, with introduction by Gerald Norland. Los Angeles, 1964.

Lipchitz, Jacques (with H. H. Arnason). *My Life in Sculpture.* New York, 1972.

Rewald, John. *Maillol.* New York, 1939.

Waldemar-George. *Artistide Maillol.* With biography by Dina Vierney. Greenwich, Conn., 1965.

Marino Marini: Complete Works. General text by Patrick Waldberg; catalogue and notes by G. Di San Lazzaro. New York, 1970.

Hammacher, A. M. *Marini.* New York, 1970.

Barr, Alfred H., Jr. *Matisse: His Art and His Public.* New York, 1951.

Legg, Alicia. *The Sculpture of Matisse.* Exhibition catalogue. Museum of Modern Art, New York, 1972.

Werner, Alfred. *Amedeo Modigliani.* New York, 1966.

Kostelanetz, Richard, ed. *Moholy-Nagy.* New York, 1970.

Moholy-Nagy, László. *The New Vision.* 4th rev. ed., New York, 1947.

James, Philip, ed. *Henry Moore on Sculpture.* New York, 1971.

Melville, Robert, ed. *Henry Moore: Sculpture and Drawings, 1921–1969.* London, 1970.

Neumann, Erich. *The Archetypal World of Henry Moore.* Translated by R. F. C. Hall. New York, 1959.

Read, Herbert. *Henry Moore: a Study of His Life and Work.* New York and Washington, 1966.

Russell, John. *Henry Moore.* Baltimore, 1973.

Glimcher, Arnold B. *Louise Nevelson.* New York, 1972.

Penrose, Roland. *Picasso: His Life and Work.* New York, 1973.

———. *The Sculpture of Picasso.* New York, 1967.

Champigneulle, B. *Rodin.* New York, 1967.

Elsen, Albert. *Rodin.* New York, 1963.

———, ed. *Auguste Rodin: Readings on His Life and Work.* Englewood Cliffs, N.J., 1965.

Jianou, Ionel. *Rodin.* Paris, 1970.

Krauss, Rosalind E. *Terminal Iron Works: The Sculpture of David Smith.* Cambridge, Mass., and London, 1971.

McCoy, Garnett. *David Smith.* New York, 1973.

Smith, David, C. Gray, ed. *David Smith.* New York, 1968.

Index

The titles of works of sculpture illustrated in the book appear in italics. Numbers in brackets refer to illustrations.

170 INDEX